Radical Approaches to Contemporary Housing

New Residential Architecture

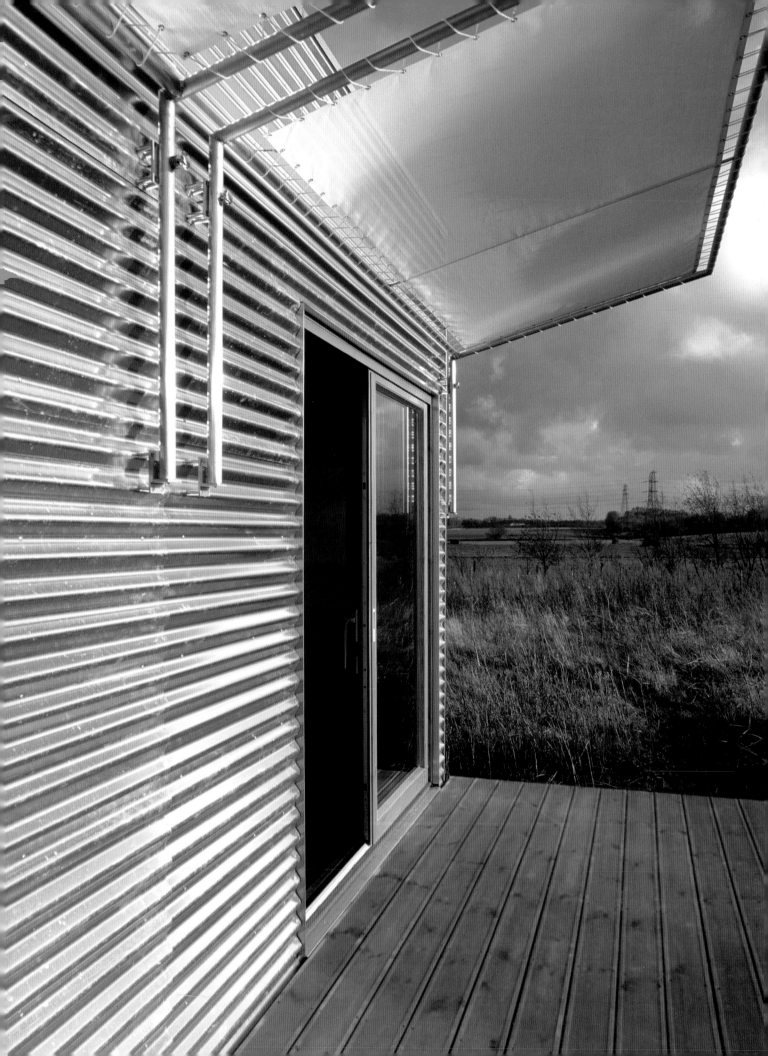

Radical Approaches to Contemporary Housing

New Residential Architecture

Will Jones

MITCHELL BEAZLEY

New Residential Architecture
Will Jones

First published in 2005 by Mitchell Beazley,
an imprint of Octopus Publishing Group Ltd,
2-4 Heron Quays, London E14 4JP

ISBN 1 84533 028 5

A CIP catalogue copy of this book is available
from the British Library

Commissioning Editor Mark Fletcher
Executive Art Editor Sarah Rock
Managing Editor Hannah Barnes-Murphy
Project Editor Emily Asquith
Designer Peter Gerrish
Production Manager Gary Hayes
Copy Editor Kirsty Seymour-Ure

To order this book as a gift or an incentive contact
Mitchell Beazley on 020 7531 8481

Set in Interstate

Printed and bound in Hong Kong by
Toppan Printing Company Limited

CONTENTS

FOREWORD

People are conservative-minded about housing design. The same individuals who embrace new technology or dress in the latest fashion will quite happily live in a mock-Tudor semi-detached house that sits on an estate covered in countless other half-timbered clones. Even sportspeople and rock stars, with money and attitude to spare, tend towards the mundane when having a home built. But why is this?

The Modern movement supposedly liberated us from traditional housing design in the early 20th century. Architects including Mies van der Rohe broke from tradition and experimented with fluidity of space. His Farnsworth House and Barcelona Pavilion heralded a new era of architecture and residential design, or so we thought.

New architectural designs, along with new technology and materials, have to be embraced. In the 21st century computers will play a large role in advancing design. Curvilinear buildings, for example, are as yet rare but architects are now exploring new possibilities in biomorphic form. Environmentally conscious architecture is another a challenge that has not yet been fully met and embraced.

This book illustrates the opportunities to be taken in housing design. It is divided into five distinct chapters, each tackling a key area for architectural consideration. Some of the properties embrace the ultimate in luxury. Barclay & Crousse's Casa Equis has a glass-sided lap pool overlooking the Pacific that would not be out of place in a James Bond movie. This is a dream home for the new millennium, a progression of John Lautner and Pierre Koenig's Los Angeles houses of the 1960s, and an emphatic design statement.

Conversely, Ahadu Abaineh's Growing House or the Fin-Topped House by Ben Addy seek to solve spatial and economic problems. This burden has pushed them to use innovative techniques, sustainable materials, the latest in three-dimensional computer software, and futuristic concepts to create altogether more modest abodes.

That is the point of this book: to open people's minds – both client's and architect's – to the potential of residential architecture. Houses can reflect and even improve our modern world, if we think progressively, rather than reverting to neo-vernacular representations of the past.

Chris Wilkinson
Wilkinson Eyre Architects

Opposite Architect Sean Godsell's dramatic use of material and form for Peninsula House in Australia – a design simple in style but awe-inspiring in its beauty (pp. 50–55).

INTRODUCTION

What is the house to architecture? It is the opportunity to experiment and create. With the blessing of an open-minded client, it can be a chance to run riot with ideas and make concrete previously unrealized design dreams. But it is also the one type of architecture that virtually every being on the planet has experienced in some shape or form. The house is the connection between the architect and the general public. It has meaning within all of our lives and this makes it more easily understood, more widely fêted when designed at its best, and more vehemently criticized if found to be lacking.

When reading an architectural critique of, say, a museum or gallery that is being derided for its "poor spatial dynamics and lack of aesthetic continuity," the reader attempts to picture the scene and understand the reasoning. When a house is criticized for its "ill-conceived internal layout" or "deficient natural light," we all know that its interior is dull and depressing and the bathroom is not where it would normally be. It is our connection with the genre that instills an understanding of it and, as a consequence, gives everyone a valid opinion on it.

However, while the house is the architectural project most understood, and hence most scrutinized, it is also often the architect's first commission. Whether for a client or as a personal project, it is a journey of discovery, an expression of design intent, a test-bed for burgeoning talent. Think of the Villa Fallet, designed in 1906 by Charles-Edouard Jeanneret-Gris, or Le Corbusier as he would become known. The architect used traditional style and methods while testing out geometric theories on such elements as windows and gable detailing. Or consider Oak Park, Illinois, Frank Lloyd Wright's first house and also his home, designed and built while he was still under the tutelage of Louis Sullivan. These houses and every other architect-designed property were and still are the opportunity to put into practice long pored-over ideals, to use new experimental materials, and to express oneself in a way that all but a few commercial or public projects prohibit.

Yet this freedom comes with a catch. If an architect does not design with the client in mind, what was supposedly a joint vision can soon crack and become two disparate views. The layperson's perception of what is architecturally inclusive is often not all that the designer desires. What the architect sees as pristine minimalism, the client may view as clinical emptiness. And therefore architects blame unimaginative clients, short-sighted planners, and a general lack of vision for the demise of their most treasured schemes: while conversely, disparaging clients target the designer's superficial yearning to shock, or their disregard for the norm, as a major blunder.

But it is this conflict that architecture thrives on. As with any art form, there will always be detractors. From Picasso to Tracey Emin, Van Gogh to Jeff Koons, artists have rallied against public vilification. And this is no bad thing: bring debate to the fore, and for every one who hates an artwork or architectural intervention there will be another who starts to understand it. The architect who moans about being misunderstood has a simple path to tread: teach people to understand. Criticism, if articulated and directed properly, is a positive force, and only those who can take it and become stronger will succeed.

The unsettling truth here is that while art can be loved or loathed and then forgotten about, shut away in some gallery or private collection, architecture – and residential design in particular – is the very real fabric of our society. It is the set on which we play out our lives. And while art, good and bad, is praised and vilified in equal measure, after its unveiling

Below Alsop Architects creates a
sculptural landscape in which to live
with CiBoGa. Gone are traditional
rows of homes, in favour of a new
residential aesthetic (pp160-163).

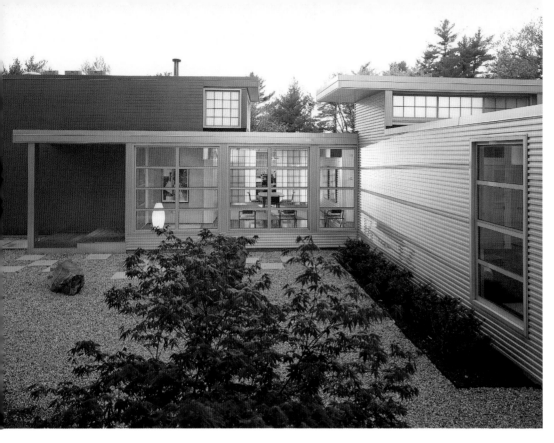

Left Colours and textures merge: hard stone and metal, delicate foliage, and warm hues, all combine to create Mark Hutker's Skolos/Wedell Home (pp62-63).

Opposite The surroundings play an important part in Barclay & Crousse's Casa Equis, where the built forms blend with the desert and water mirrors the sky. Similarly, the property's design reacts to its environment – strong in the rugged landscape, and open to the sky because no rain falls here (pp16–21).

most architecture receives little or no attention if it is brilliantly executed, or even merely good. The only residential architecture that makes headlines after its initial completion is bad architecture.

Think of the derision now heaped upon the glut of tower blocks erected in cities across the UK in the 1950s and 1960s – Ronan Point in Liverpool, Park Hill in Sheffield – the same ones initially championed as being the "modern" way to live. Remember the now demolished Darst-Webbe and Pruitt-Igoe projects in St Louis, Missouri, USA: Bauhaus experiments flattened to make way for nice "safe" three-storey town houses. Now try to recollect the last time that a house design or residential scheme was highlighted for its long-term success. Architecture is not an industry for those in search of plaudits and praise.

As such, the designers of houses and homes are very seldom media stars. But every one of them must realize the importance of what they are creating; that they influence every moment of the lives of those who inhabit their "work." Creating a home is, in a nutshell, the most important project that an architect can take on: social responsibility rears its head, pragmatism comes into play, and architects are forced to realize the gravity of their work. This chance to express their design ideals and desires has to be balanced with the creation of a functional fortress that the owner will rely on as a vessel for living and a buffer against the stresses of everyday life.

This book brings together a collection of residential schemes. both single homes and mass-housing projects, some of which are unusual in their design or use of materials, some of which are exquisitely simple. Each chapter tackles a different aspect of design, part of the jigsaw whose pieces, when fitted together correctly, produce strong, considered solutions.

Some of the properties featured look to the future, seeking to tackle an assortment of dilemmas including environmental awareness, affordable housing, urban regeneration, and social inclusion. On other schemes the architects examine the space that the property will inhabit, and create the optimum response to that particular set of rules. However, all of the projects can be analysed in numerous ways, explored differently, and dissected to reveal inherent outstanding qualities. Each is its own unique mix of art, imagination, understanding, and pragmatism, but all have a major impact on those in and around them.

This book hopes to do that. It is designed to inspire, and to provoke thought and discussion. It will change your mind as to the best way to achieve a given ideal or overcome a design problem. This book attempts to be as interesting as the residential architecture all around you; to be exciting, functional, emotive, and practical; but most of it should bring enjoyment to readers, just as houses should be enjoyed by their occupants.

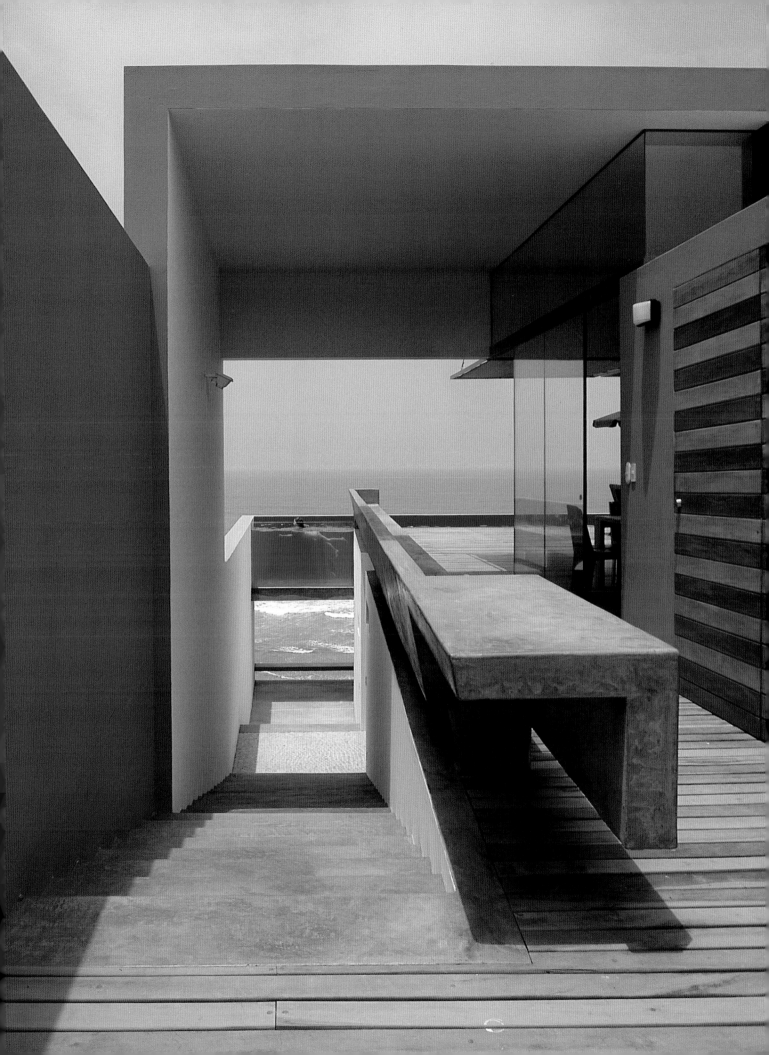

CONDITIONS

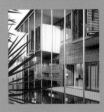
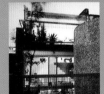

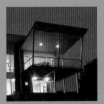

Introduction

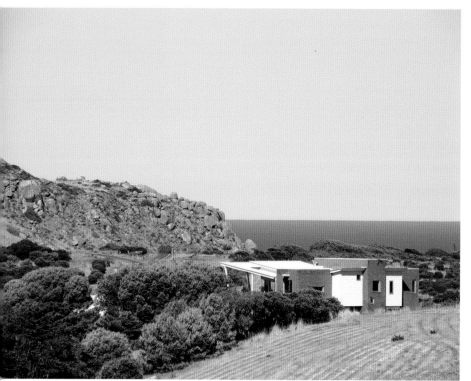

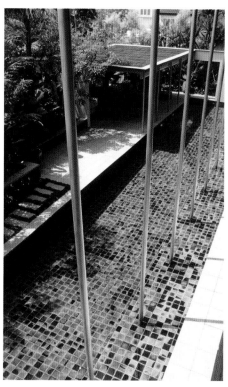

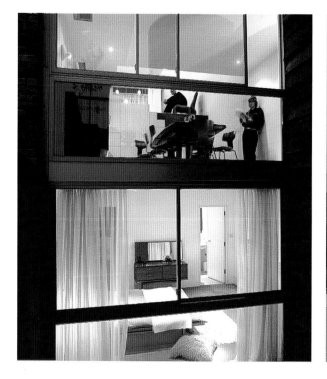

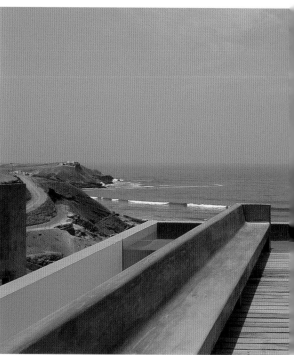

Residential architecture, more than any other sector, is the stage on which architects are allowed to indulge their most creative whims: Minimalism is never more stark, nor Post-Modernism more daring than when allowed to rule in the private house.

However, where most art forms are abstract and unaffected by their environment, architecture must interact, stand up to and react against the conditions in which it is realized. Each project presents a new set of conditions and constraints that the designer must adapt to or overcome for the work to be a success. The site for a new house can be flat or sloping, or it may be set in an urban jungle or a rural idyll. The outlook may be instantly inspiring or depressingly dull; and climate must be considered, too. The architect must, above all else, design to suit the conditions.

However, it is these constraints that conspire to extract the best from any architect. If asked to name Frank Lloyd Wright's most famous house, many would answer Fallingwater. While his Prairie Style houses took up a much larger part of his working life, this one project, perched on top of a waterfall, threw up a bigger challenge, which he met with an iconic solution that is now renowned the world over.

The architects within this chapter tackle projects in a variety of conditions. And while, as with Lloyd Wright's *pièce de résistance*, they endeavour to create the perfect response to their situation, in the mêlée of the 21st century, designers are pushed to the limits of their knowledge and creativity on every project.

Space is perhaps the most common constraint that architects are coming up against today. Urban conurbations are expanding at almost exponential rates; or, where they are restricted, the space within them is becoming ever more overcrowded. What should the designer do? The designs of British architect Ben Addy indicate how high-tech lightweight, modular construction might solve property shortages in crowded Asian cities such as Tokyo. Austrian architect Delugan Meissl has looked beyond the norm to find an alternative site: the result is Ray 1, a vast open-plan apartment, complete with outdoor swimming pool, on top of an office block in Vienna.

A sanctuary within the urban hubbub is another design type now often yearned for. No longer can people guarantee a relaxed home atmosphere within the city. WOHA Architects tackles the problem in Singapore by turning a house in on itself. The configuration of rooms and views orients life around and overlooking a private pool and courtyard. The architect has shunned the outward aspect in favour of

creating an inner tranquility that can be controlled. "What today may be a tract of unspoilt forest might tomorrow be a multi-storey office block," says practice partner Wong Mun Summ.

This project also responds to Singapore's hot, wet atmosphere. Quite simply, the roof has a large overhang that shields the windows and balconies from rain, even in the monsoon season. And this tactic is turned on its head by Architects Ink in Australia, whose coastal house features a deep balcony to the first floor and wide eaves at roof level to shield the interior of the property from baking summer sun but allow in the lower, weaker rays during winter.

For all these hurdles, some residential projects are indebted to their location. Edge Design's Suitcase House is situated in perhaps one of the most awe-inspiring areas in the world — on a mountainside overlooking the Great Wall of China. Here, the architect has taken every opportunity to defer to the view: a rectangular wooden box-like house is lined the length of its two longest sides with glazing. The interior can be split into rooms but is usually left as one open space so as not to obstruct the view; the flat roof doubles as a viewing platform.

Similarly, Barclay & Crousse's Casa Equis in Peru takes liberties with its desert location and the unusually stable weather conditions. In a place where no rain has fallen in more than 30 years and the temperature never drops below 14ºC (57ºF), why put a roof on every room? Corridors are left open to the stars to make the night-time stroll to bed a magical experience.

These projects are exemplary because they are born out of adversity. Just as an athlete runs a better race when pushed hard, the architect needs to be challenged to produce the optimum design. And, while the client can put pressure on the designer, there is nothing that does this better than the physical conditions in which the property is to be built.

Opposite left Beach House, Adelaide, Australia (pp. 36–37)
Opposite right Hua Guan House, Singapore (pp. 26–29)
Opposite bottom left Voss Street House, London, UK (pp. 30–31)
Below Casa Equis, Cañete, Peru (pp. 16–21)

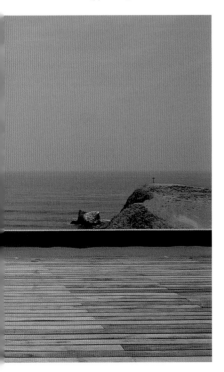

Casa Equis

Barclay & Crousse | Cañete, Peru

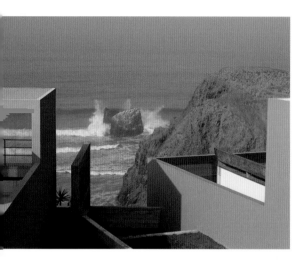

Between the Andes mountain range of Peru and the Pacific Ocean stretches a long strip of dusty, dun-coloured land known as the Peruvian Desert. This is one of the most arid areas in the world but, surprisingly, its climate is not extreme: temperatures range from 14ºC (57ºF) in the winter to 29ºC (84ºF) in mid-summer, with very little fluctuation between night and day.

On the very edge of this stark landscape, Paris-based architect Barclay & Crousse has created an architectural oasis. Sitting high above the ocean atop a steep cliff, Casa Equis seems hewn out of its setting.

The great distance between the architect's office in Paris and the site of the project made necessary the rationalization of construction techniques, together with the simplification or eradication of all details deemed non-essential. Hence the house's walls are of exposed *in situ* concrete, both simple to construct and acting as good interior temperature regulators. Even the ochre colouring of the walls has a purpose: to minimize the visual impact of wind-blown desert dust.

The architect describes the creation of the house as like taking a solid object and excavating bit by bit to form the building, rather as archaeologists in the region remove desert sand to uncover pre-Columbian ruins. This "subtractive logic" has been used to produce an architecture that blurs internal anfd external spaces – easy in an area in which it never rains. Shelter from the wind is the only climatic concern, enabling the staircase linking the upper living space and the lower bedrooms to have no roof. The main living room can be completely opened to the elements and the view, courtesy of a wall of frameless sliding glass panels. These open on to a large terrace, or "artificial beach," bordered by a narrow swimming pool whose presence establishes a connection with the ocean below.

Above The view between Casa Equis and its neighbouring property, also designed by Barclay & Crousse, illustrates the magnificence of their vantage point above the Pacific Ocean. While differing in layout and looks, both houses are of *in situ* concrete construction.

Right The concrete wall extends up from the lower sleeping quarters, flying past the upper level and providing shelter from the wind. The heavy nature of the construction both protects and blends well in this rugged landscape.

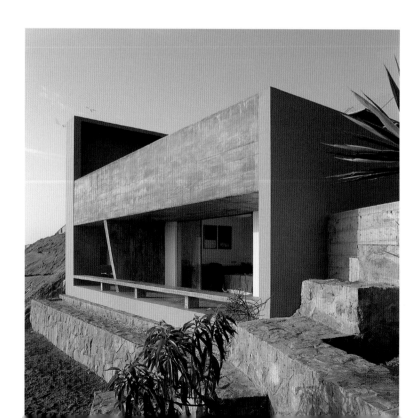

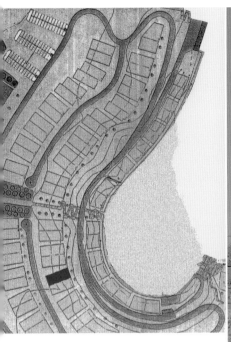

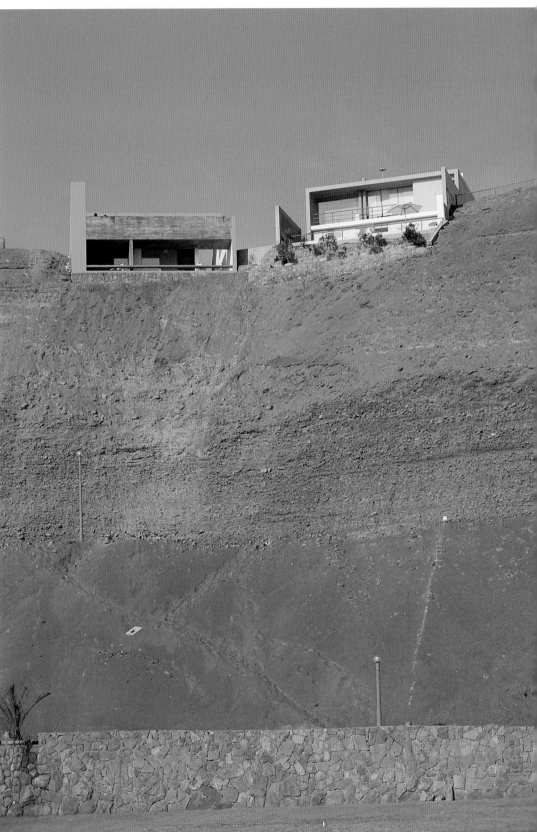

Above A plan view of the full site shows the extent to which the area will eventually be developed. Casa Equis is marked in red. Currently, however, other plots have not been developed and the two built properties stand together, alone.

Right Casa Equis, to the left, sits high above the Pacific with its sister property, designed by the same architect. The properties exude strength, both in their construction and in their earth-like colouring. They stand champions over this remote, arid environment.

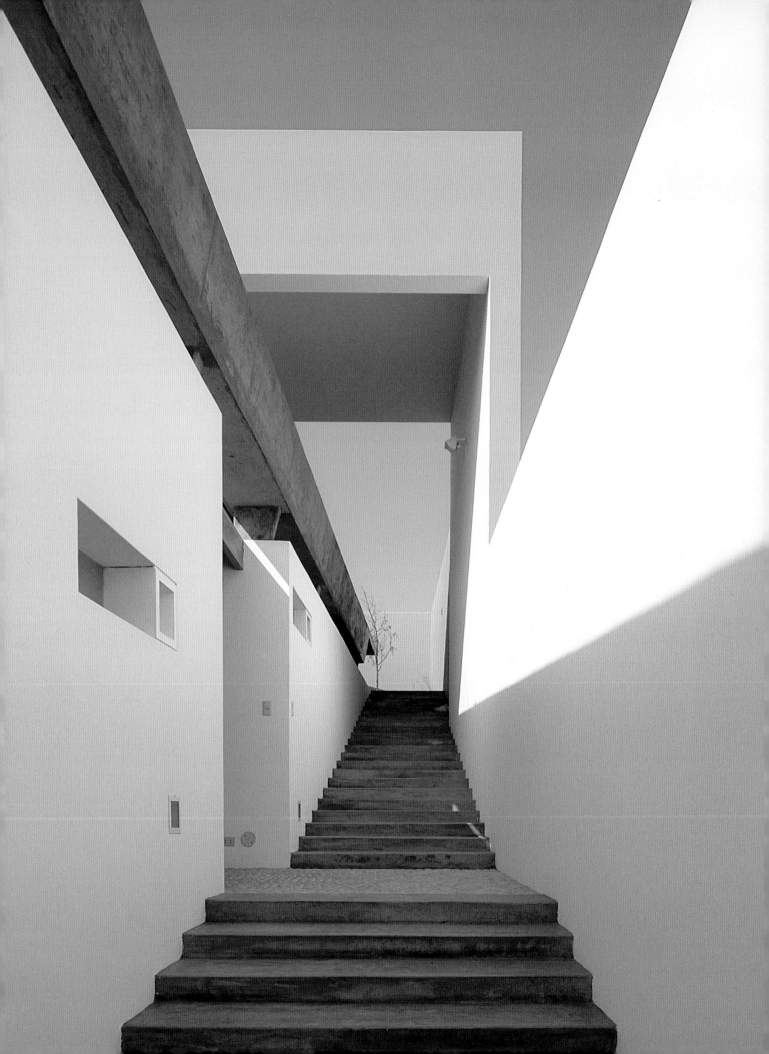

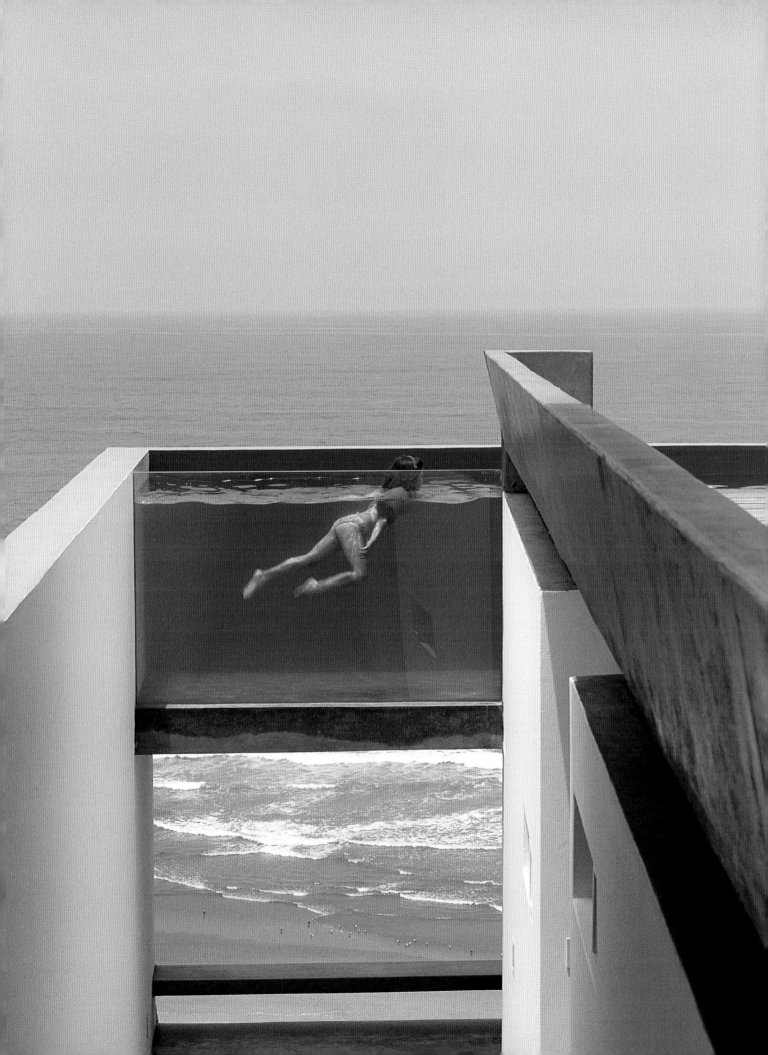

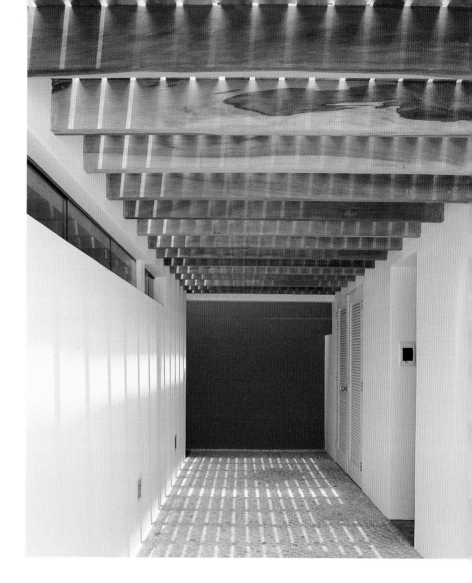

Previous pages In a land where it never rains, a home need not be a shelter. To the left is a view looking away from the ocean, up the open stairway that leads from the upper living quarters and terrace down to the bedrooms in the building's base. Turn 180 degrees to face the ocean and the view (right-hand page) from the same stairway is dramatic in the extreme. The lap pool with its glass side is suspended above a void offering views of the ocean. This is what you see when wandering downstairs to bed.

Right Under the timber-decked terrace is a corridor leading to the bedrooms. The slatted floor filters the sunlight, creating simple, beautiful, and ever-changing effects.

Below Barclay & Crousse's sketches show the true simplicity of the project. The architect describes how the building is envisaged as being chipped and scraped out of its surroundings, like a treasured archaeological find.

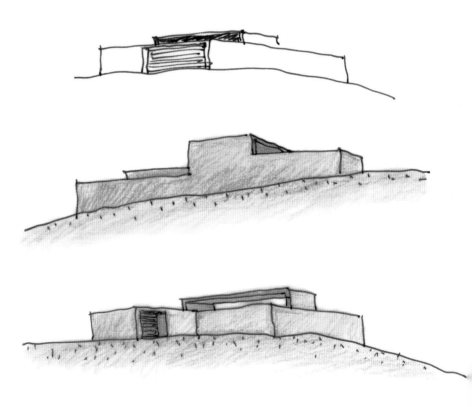

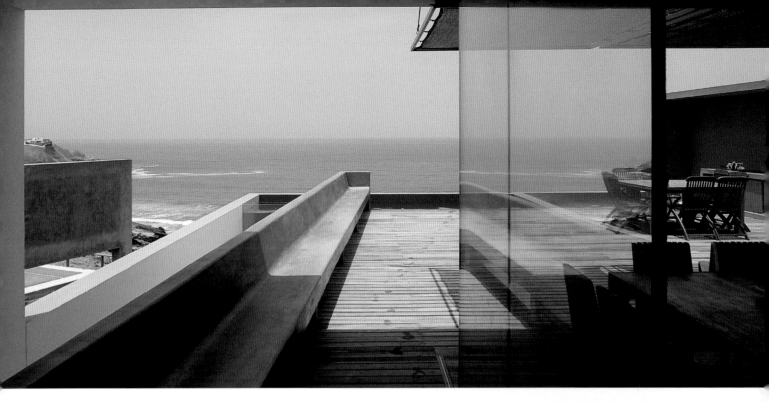

Above As one looks out on to the large open-air terrace, the ocean seems nearer than it actually is. This feeling is enhanced by the presence of the lap pool at the terrace perimeter. The wall at the left side of the terrace is formed into a fixed concrete bench.

Right The timber decking of the terrace continues inside the house. This removes perceived barriers between internal areas and the exterior, an impression that is reinforced by the extensive glazed walls that slide back to open up the entire façade.

Bottom Two views of the property show the steepness of the site's gradient and the position of the stairway linking living and sleeping quarters. They also illustrate the small percentage of covered living space – the portion under the central concrete wrap-over.

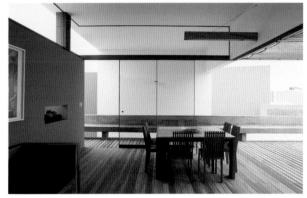

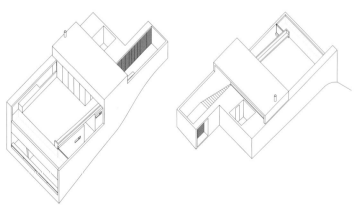

Ray 1

Delugan Meissl | Vienna, Austria

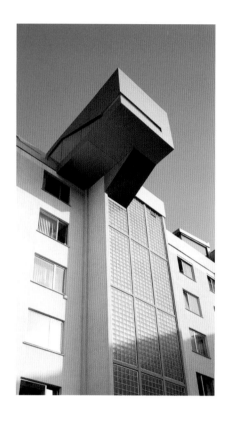

Perched on top of a five-storey office building in central Vienna, opposite architect Delugan Meissl's studio, is Ray 1, a luxury apartment that would be perfectly suited as the set of a James Bond movie. But this is no fake set: rather, it is the home of the practice principals Roman Delugan and Elke Delugan-Meissl.

This bizarre rooftop property was born out of a lack of availability of ground-level inner-city locations. It makes maximum use of its lofty yet confined site via a framework of 52 tonnes (51 long tons) of steel beams, which creates a structural skeleton for the property. This steelwork transfers the load of the apartment evenly over the roof area, reducing point loads and minimizing the need for internal columns. Covered in weatherproofed aluminium cladding, the slopes and angles of the steel frame create a unique rooftop spectacle, but one that evokes the lines and forms of the classical dormers and mansard roofs of its older Viennese neighbours.

Maximizing the floor area of the apartment was important on the tight rooftop site, and so the architects cantilevered the entrance stairway out over thin air. This allows every inch of space on the roof to be taken up by the living areas, two terraces, and a lap pool. Internally, other than the bedrooms and bathroom, the area is one open space. Differentiation between "rooms" is communicated by changes in floor height, and by boundary markers such as the monumental white kitchen work surface.

Ray 1 has been designed and built as a showcase for the practice, and as such it displays not only the architect's ingenious aesthetic leanings, but also a remarkable ability to see and to realize the full potential of a difficult site.

Above Cantilevered out some 6 m (20 ft), the final flight of stairs and entrance to Ray 1 extend from the vertical circulation route of the building on which it sits. This precarious-looking design allows the entire roof area to be utilized as living space.

Right Most of the walls of the property are fully glazed. The futuristic roof and parapet wall are supported by the steel skeleton, allowing unimpeded panoramic views. This terrace and a lap pool constitute the external space.

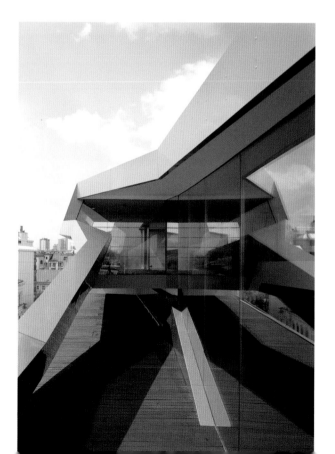

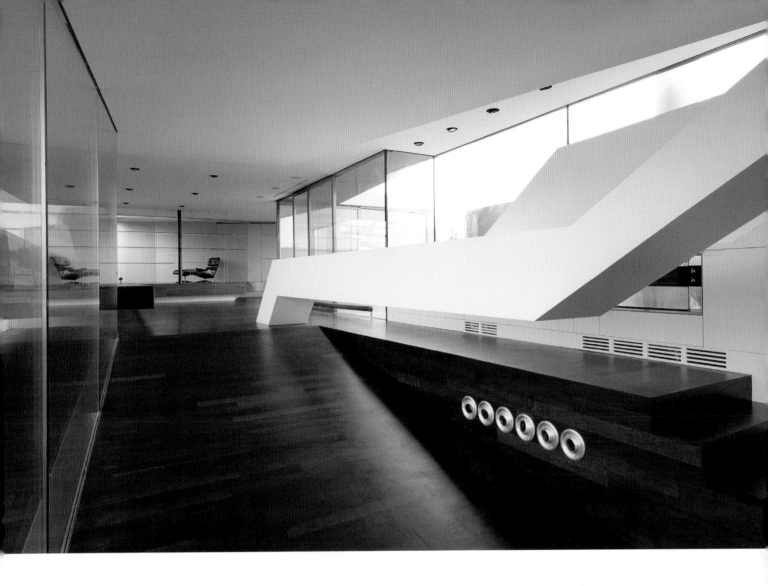

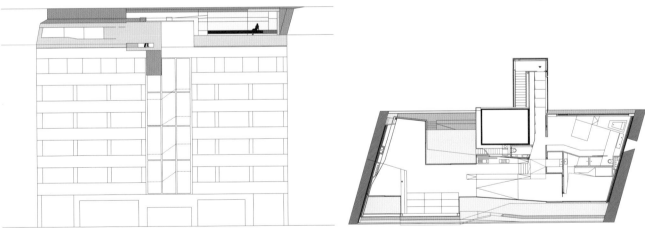

Top A monumental white
intervention through the main living
space is actually a work surface and
storage facility. It also denotes the
boundary of the kitchen area, its
clinical feel and colour contrasting
with the high-quality hardwood
flooring and luxurious furniture.

Above, left and right In
elevation (left), Ray 1 uses the whole
of the roof space on this five-storey
building. The link to the stairs is
shown by the lowest grey portion.
In plan, the open living spaces are
seen with lap pool at top left; the
service core is shown as a black box.

Overleaf Night-time is not always
for sleeping. This bed has a host of
features, including built-in lighting
and ventilation, but it is its position,
looking out over the city, that is
truly awe-inspiring. Note also the
main entrance hall with its shallow
steps, seen through the window.

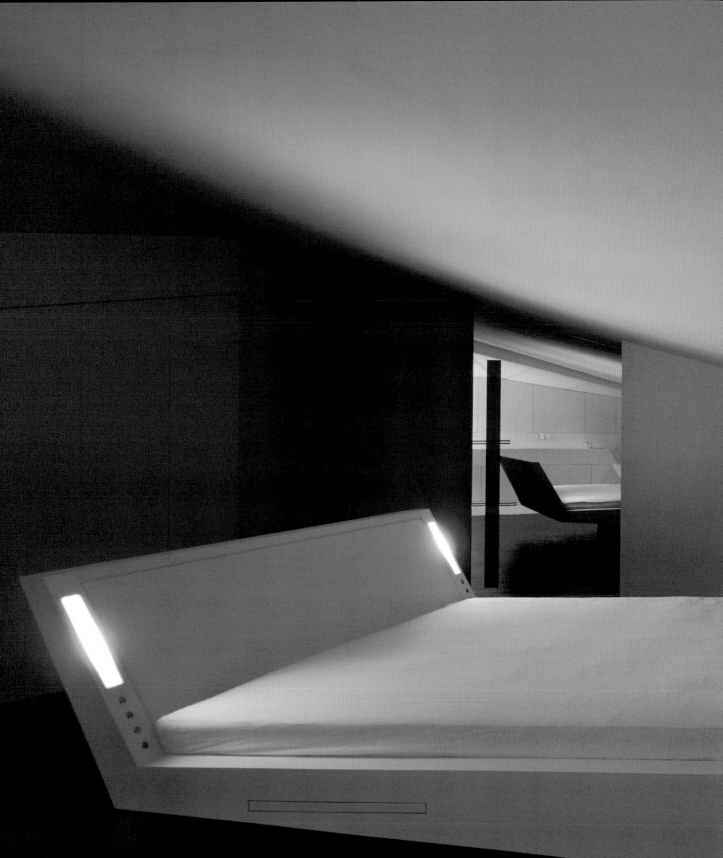

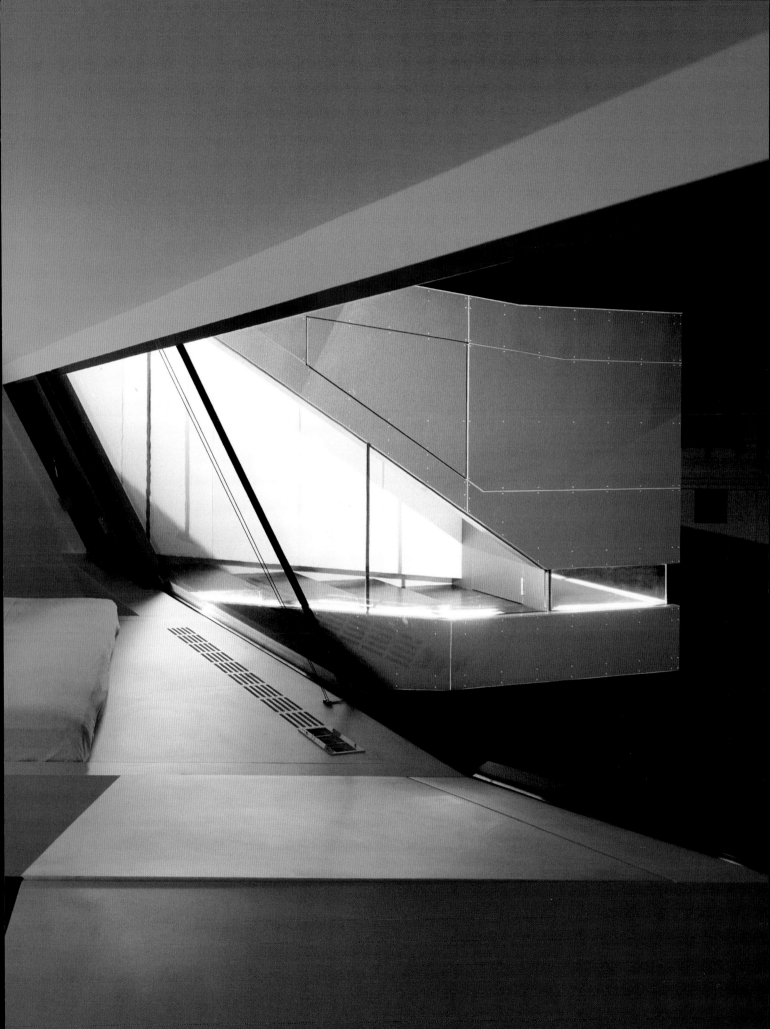

Hua Guan House

WOHA Design | Singapore

Private space is at a premium in the densely developed suburbs of Singapore, with properties often being overlooked on all sides. This created a dilemma for WOHA Design, in that it is effectively impossible to control the view from a property – what today might be an unspoiled vista could tomorrow be a multi-storey office block.

With Hua Guan House, therefore, the architect has oriented all the spaces within the house to face into a private garden area. There are virtually no windows on to the street, but a long circulation space, lit naturally from high level, runs along the southern aspect of the property. Off this are the living areas: on the ground floor, a study, living room, dining room, and kitchen; on the first, a master bedroom, a family room, and three smaller children's bedrooms.

Nearly all of these spaces are directly connected to the garden area, which has been maximized by pushing the building to the boundary limit, hard against the neigbouring property. Glazed screens to the ground-floor rooms open out on to a paved area and a lap pool. Upstairs, the bedrooms push outward from the main building as cube-shaped pods. Full-height louvred screens shield these rooms from the sun, or are drawn back to turn each pod into a balcony. A large 3 m (10 ft) wide veranda, supported on slender steel columns, allows these balconies to be opened even in monsoon weather.

The part of the small garden that is not taken up by hard-landscaping or pool is planted with masses of dense foliage. This completes WOHA Design's strategy for creating a tranquil private space in a densely populated area.

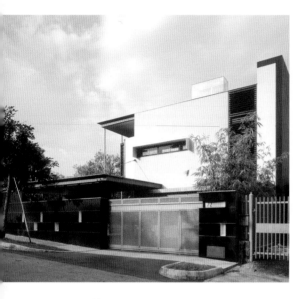

Above From beyond its perimeter walls, Hua Guan House is interesting but impenetrable. Its west wall features only a vertical louvred section to allow light into the double-height circulation gallery and a slit window on to a bedroom.

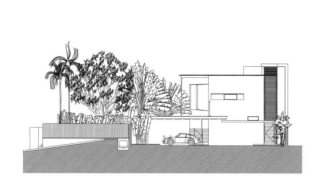

Above The elevation and plan show how the house and its outdoor areas are protected from prying eyes. While the house screens views from the south, heavy planting obscures any view of its open north elevation and the pool and terrace.

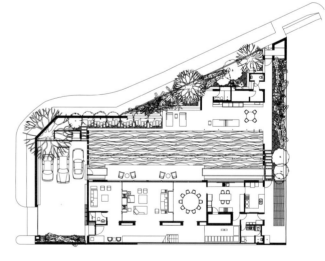

Opposite The multiple openings of the north elevation look out over an exquisite pool. Bedroom pods protrude at first-floor level; louvred screens and a large overhang allow the house to be open and aerated even during monsoon season.

Overleaf Extensive use of water and foliage transports the occupant to another place. The view from the ground-floor living space evokes solitude and tropical tranquillity, in stark contrast to the reality of the property's suburban surroundings.

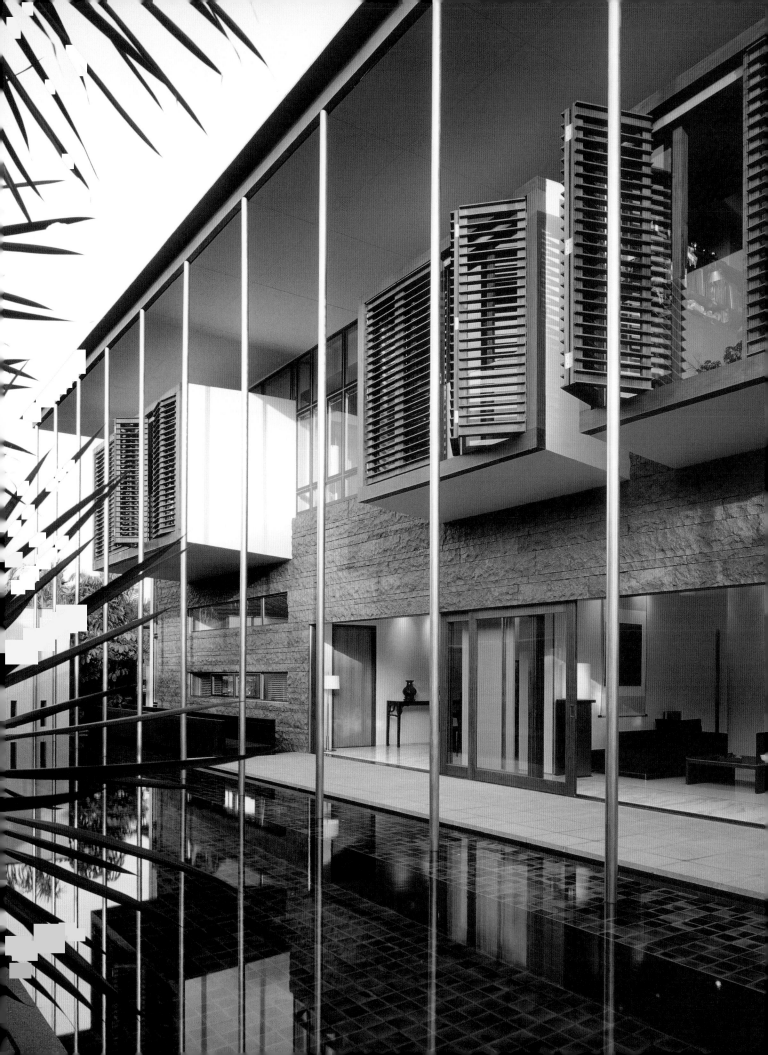

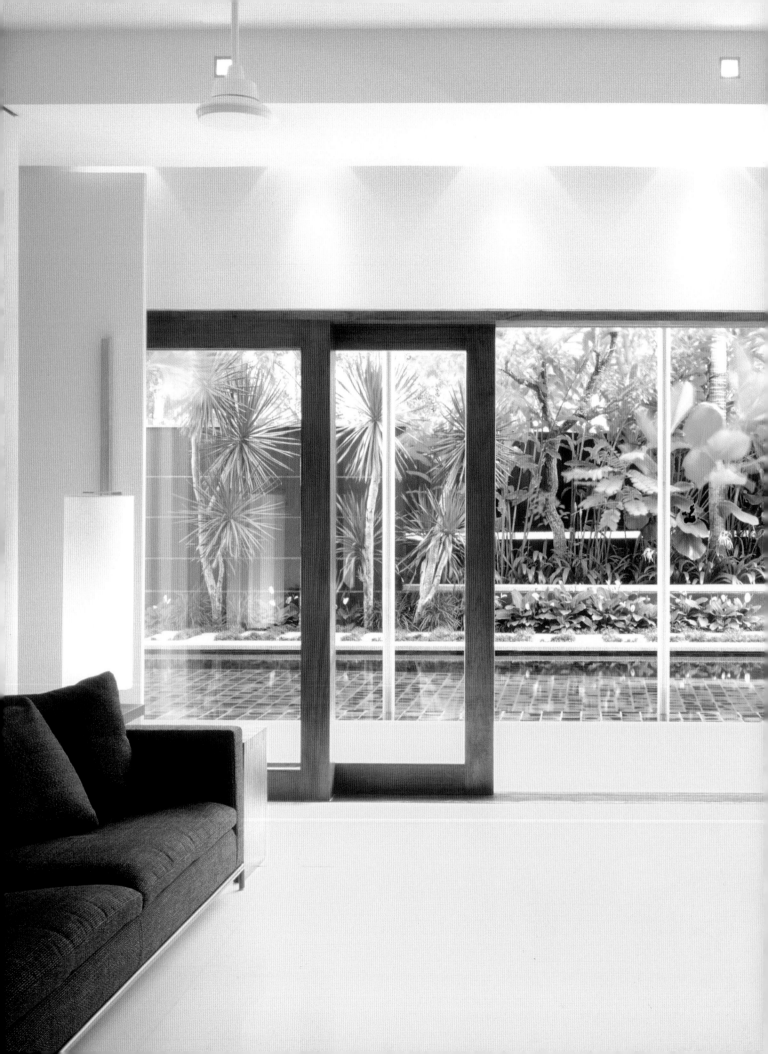

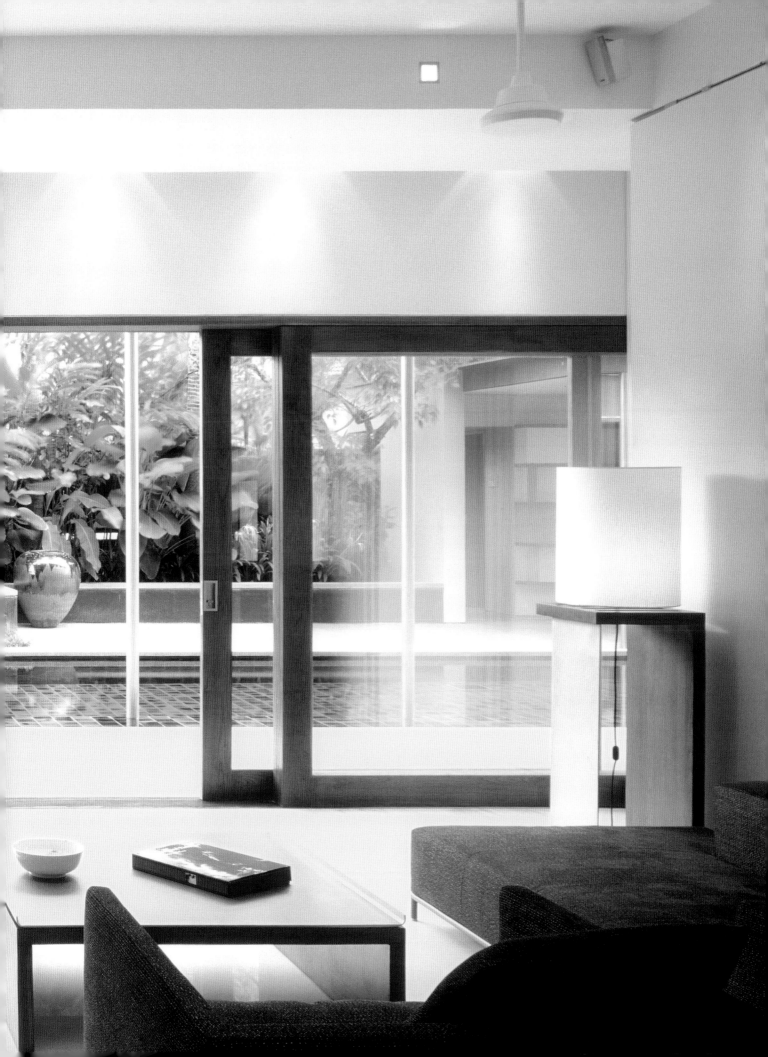

Voss Street House

Featherstone Associates | London, UK

Above The elliptical stairwell makes a striking feature, here seen from the second-floor balcony. Its compact design takes up the minimum of space and allows for a larger central courtyard area.

Right The house's narrow site means that rooms are stacked. Unconventionally, the living area is situated highest (top left with sunken seating area), while two bedrooms sit either side of the open central courtyard. Space on the lower floors (left) is taken up by a shop.

The Voss Street House is situated on an inner-city brownfield site measuring 20 x 4 m (66 x 13 ft), bordered on both sides by residential and commercial properties. Much of the ground floor is a shop. Featherstone Associates' courtyard house design maximizes the available space and provides privacy from neighbours by its inward orientation.

The house presents a blank façade to the street, heightening the sense of retreat and introducing an element of surprise. A red-leather clad, artificially lit staircase leads up to open, naturally lit spaces that are oriented towards the internal courtyard. This influx of light enhances the sense of space that the architect has achieved by removing the traditional vertical room boundaries. An open stairway links the kitchen with the living space some 2.5 m (8 ft) above; two more steps, and an open corridor leads out on to one of two balcony areas. In this way, one single space is created from three separate rooms. The effect is that of a greater social dynamic, a communal open experience.

Throughout the property Featherstone has created a feeling of spaciousness. This has been achieved in a variety of ways, including the use of cityscape murals in bedrooms and innovative storage solutions to all rooms. The project is the home of practice principal Sarah Featherstone, but, more significantly, it is a prototype for larger schemes currently under design that will incorporate the modular courtyard design and show how this one-off house is readily adaptable to larger urban residential projects.

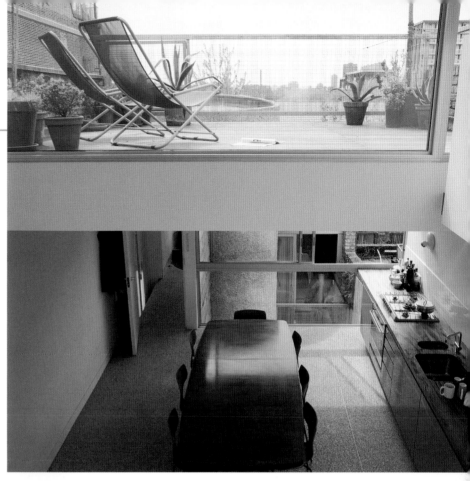

Right Floor levels have been staggered to allow light into all areas. Here, the view from the living space looks down into and through the kitchen, as well as up and on to the higher of the property's two balcony areas.

Below right Exquisite use of materials makes for an invigorating environment to live in. The living space has a white pebble-and-resin floor. The addition of hardwood steps and walkway alleviates the whiteness and shows the way to the wooden decked area of the balcony.

Below The entrance to the property reveals nothing of the radical design within. This single solid door and blank brick façade fend off the rigours of London life, allowing inhabitants to enjoy the seclusion that the house offers.

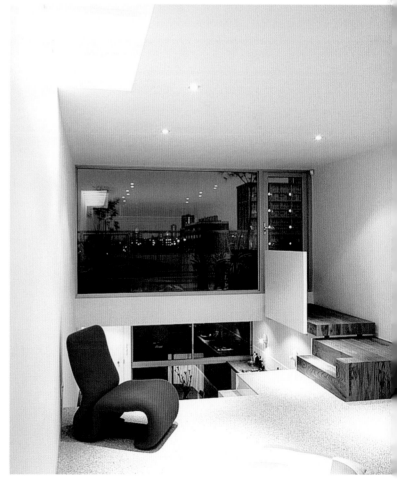

East Asia/Non site-specific

Winner of an international competition to design culturally sensitive housing for booming Asian cities, Ben Addy's Fin-Topped House is a multilayered exercise in prefabrication, mass housing, and spatial design. The house is a lightweight, replicable shell that cantilevers off a central concrete core. It is designed to be assembled in a variety of ways, depending on the conditions on each site — from a single dwelling to large vertical developments or low-rise clusters.

The living space is a monocoque shell constructed by "stretching" a thin aluminium skin over stiff ribs to pre-stress the entire envelope. This is covered in recycled rubber to waterproof it and provide some heat retention. The concrete core contains the kitchen, bathroom, and main entrance, and vertical services including mechanical and electrical supplies, lifts, and emergency escape routes. Its high thermal mass is used to dissipate heat from the property, while the large cantilevered wing houses a wind-cooled/solar-heated reservoir that circulates water around the concrete structure to regulate the internal temperature.

Internally, a cocoon-like atmosphere is created by the upholstered floor and walls and a modern interpretation of the moveable Japanese Shoji screen, which allows occupants to form different rooms.

The intention of the Fin-Topped House is to encourage families to move back into the city where they work, allowing them to spend more time together, rather than commuting for hours each day from the suburbs. Addy has created something that may not be built this year — but watch out for it in 2020.

Opposite A single dwelling is highlighted within a vertical multiple-unit scheme. The living quarters are cloaked equally in transparent and solid glass-reinforced plastic (GRP). The two wings provide external relaxation space and a site for solar water-heaters. The concrete service core is indicated by the straight vertical element to the right.

Below Conceptual visualizations of the Fin-Topped House illustrate the way in which it can be stacked to form multiple-housing blocks. A vertical structure (below left) with one service stack produces a tower, while two stacks enable the dwellings to be linked horizontally to create a medium-rise scheme.

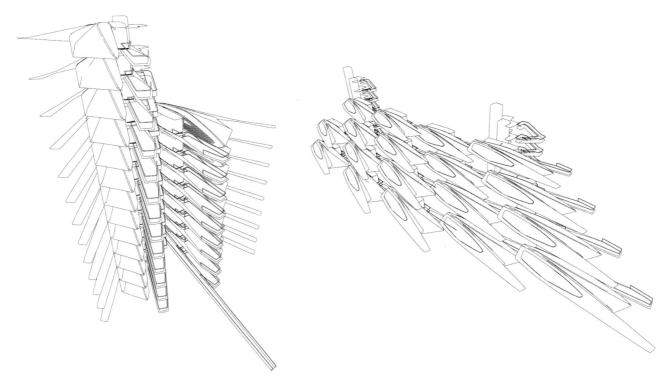

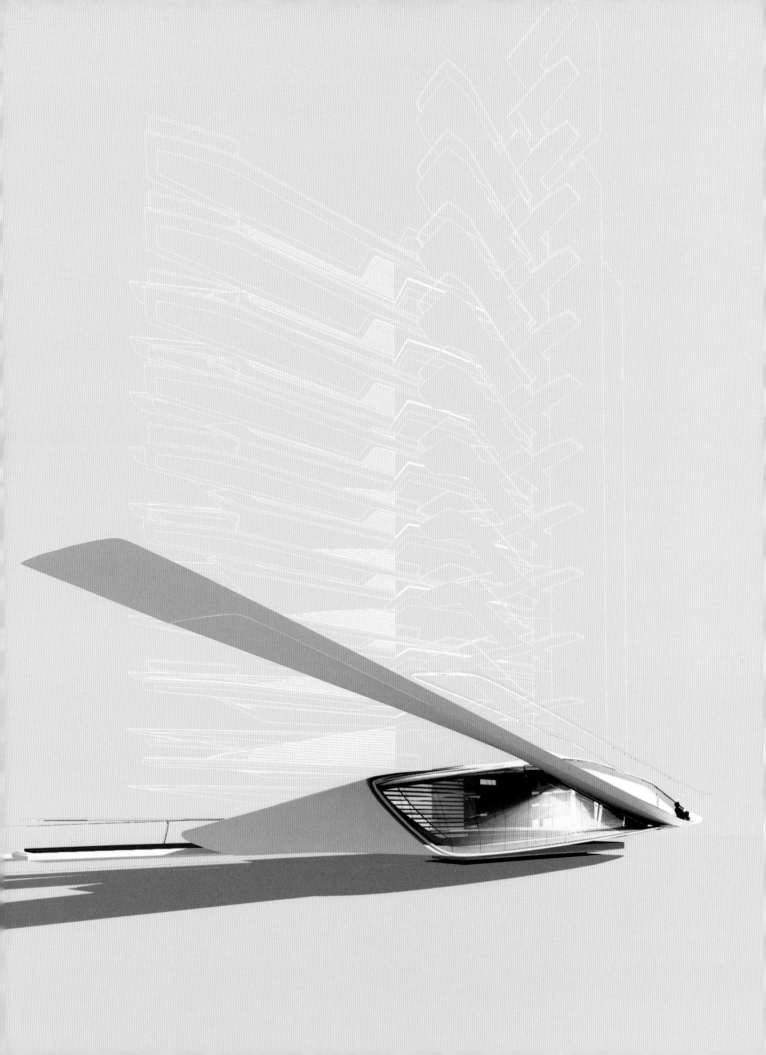

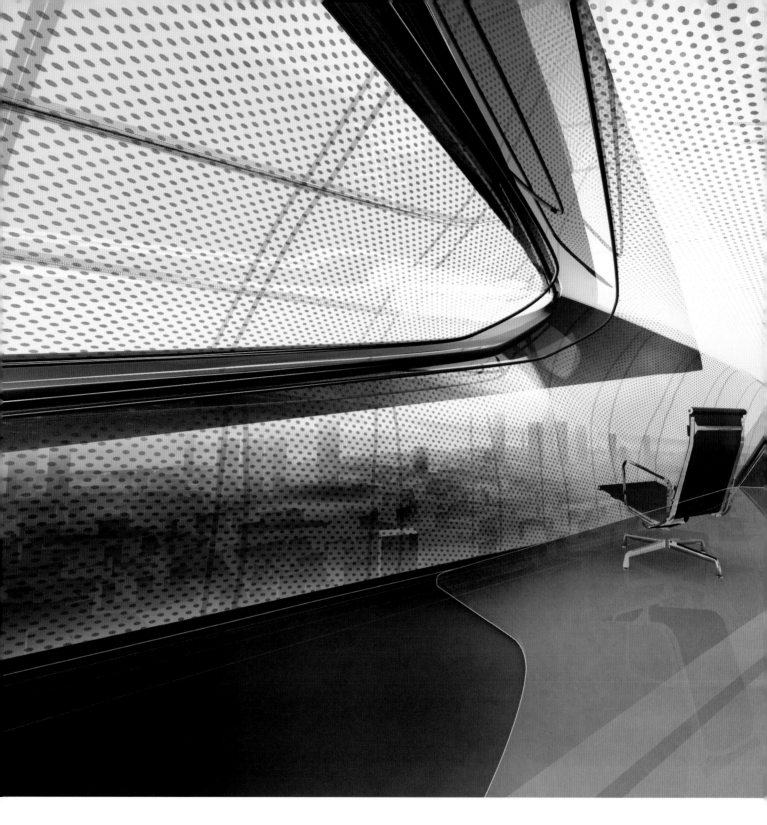

Above and opposite Large transparent elements in the monocoque shell provide dramatic views out of this dwelling, which has a moulded vehicular feel. Within, multilayered internal finishes cloak the occupants and differentiate between space types. These can be manipulated to form progressively thicker visual and acoustic barriers.

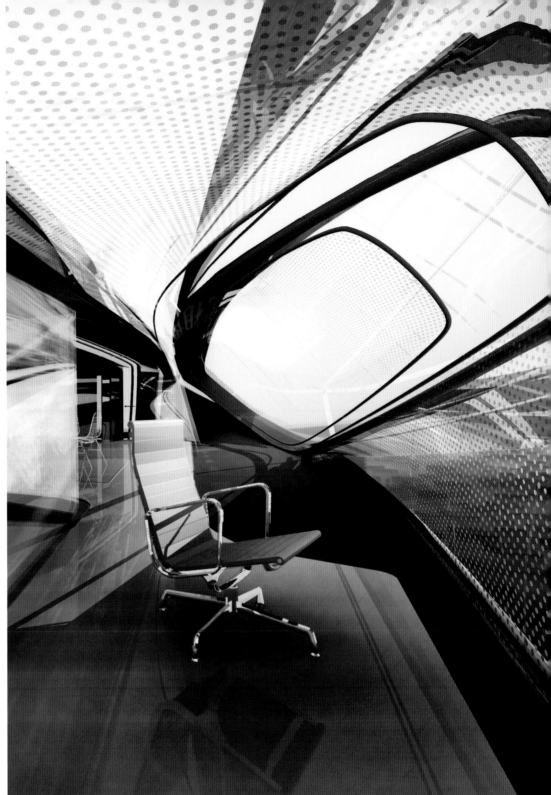

Beach House

Architects Ink | Adelaide, Australia

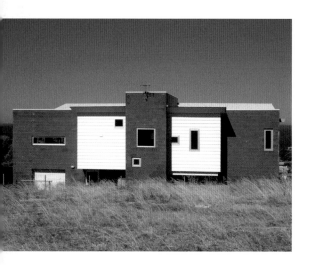

Above The rear of the house presents a defensive shield to the landscape in the form of a solid façade. The few windows are irregularly positioned, cutting through the façade at specific points to frame particular views.

Right A section through the property highlights the large balconies and shallow-pitched roofs that drain away from their extremities to a valley gutter running along the inverted ridge. The circulation core (denoted by the two-storey square) is a slim enclosed volume set to the rear.

The brief for this seaside dwelling by Architects Ink called for enough scope and flexibility to sleep 12 people, and provision for both indoor and external living as well as play spaces for adults and children. This was no small task on a steep, sloping, rectangular plot.

To take advantage of dramatic views out to sea and to save money by minimizing cut and fill, the design is a long double-storey platform with an extensively glazed north (sun-facing) elevation. This orientation presents the problem of solar gain during the summer so a deep veranda protects the ground- and first-floor living spaces in high season, while still allowing in lower winter light.

Externally, the use of materials reflects the client's wish for a robust, low-maintenance home. Charcoal-grey concrete blocks present a solid face to the south and parts of the east and west elevations. An additional skin of weatherboard panels gives a warmer feel to much of the north elevation. These external skins, along with stainless-steel balustrades, have been specified to contend with the harsh coastal environment.

Internally, the house is set around a circulation core. Here, the dark blockwork is used again to create a central cave-like ambience. This is punctuated with slotted windows that offer tantalizing views of the shoreline and the sea beyond. Contrasting with the dim stairway, the rooms are positioned so that all the main living areas are filled with light and have a sea view. The large first-floor family space opens on to a deck, which in turn creates the deep veranda for the ground-floor "rumpus room." The main bedroom also has a good-size balcony, affording the owners a little privacy when the full quota of guests is in residence.

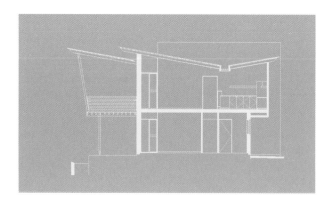

Opposite top In contrast to the rear, the front of the property is dominated by glazed openings. Large outdoor "rooms" are also a main feature as the architect reacts to the coastal environment, promoting a semi-external living ethic.

Opposite left The combination of heavy and light, masonry and woodwork, makes reference both to the rugged landscape on which the house is built and also to the maritime architecture in the area.

Opposite right The simple material palette of stone, wood, glass, and stainless steel is a reaction to the shore environment and the sometimes extreme weather conditions. All elements are simply designed and robust for maximum longevity.

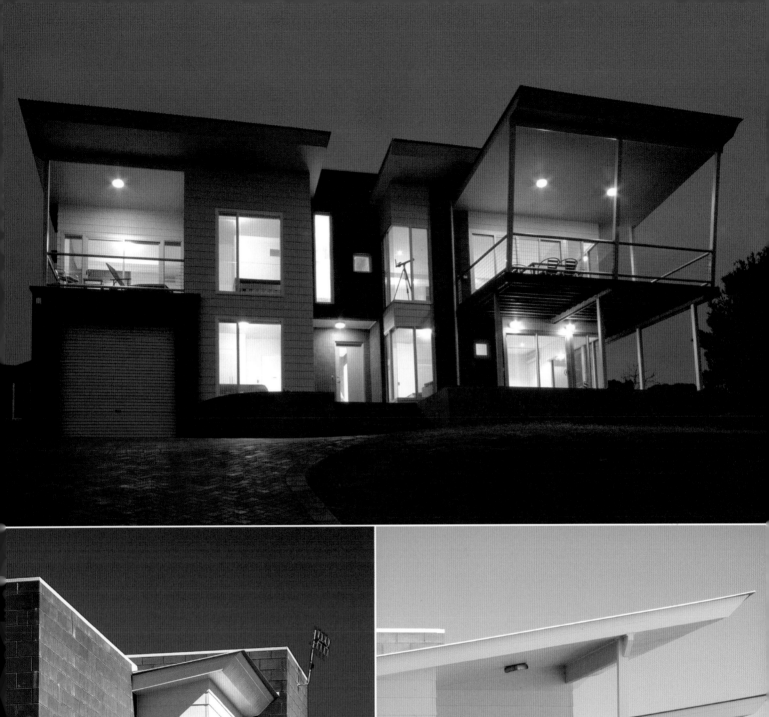

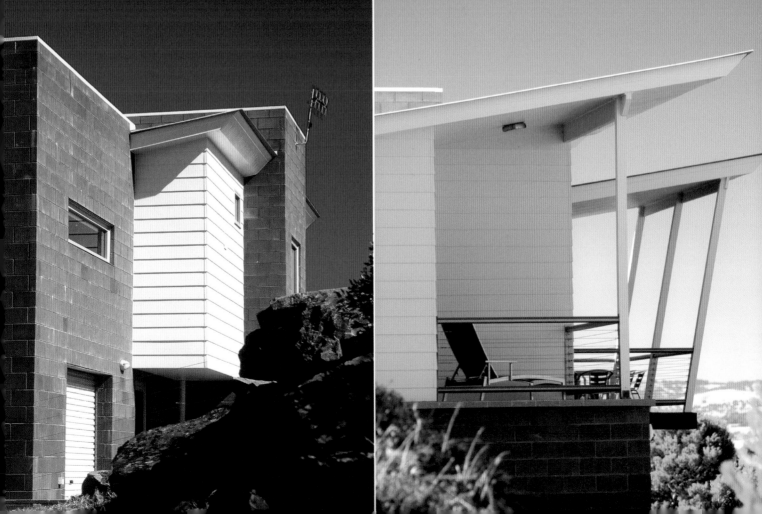

One Centaur Street

de Rijke Marsh Morgan | London, UK

Urban sites can often be unpromising, and One Centaur Street was no exception. A tight, derelict plot, sitting hard against a railway viaduct near one of London's busiest railway stations, presented de Rijke Marsh Morgan (dRMM) with a big challenge when it was asked to design four luxury apartments.

The resulting award-winning block took its shape, mass, and layout from the proximity of the viaduct. dRMM has positioned the communal stairway and entrance areas nearest to the viaduct, and, by constructing the block from *in situ* concrete, insulated the apartment interiors from much of the train noise. In addition, bathrooms and bedrooms are situated nearest to the wall adjoining the communal stairwell (trains run very infrequently at night so any noise is at a minimum), thereby protecting living areas from disturbance.

The block is clad externally with iridescent cementicious (cement-based) boards, hung from a bespoke fixing system. Glazed elements are cut out of the cladding and recessed, emphasizing the building's substantial structural bulk.

Internally, the apartments are laid out according to Viennese architect Adolf Loos's "Raumplan" model, where rooms are loosely arranged around a central space. Each apartment is split-level, encompassing double-height spaces and a winter garden, balcony, or roof-deck. A starkly minimal concrete aesthetic dominates. The smooth-faced concrete is uncluttered by any adornments – there are not even any ceiling lights or wall-mounted switches. One Centaur Street exudes a stripped urban aesthetic in tune with its location.

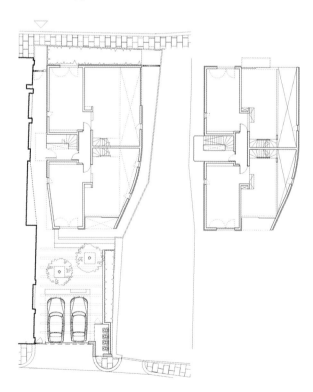

Left Far left is a plan view of the ground floor, illustrating the restricted nature of the site. Within 1 m (3 ft) of the west façade is the railway viaduct. Main living areas on all floors (see first floor plan, left) are located away from the rail tracks, to reduce sound penetration.

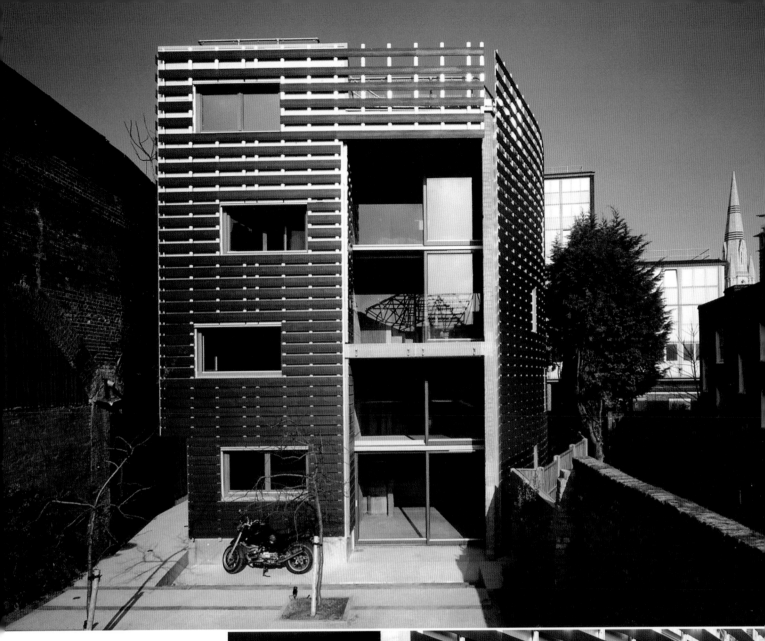

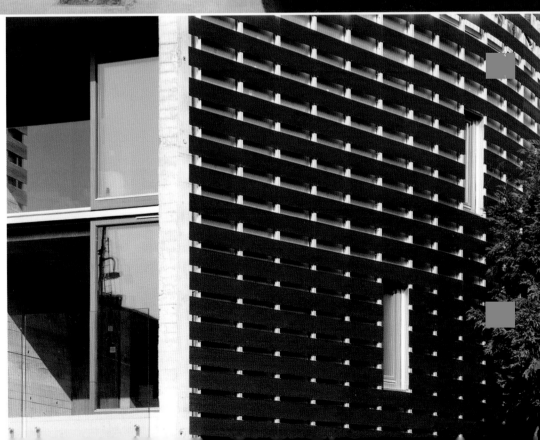

Above With its striated façade of cementicious boards and deep cut-out glazed sections, the structure of One Centaur Street exudes a weightiness worthy of its thick *in situ* concrete structure. Hard landscaping using concrete and railway sleepers continues the industrial feel outside.

Right This detail illustrates the way in which the structure is layered. The structural concrete shell of the building is overlaid with vertical runners on to which the façade of cement-based boards is fixed. The boards accentuate the curve of the building as it pushes to the boundary of the site.

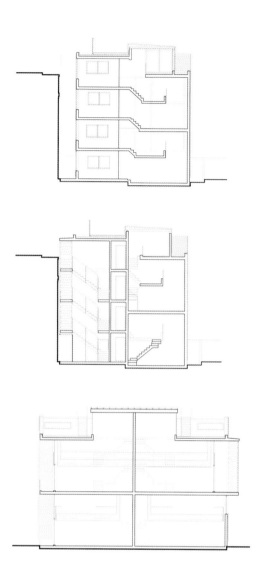

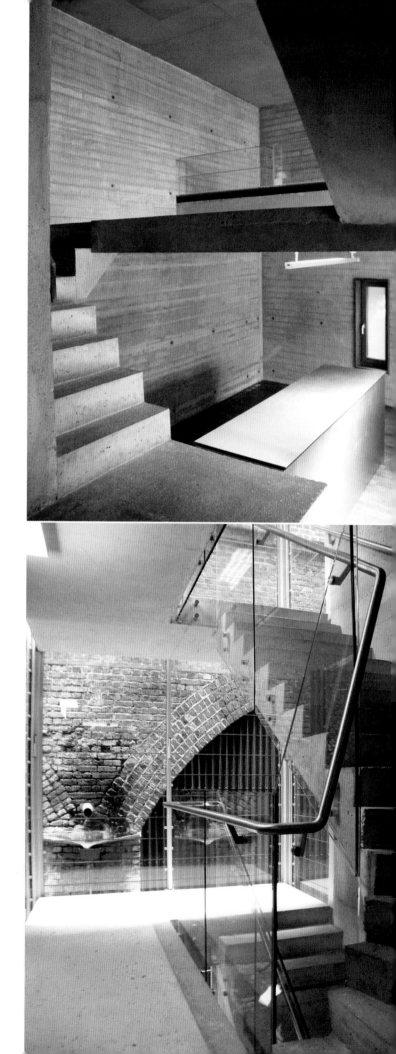

Above dRMM's design along "Raumplan" principles includes open-plan double-height spaces to each of the four apartments. All include two floors with living space and galleries to the right, and bedrooms, bathrooms, and communal circulation to the left.

Right top Bare concrete walls are left rough, showing formwork marks. This is in contrast to the high-quality glass, timber, and stainless steel fixtures and fittings. Cooking and washing appliances are hidden under a sliding work surface in the kitchen area (bottom of picture).

Right In the communal circulation area the stark industrial aesthetic is reinforced by the view straight out on to the railway viaduct wall, its ageing brickwork contrasting well with the sleek stainless steel and glass of the stair balustrade.

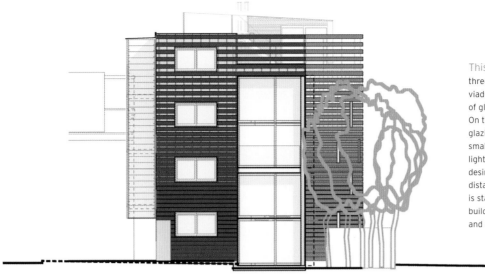

This page Visualizations of the
three elevations not abutting the
viaduct show different treatments
of glazed areas and cladding.
On the south and north elevations
glazing features prominently, while
smaller feature windows allow in
light but do not promote the less
desirable views to the east. The
distance between cladding panels
is staggered towards the top of the
building to lighten its visual impact
and make it less imposing.

South elevation

North elevation

East elevation

Suitcase House

Edge Design Institute | Nanguo Valley, Beijing, China

Built into the rugged countryside at the head of the Nanguo Valley, Suitcase House overlooks the Great Wall of China. Architect Gary Chang jumped at the chance to design a residence in the area and his work is designed to capture the beauty of the place, focusing on views of the Wall and the dramatic landscape.

The house, some 44 m (144 ft) long by 5 m (16 ft) wide, is a steel-frame construction seated on and cantilevered off a central reinforced-concrete base. Both the interior and the exterior are clad in timber to blur the building into its surroundings, establishing a rapport with nature that continues with the large roof terrace. Extensive glazed areas to both sides of the property can be opened up almost completely to the view, each panel being a full-height glazed folding door.

The large flat roof is reached from within via a moveable stairway. The interior can be configured to be as barren as the terrace above, or it may be converted into a compartmentalized home. This thinking stems from the brief, which called for a space that could transform itself according to the nature of activities, number of inhabitants, and personal preferences for degrees of privacy.

Sliding partitions divide the space up into a living area and as many as seven double bedrooms. However, the real ingenuity is demonstrated as sections of the floor are raised on gas-assisted struts to reveal all the trappings of a conventional dwelling hidden below. This lower stratum is a reverse mezzanine, a half-level that includes a kitchen, a bathroom, and storage areas, as well as a meditation space with a glass floor, a music chamber, and a library.

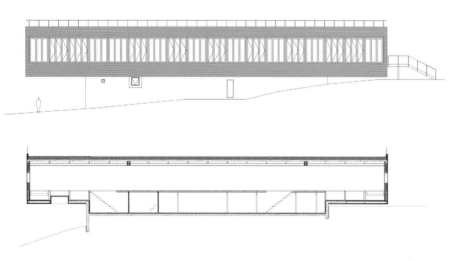

Above Two elevations illustrate the rectilinear nature of the house, which sits on a hollow-cored concrete base block. This creates two-and-a-half levels, enabling compartments for washing, meditation, cooking, and storage to be situated at semi-basement level.

Right Set amid beautiful natural surroundings, the timber-clad building aims to make a statement yet blend with its environment. An extensive viewing platform allows appreciation of the landscape, while discreet cladding materials avoid heavy-handed encroachment on it.

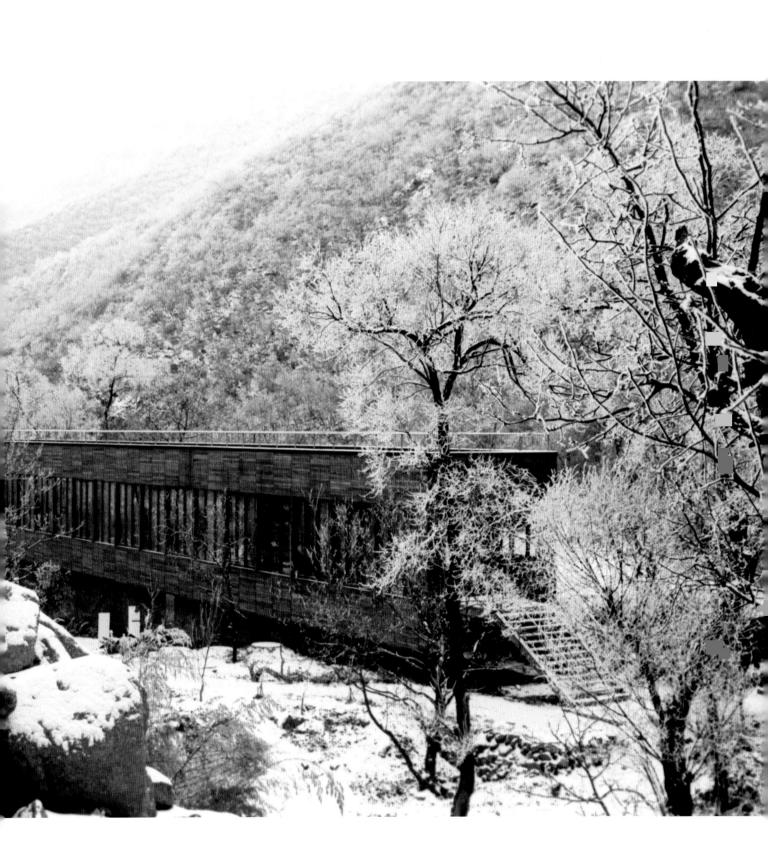

Below Three floor plans. From top: the main floor space, showing closed compartments, and opening elements in the glazed façade; the reverse mezzanine, showing compartments for living; and the concrete basement, with guest facilities and separate entrance.

Opposite left The main floor space opens up to reveal various living compartments. Seen here are a bathroom pod (left), and a meditation space (centre). Sliding partition wall sections are also visible to the rear.

Opposite bottom left The entrances to the roof terrace and basement, via a pull-down ladder and concealed stairway respectively. Also visible are the kitchen compartment (right) and partition walls to separate off sleeping areas.

Opposite right With the compartments closed, the entire Suitcase House becomes one large open-plan space. In this guise it is suitable for parties or events. The timber-clad interior glows in low winter sunshine.

Opposite bottom right The bathroom compartment is luxurious, if not very private. Floor panels lift on gas-assisted struts to reveal slate-lined washing and shower areas with the added bonus of views out over the Nanguo Valley.

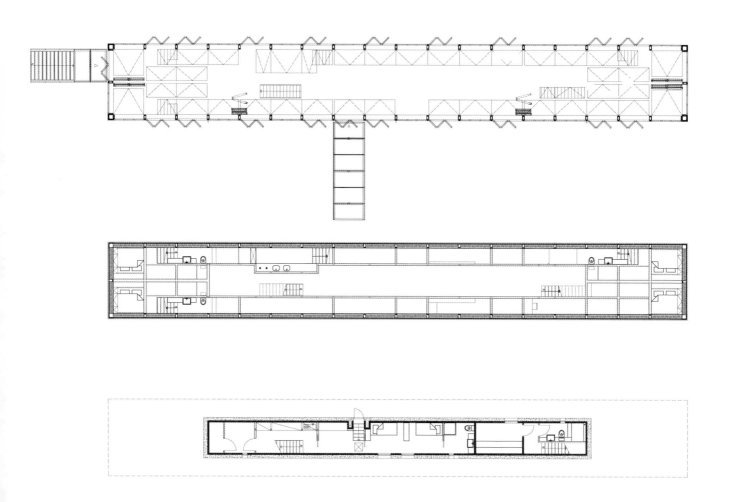

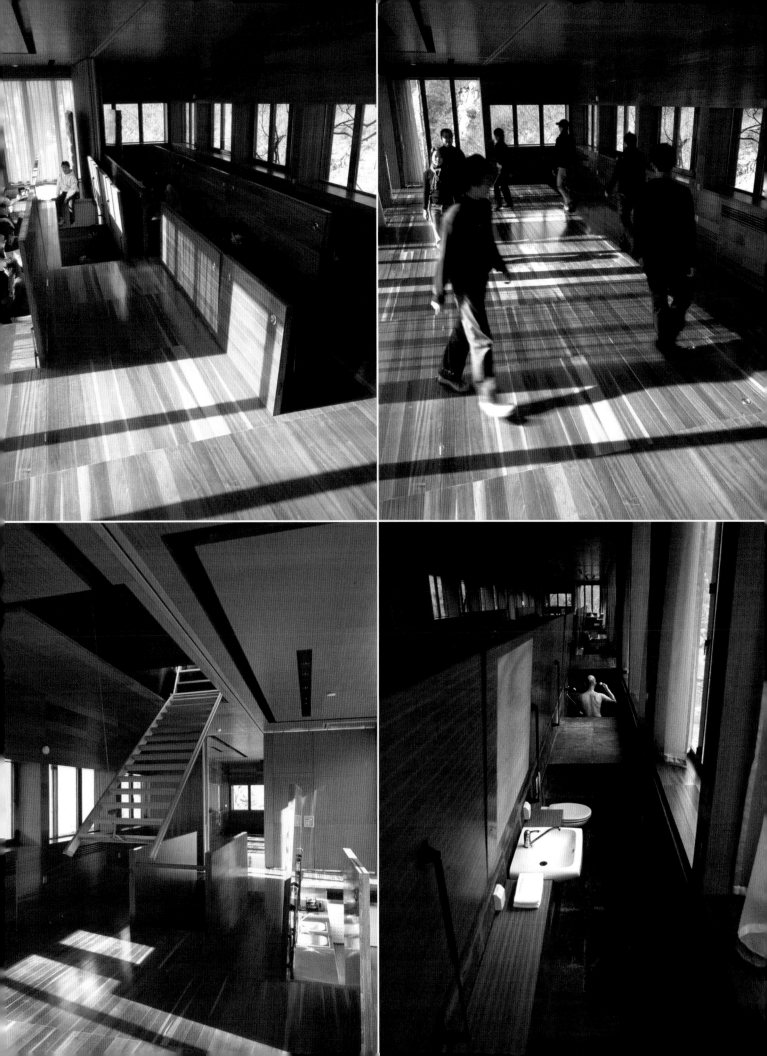

MATERIALS

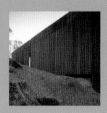
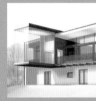
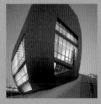
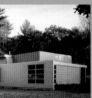
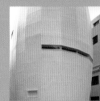

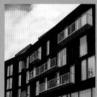

Introduction

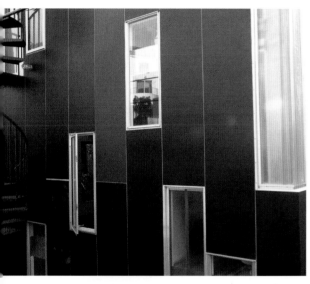

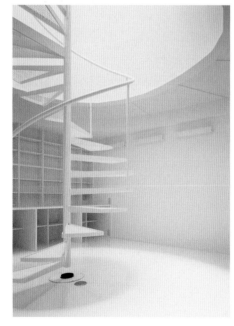

Top Vertical House, California,
USA (pp. 68–69)
Above Natural Ellipse, Tokyo,
Japan (pp. 64–67)
Right Peninsula House,
Melbourne, Australia (pp. 50–55)

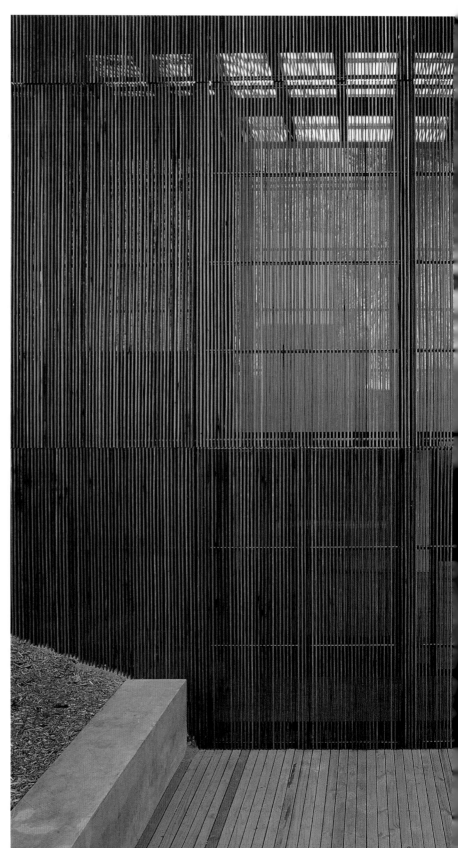

Ever since his decision to move out of the cave and get on the property ladder, man has sought out materials to build with. Initially, the medium used was dictated by location: what was the abundant local material? For the Inuit living near the Arctic Circle it was snow, in Africa and Asia empires have been built from mud, while in Europe wood and stone were the building blocks of choice. These local construction palettes have since been supplemented by a vast array of products, until in the 21st century houses can be built from plastic, titanium, even paper.

With the greater availability of different material types, architects are pushing boundaries and challenging traditionally held views of what a house looks like and what it is constructed of. However, the choice of materials alone cannot guarantee a successful design. It is the architect's ability to extract the best qualities from a variety of building elements that leads to a favourable outcome.

This chapter aims to show a variety of projects that, for different reasons, look anew at the construction of housing, the materials used, and the way they are combined to create a good space to live in. Sean Godsell's Peninsula House combines two common construction materials, wood and glass, to such effect that the separate elements are almost forgotten in reverence to the finished house. The architect's skill has produced an exquisitely simple design by rethinking how the materials are used. Instead of framing glass with timber, as is the norm, Godsell shrouds the glass box in a pin-striped cloak of wooden laths. The result is unusual and extremely beautiful.

Anthony Hudson is another architect who understands well the way in which diverse materials can be married together to create the perfect whole. His Belper House design is a lesson in materials and context. From the heavy stone retaining wall to the north of the property, through to a suspended glass volume at its southernmost point, the design takes occupants on a journey of subtle steps, moving from heavy, safe, and protected to light, open, and ethereal. Were the house to be built of different materials from the stone, steel, and glass chosen it would still be a workable solution, but it is the nature of these elements and the way they are used that make the design stand out and create a unique space.

While both these architects use conventional building materials to good effect, some designers strive to create homes out of unlikely substances. American practice Mark Hutker Architects & Associates and European architect Gerner Gerner

Plus have both used materials more often associated with commercial or industrial architecture in their search for an eye-catching but also livable home. The resulting properties share numerous similarities, including being clad in metal. The reason? Partly because they have clients who are willing to experiment and want an aesthetically different dwelling, and partly because the cladding is a cost-effective and quick method of covering a building. Why should a good construction solution be limited to a particular building type?

However, not every material is easily transferable between industry sectors or project types. When Tadao Ando creates an austere concrete edifice the world bows to his unparalleled skill with this unforgiving material. But one only has to think of the urban slums that have grown up in so many cities, with their poorly designed precast concrete housing blocks contributing greatly to creating disaffected, unhappy residents. It is the architect's duty to understand not only the material used and good residential design but also the environment, both geographical and social, in which the building is to be situated.

Perhaps the most unusual example of a house in this book highlights all these aspects perfectly. Japanese architect Masaki Endoh's Natural Ellipse is a sanctuary of inward-looking tranquillity that has been shoehorned into one of the most densely populated parts of Tokyo. The house is like no other. Elliptical steel ribs form a structural frame over which is stretched a skin of fibre-reinforced polymer. The material and shape create a bizarre spectacle to passers-by and an otherworldly experience for those within. Yet to the architect, the design is purely pragmatic – the unusual shape fits the site perfectly and the material used is the ideal solution for cladding the structural skeleton.

This is what good architectural design is about: having the knowledge and ingenuity to be able to create using diverse materials and methods, but always finding the optimum solution.

Peninsula House

Sean Godsell Architects | Melbourne, Australia

The imaginative and intuitive use of local materials and natural light is the essence of almost all of Sean Godsell's work, and Peninsula House is no exception. Nestled into a sand dune on an idyllic beach location outside Melbourne, the house consists of a steel-framed glass box that contains an open kitchen/living/dining area, a bedroom, a bathroom, and a library.

The architectural magic is created by an outer layer, a slatted wooden box, that completely covers the glazed structure. Constructed of recycled jarrah wood slats, the wooden skin allows shimmering strips of soft light to filter through, casting constantly moving shadows across the interior. Such liberal use of slender-sectioned hardwood is limited in Europe by both price and availability, but its relative cheapness in Australia means that the architect can fully utilize it to integrate the house into its surroundings.

The different elements of the house, including a veranda on the north (sun-facing) elevation, are set out in a rectilinear form. The way in which each is treated is the key to the project's success — the light-filled aesthetic of the main living area is juxtaposed with the more serene library, protected from the sun below the bedroom balcony. Certain screens can also be raised to allow extra views and access to a timber-decked court.

Godsell sees the property as a fusion of attitudes to materials, styles, and cultures. The local timber, in plentiful supply, is worked to produce a Japanese-influenced minimal aesthetic of translucent wood screens that divide up living areas, while the veranda, an Anglo-Indian custom, is set well against European ideals of a closed private study. All fits comfortably within an ordered volume that treats wood and light with an almost oriental reverence.

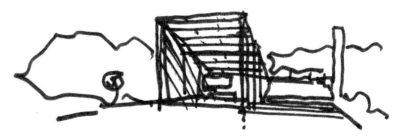

Above left This exquisite site on Australia's southern coast is in close proximity to other properties but remains secluded, surrounded as it is by trees and vegetation. Because of this, Peninsula House's unique design does not come into conflict with other built forms.

Above Sean Godsell's sketch sets out the simple concept of the property and already hints at a semi-transparent façade. The architect is renowned for his intuitive use of natural and local materials: here, the site shouts timber.

Opposite Austere yet welcoming, the apparent solidity of the façade hides surprises. Sections that look like plain wall lift to allow access to a concrete terrace (far right). At night, the house glows with a golden hue reminiscent of the colours of the wood and earth.

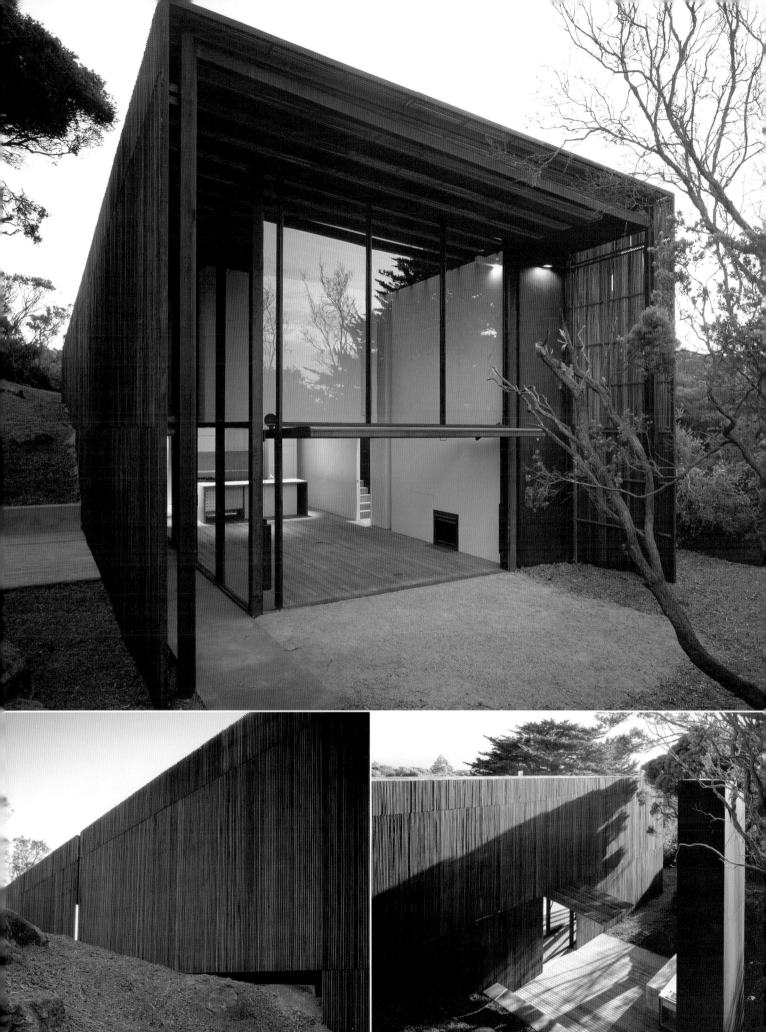

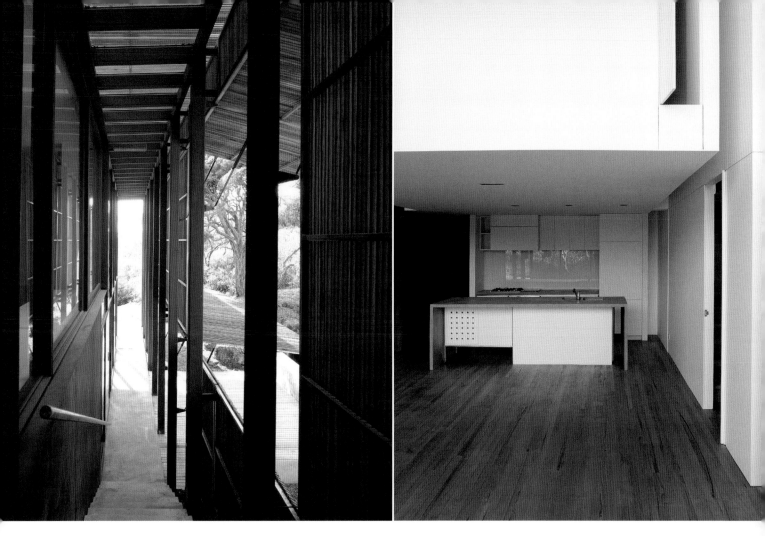

Above A double-height stairway and corridor stretch the length of the east elevation of the house. The slatted façade opens, using gas-assisted struts, on to a veranda which allows extra light into the glass-protected interior spaces.

Above right Internally, a simple white colour scheme contrasts sharply with the natural tones of the façade and surrounding habitat. Cantilevered out above the kitchen is the closed bedroom volume, with adjoining bathroom and private courtyard (see opposite page).

Right Sketches set the house lightly into its surroundings, its striated façade blending with the fragility of the landscape, while internally the transparent jarrah wood skin contrasts with solid, permanent volumes.

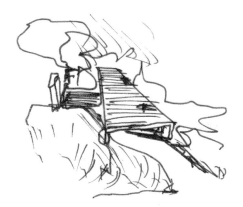

Above The glazed southern wall of the bathroom can be raised, opening on to a sheltered courtyard. Here, the open slatted roof contrasts with the solid walls and produces a wonderful striped effect that occupants can enjoy in complete privacy.

Below Formal drawings of the side elevations of Peninsula House highlight the steep gradient of the site. The property is cut into the earth to allow double-height living spaces towards the sun-rich north, while further back the bathroom (above) is only a single storey high.

Overleaf The strong connection between built form and nature is apparent throughout this property. Local jarrah wood is used in such a way that it takes on an almost fragile quality as the sunlight penetrates through, as it does the branches of a nearby tree.

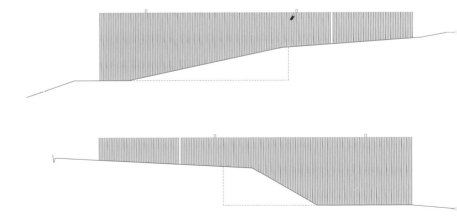

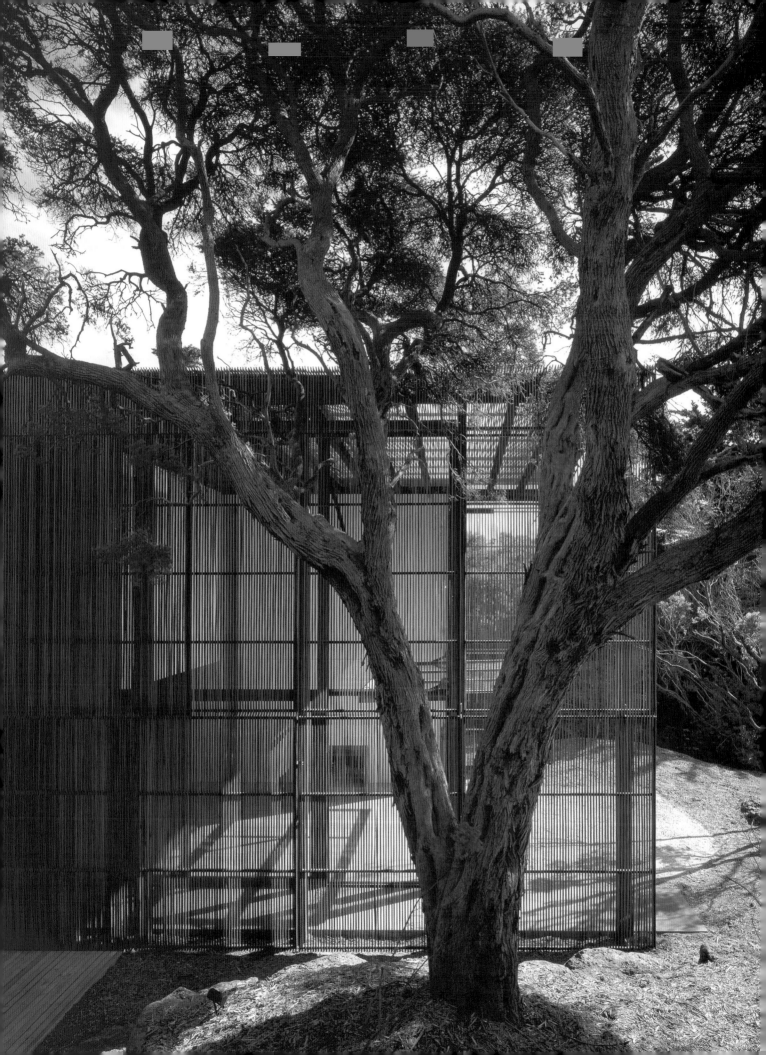

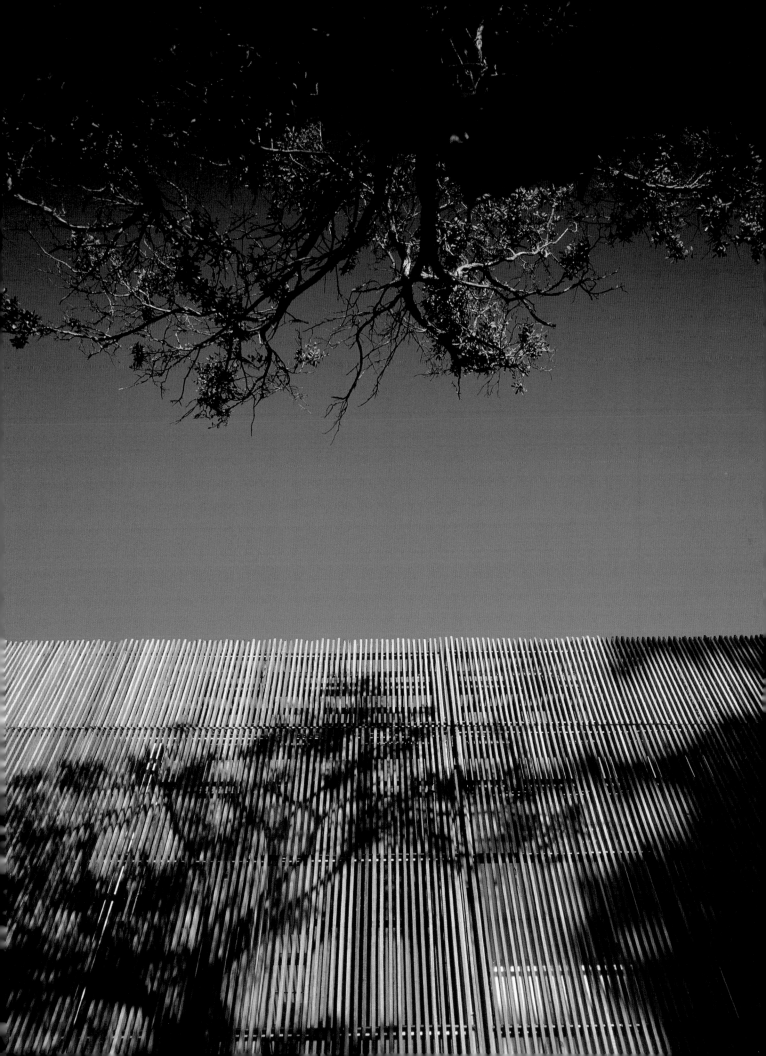

Hudson Architects
Belper, Derbyshire, UK

With its northerly side built into a hill and protected by a heavy red sandstone retaining wall, Belper House by Hudson Architects is a study in sensitive material use and zoning. The property is split into three material-led areas – heavy to the north, moving through light, to floating in the south.

The red sandstone of the northern boundary retaining wall continues to the property interior. It features extensively in polished form in both the entrance hall and the master bathroom, where walls and floor are stone-clad. Wrapping over the west wall and covering the entire house is a heavy slate roof. This protective shroud is punctured only once, with a 3.8 m (12 ft 6 in) diameter hole, which allows light down into a central courtyard. Otherwise, the slate shields the property from prying eyes and traffic noise.

Moving south, further into the house, the aesthetic gravitates from this monumental feel into a much lighter, open-plan living space with a completely glazed south-facing elevation. Here, the dominant aesthetic is that of glass and stainless steel. The kitchen, living, and dining space is a single area. However, the dining area can be screened from the kitchen and living room by a circular screen, to create varying degrees of privacy. The living space is oriented towards a fireplace with a surround of brushed stainless-steel shingles. This shimmering wall attracts the eye and draws the gaze through the glazed south wall to the final zone, the sun lounge and balconies.

This "floating" zone comprises balconies the length of the southern elevation and a double-height fully glazed sun lounge that is cantilevered out from the property at first-floor level – a crystal box that captures every ray of summer sun.

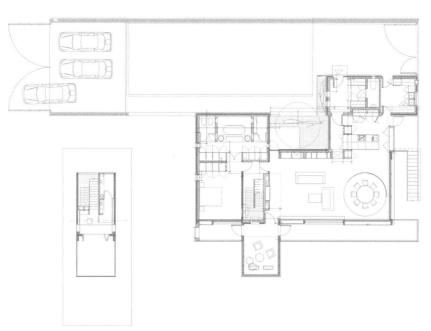

Left This plan illustrates how visitors arrive at the rear of the property and enter into the solid hallway, around which are situated bedrooms and bathrooms. Moving further into the house, lighter aesthetics become apparent, with views over the valley. Far left is a detail of the study situated above the living space and the void above the sun lounge area.

Opposite top The lightness of the south-facing façade is particularly evident in the spectacular sun lounge. Frameless fully glazed walls allow 180-degree views, while the cantilever provides occupants with a sense of floating in space.

Opposite A view of the property from above illustrates the weight of the northern elements that anchor it to the landscape. Heavy stone elements include a retaining wall around the courtyard and the garage walls. The slate roof wraps over and down the west elevation.

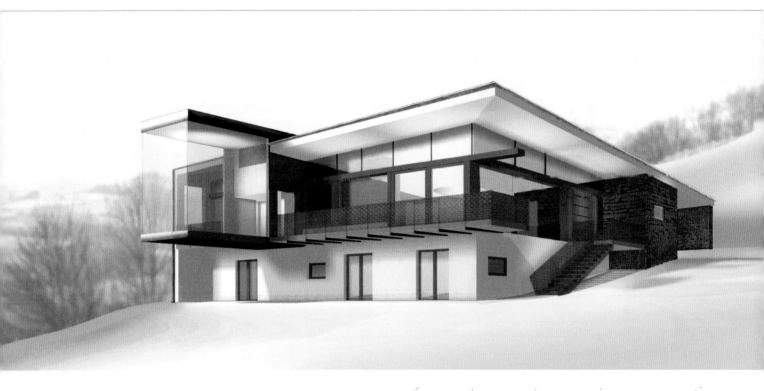

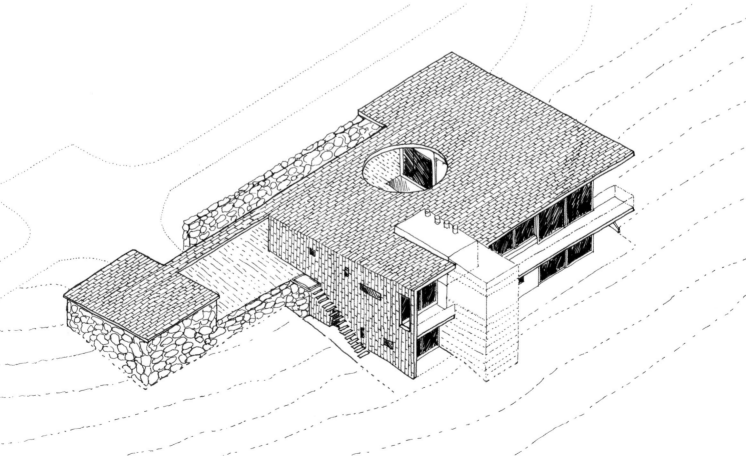

Living Tomorrow 3

Living Tomorrow/UN Studio Amsterdam, Netherlands

Living Tomorrow is a Belgian organization that works with architects to design and build houses of the future. This incarnation, the third in total and the first to be built outside of Belgium, is in collaboration with Dutch practice UN Studio.

The 3,300 m² (35,500 sq ft) property is described as a laboratory of architecture. It is a combination of house and office, designed to showcase innovative techniques and technologies that will be available over the next decade. Architecturally, the curving steel-clad building is derived from the concept that its vertical and horizontal parts form one continuous shape. The architect treats the super-insulated, weatherproofed façade like layers of skin, one of which has been peeled from the tower to form the lower volume.

The building interior is seen as a blank canvas that will adapt to suit user requirements. White-plastered walls change colour when lit with pre-set lighting to stimulate different moods, and scent can also be diffused into the atmosphere. The environment is heated and powered by semi-transparent solar panels on the building's roof and regulated via a heat pump and control system.

The four-storey tower, some 32 m (105 ft) high, is largely open and double-glazed with UV-reflecting glass. The lower, more private volume is closed, encased by hard-wearing, impact-resistant, ribbed-steel cladding. The floor space is maximized by a design that mixes low- and high-rise: domestic spaces are situated within the lower bulk, work areas and secondary facilities in the tower.

Tag technology, a replacement for the barcode, takes domesticity to the next level. Intelligent kitchen appliances can calculate dietary requirements and communicate with each other, the bathroom mirror doubles as a television, while a "virtual" speaking alarm uses voice recognition to be more user-friendly.

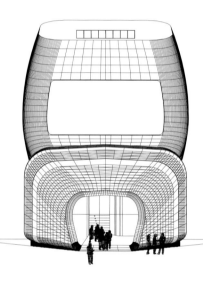

Above The building's main entrance is situated within a void, where the horizontally oriented private volume reaches its lowest point. The steel cladding wraps all around, creating a protective cowl.

Left and opposite The heavier ribbed façade of the lower volume indicates the material's role in the security and protection of the inhabitants: this design ethos is echoed in the number of windows at ground level. Above, lighter façade panels seem almost translucent, their internal structural frame visible, while larger glazed areas are situated on and above the first floor. This is a high-tech fortress disguised as a silver snail.

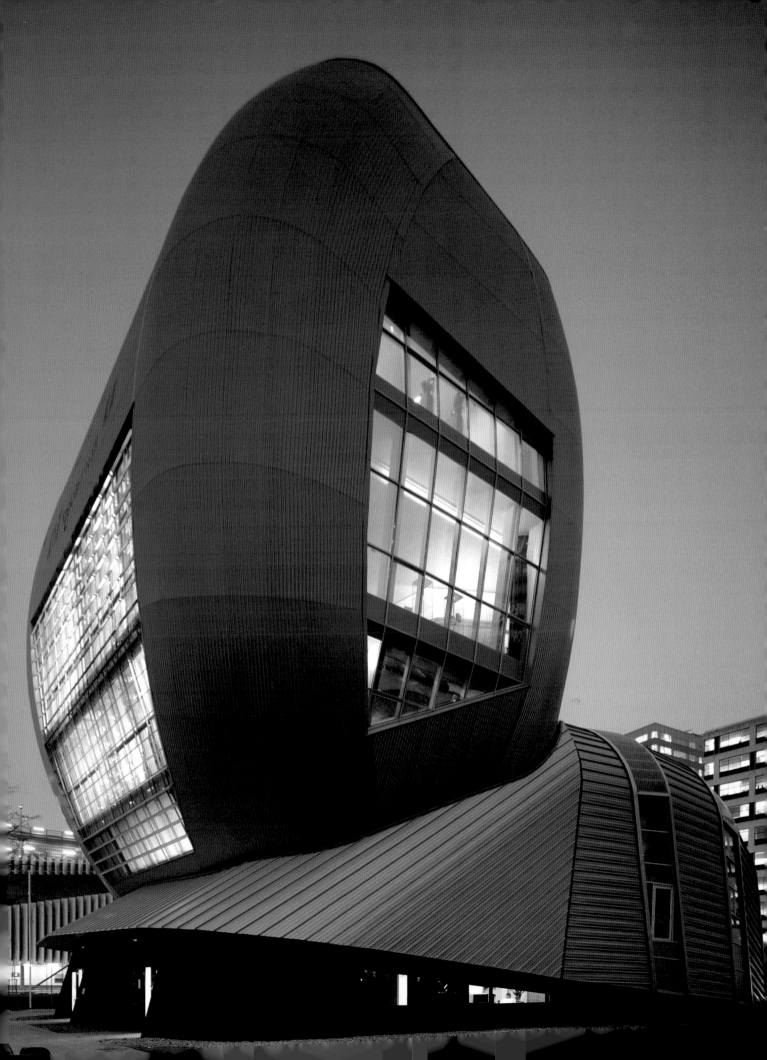

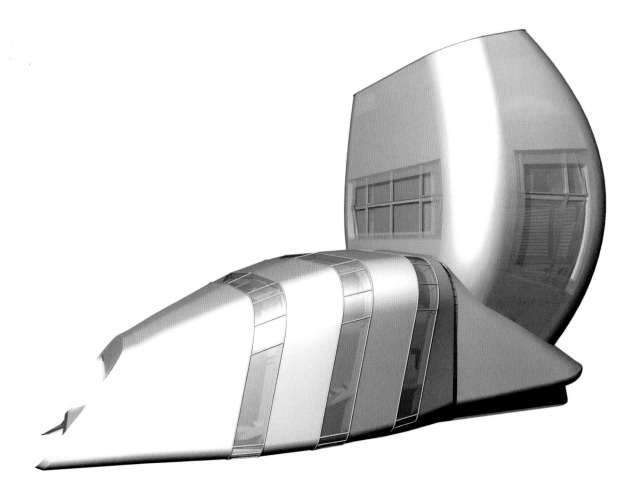

Above The concept for Living Tomorrow 3 called for a design that was a synthesis of new materials and techniques created by computer-based architecture. UN Studio describes it as "... rounder than what is presently square, ... gleaming when others are dull ..."

Below 3D visualizations of the structure. From left: in plan, symmetrical about the central circulation; a side elevation, resembling a seated figure; and an end elevation, again symmetrical and also illustrating the organic nature of the structure.

Opposite Internally, the building is spacious and light. Both materials and colours are kept neutral throughout. Living spaces, such as this open dining area of the show-house, are designed to be airy and inspirational, even in the lower, protected volume.

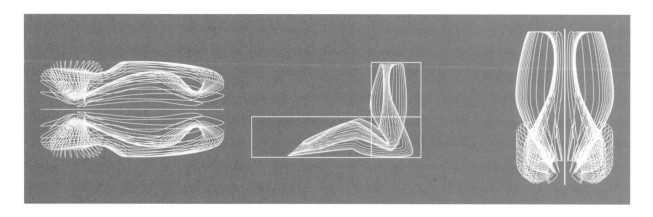

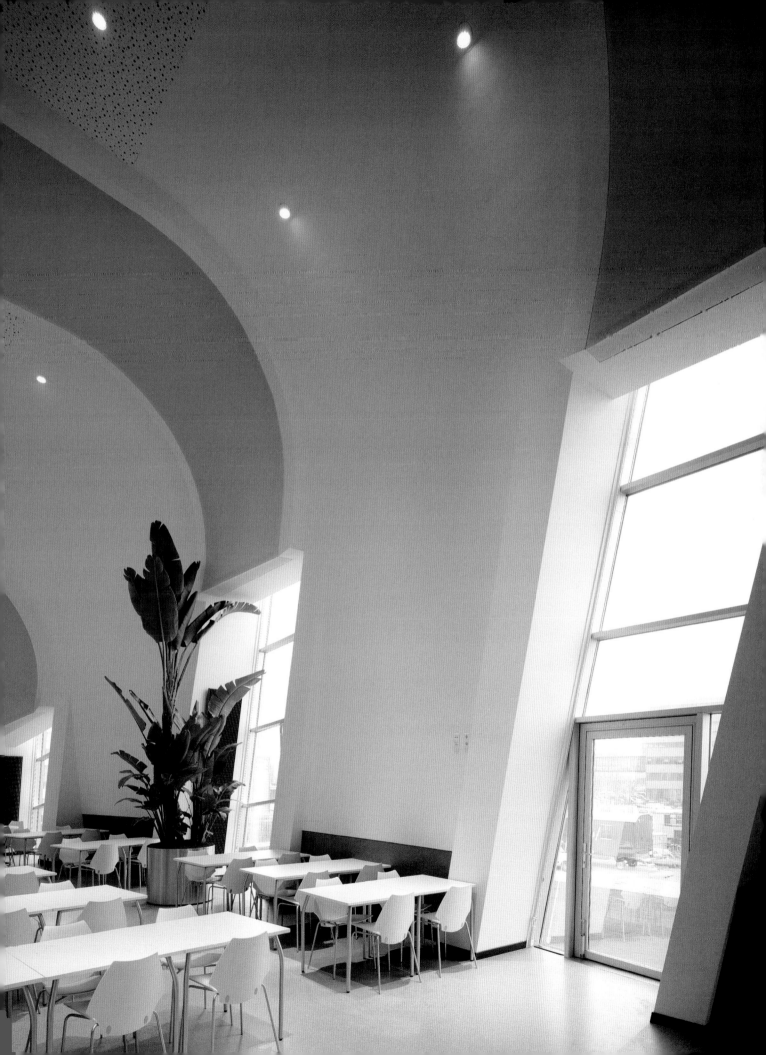

Skolos/Wedell Home

Mark Hutker Architects & Associates | Canton, MA, USA

An external skin of anodized and copper-painted aluminium panels and translucent fibreglass may sound more akin to a distribution unit than a house, but this combination of lightweight materials is used to clad the Skolos/Wedell Home.

Set on a leafy sloping site, the property has been designed jointly by Mark Hutker, Jon McKee, and the owner, artist Tom Wedell. Called the "Shell station" by one neighbour, the house's striking looks blend surprisingly with the landscape, because that is, after all, the design inspiration – panels match with the copper of beech trees and iron deposits in large rocks that stand in the garden.

While outside the orange and silver of the copper and aluminium dominate, it is inside that the true value of the fibreglass panels is revealed. These prefabricated, steel-framed wind-resistant panels alternate with solid wall space to act as mediators between the outside and ambient light. The effect is a muted glow, an almost ethereal light. The house seems to be filled with light but at the same time it is solid and warm, a quality often lost in more harsh glazed residential design.

The property is oriented about a central north–south axis in order that the sun will illuminate rooms in the same sequence as they are usually occupied. There are three main elements to the building: a work area with graphics and photographic studios; kitchen, living, and dining spaces; and sleeping and guest area. The flat-roofed boxy design gives the Skolos/Wedell Home a quirky, part-futuristic part-"1960s LA" feel. But, set against its natural backdrop of trees, this charming distribution shed is quite at home.

Opposite Two elevations illustrate the clearly defined elements of the property. The higher copper volume houses a photographic studio; the lower copper cube is the living room. Bedrooms are sited in three defined elements to the right of the east elevation.

Far right Internally, materials play an equally important role. High-quality hard (metal) and softer (timber) finishes are lit by sunlight diffused through the translucent fibreglass wall panels.

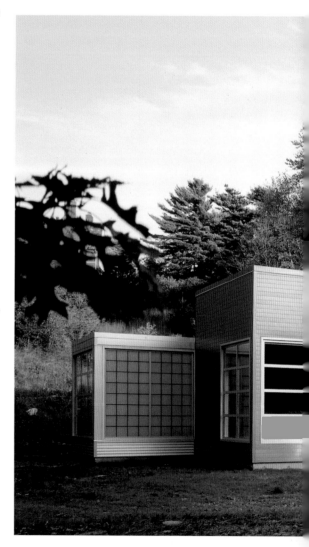

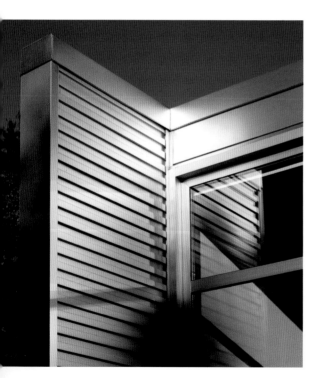

Left The detailing of the anodized-aluminium façade panels is exquisitely carried out throughout the property. This corner fin (seen to the right on the main image) is not merely an aesthetic whim: it protects formally planted ground in front of the graphics studio.

Right The Skolos/Wedell Home is designed to blend in with its surroundings. Materials have been carefully chosen for their tactile qualities and especially their colour – aluminium is similar to the grey of stones on the site, while copper-painted elements perfectly match the autumn foliage.

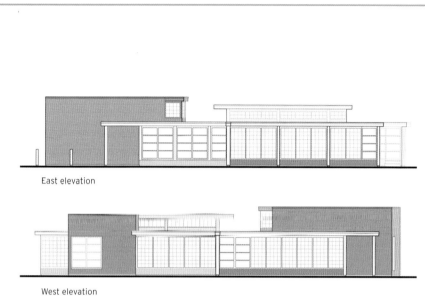

East elevation

West elevation

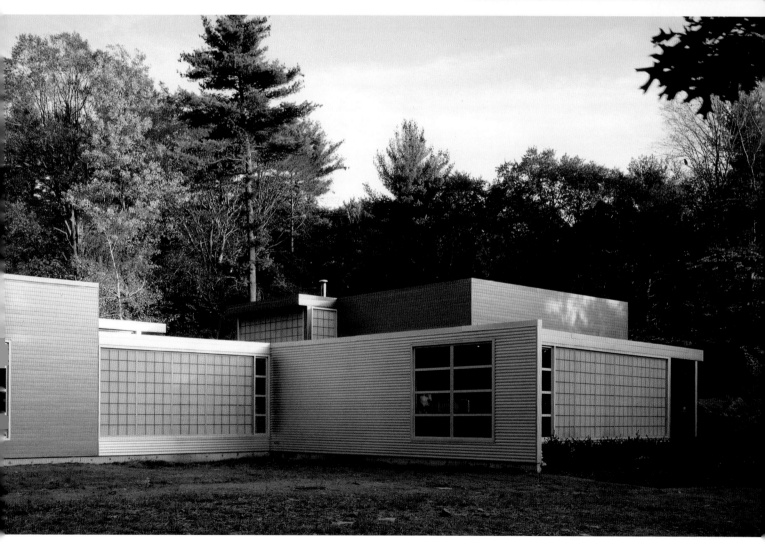

Natural Ellipse

Masaki Endoh & Masahiro Ikeda | Tokyo, Japan

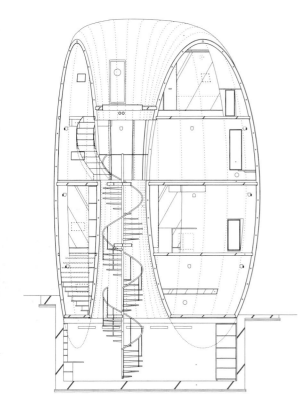

Sited in the frenetic Shibuya district of Tokyo, known for its concentration of "love hotels," Natural Ellipse is Masaki Endoh and Masahiro Ikeda's sanctuary of peace against a backdrop of noise and lights. This bizarre object is in fact two apartments "vacuum-packed" in a gleaming white skin. The design is meant both to excite and to protect: the interior is closed off from the world to ensure a relaxing environment, while the dramatic exterior competes with its surroundings.

The building is constructed of horizontal and vertical elliptical steel ribs over which is moulded the skin of weather- and fire-proof fibre-reinforced polymer. The skin was chosen for its ability to wrap this complex steel cage, moulding exactly to it, or any other desired shape, to produce a seamless exterior. An extra coat of oil-based paint was added after construction was completed.

Internally, the design is typical of Japanese minimalism. White abounds: every surface, from the concrete floor slabs finished in dust-repellent paint to the steel-plate ceilings and mineral-board walls, is snow white. The layout revolves around a spiral stair that leads from the basement to a secret sun balcony in the building's sunken apex. The stair is off-set, allowing for larger living and sleeping spaces to one side and smaller kitchens and bathrooms to the other.

The design is seen as a test-bed for other similar properties, which can be shaped to suit different numbers of occupants purely by adjusting the diameter of the elliptical steel rings. The result, says the architect, will be computer-assisted fabrication and production that will provide non-standard solutions from a palette of inexpensive and versatile materials.

Above Natural Ellipse consists of five floors, including one basement level. All levels are arranged around the spiral staircase, which is set off-centre to create different-sized living quarters. The property is split into two small apartments.

Right The framework for this unusual property was designed using high-tech computer-modeling methods. Its biomorphic shape is constructed of steel ribs that form ellipses both around the building's girth and through its vertical section. This skeleton is easily manipulated to create varying building shapes.

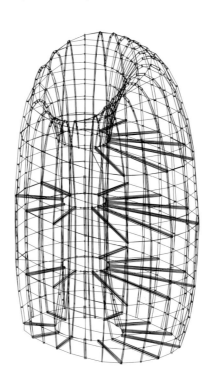

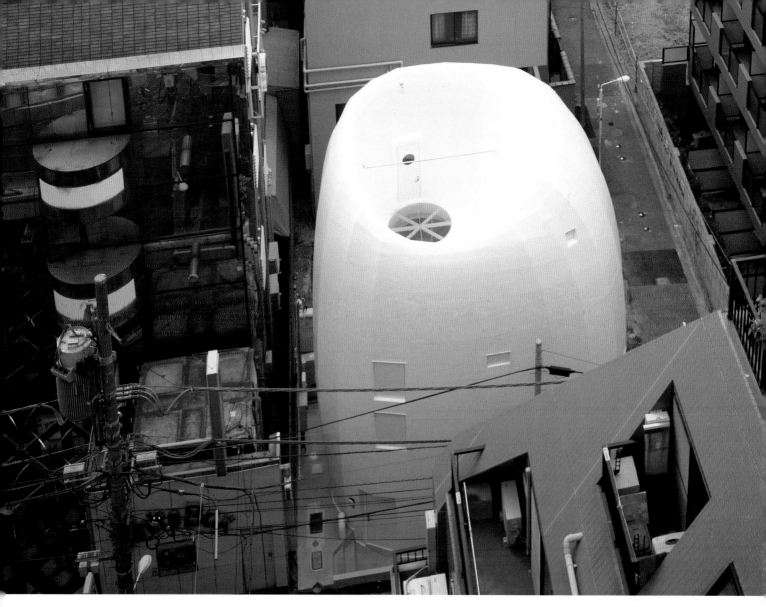

Above Shoehorned into Tokyo's frenetic cityscape, Natural Ellipse is not easily appreciated unless viewed from above. Only then can the building's private sun terrace be seen; from any other angle it remains hidden from view in the sunken apex.

Right The white sun terrace also acts as a reflector, bouncing light into Natural Ellipse through the clear section of the floor, and filtering it down via the stair shaft through the building's white mineral-board, concrete, and steel interior. This top floor is a kitchen area for the upper-level apartment.

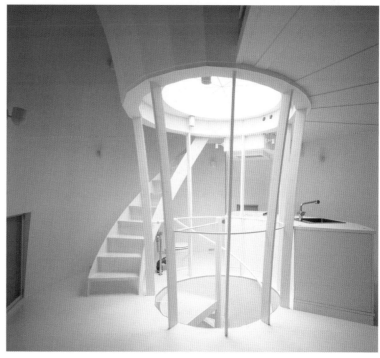

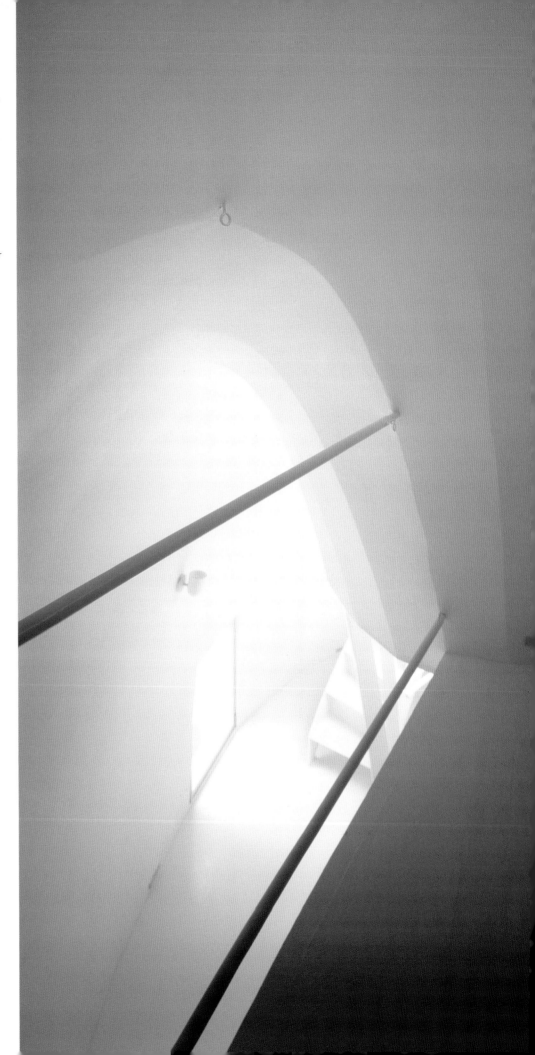

Right The fast pace of life outside goes unnoticed within the building. All internal surfaces are finished in cool white dust-repellent paint. This covering reflects natural light, and bounced it deep into the interior, creating an almost ethereal quality.

Opposite From outside, Natural Ellipse looks almost impenetrable. The building's loadbearing framework can clearly be seen through the fibre-reinforced polymer façade: the effect is that of skin stretched taut over a skeleton. The few openings in the façade serve only to further intrigue those not privy to the interior, while providing framed views of the surrounding district for the occupants within.

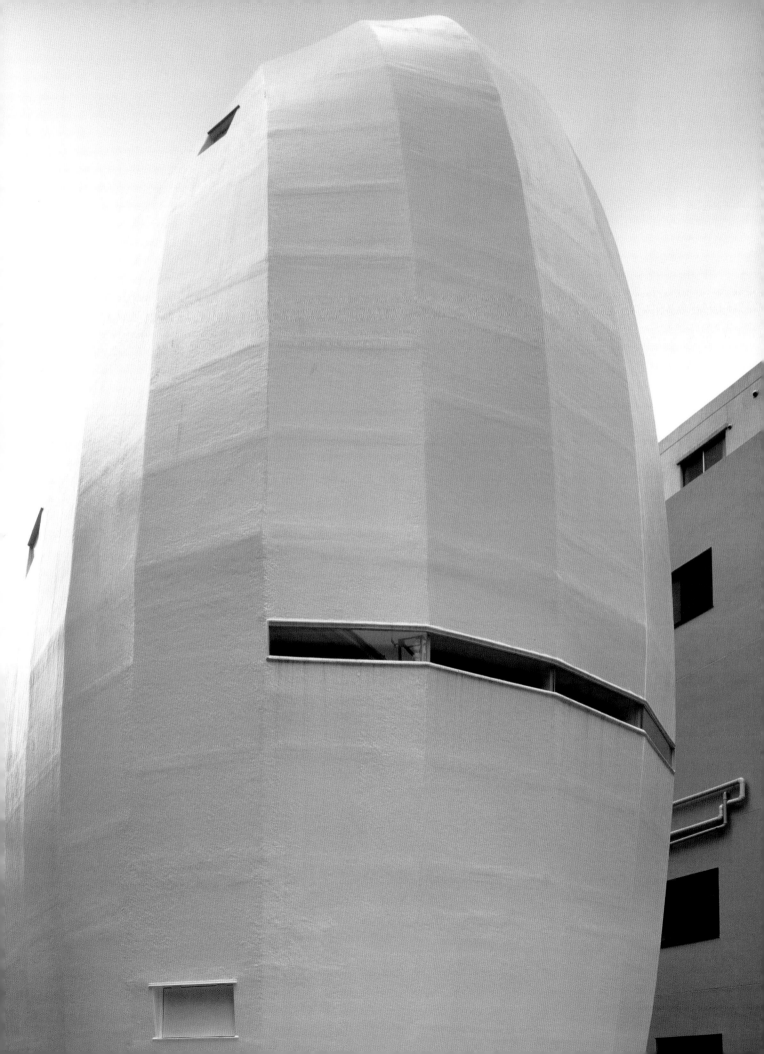

Vertical House

Lorcan O'Herlihy Architects | Los Angeles, USA

The name Vertical House is about the only unimaginative element of this property, designed by architect Lorcan O'Herlihy. Squeezed into a plot of only 12 x 6 m (39 x 20 ft), the house is a lesson in making the maximum use of space. However, its most prominent feature is the external façade, a skin of charcoal-grey stripes, broken up with thin glazed panels of various colours.

This semi-ordered collage of colour is set out at 60 cm (2 ft) centres to emphasize the verticality of the building. The strips of material, cement-based board or glass, pay no heed to structural floorplates in what initially seems a random pattern.

The positioning of the glazed sections of façade defines the way in which the inner volumes are set out – bespoke furniture is ideally positioned and ceilings are cut away to accommodate the glass openings, allowing light to stream in through seemingly deep shafts. This influx of light is something that the architect has orchestrated extremely well. O'Herlihy is a painter in his spare time, and the subtle yellows and blues cast a welcoming glow over specific areas such as the head of the bed in the master bedroom.

From the exterior the façade, with matching boundary fence, creates quite a stir. The house is built among traditional rendered properties, and passers-by often stop and stare. Gawpers can see in through many of the glazed panels, but O'Herlihy has ensured that no room is fully exposed to the street. Instead just a glimpse is offered, a snatch of what magic may lurk behind such a playful exterior.

Above Unwrapping the façade from its three-dimensional body reveals that the "random" positioning of solid, translucent, and clear panels is actually a well-formed pattern. Studies have shown that it is very difficult to create truly random patterns.

Right Internally, the property is bathed in light from the multitude of openings. These slots have no regard for floor levels, being totally dictated by the exterior aesthetic. The furniture is also designed by architect Lorcan O'Herlihy.

Opposite Located in a street of conventional properties, Vertical House is an unusual addition. The cement-based solid boards are used as a fence for the property as well as on the façade, while transparent panels clearly show that windows cut across floorplates.

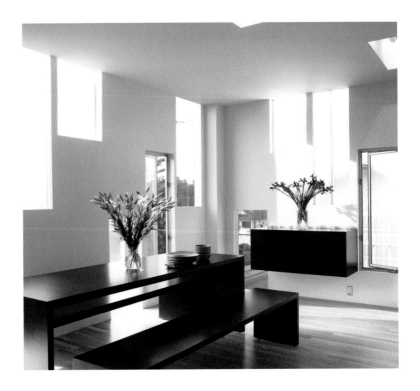

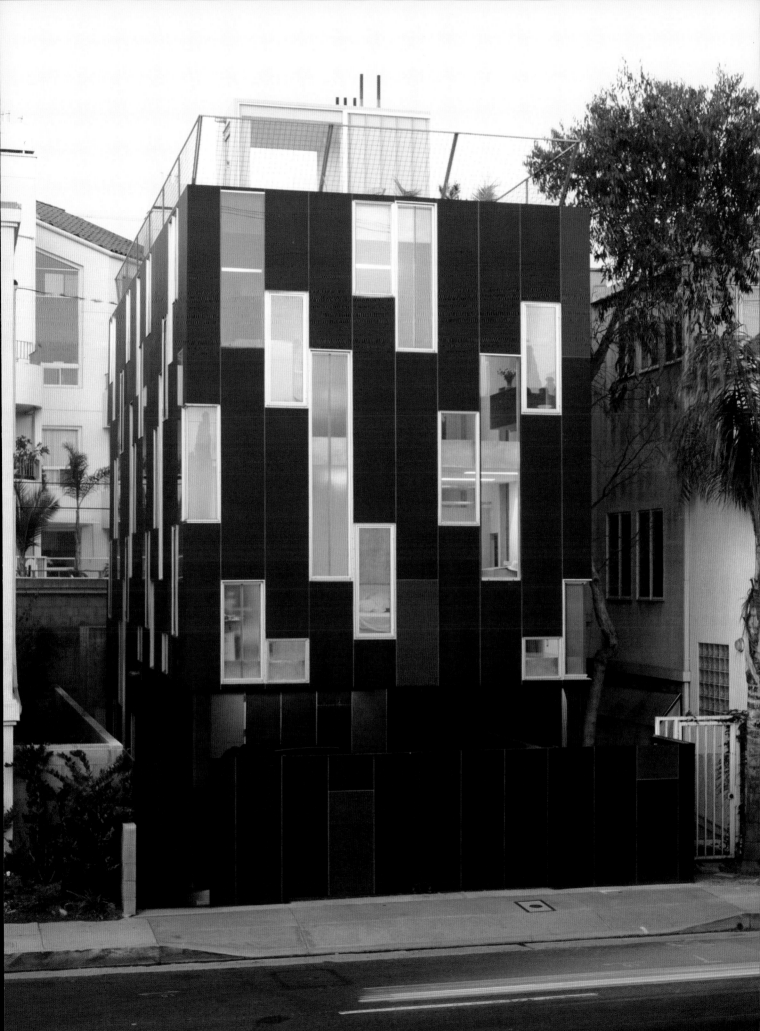

Project Orange
Sheffield, UK

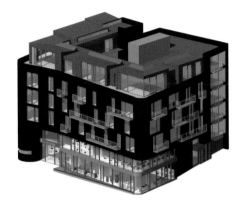

Above The six-storey block is wrapped in a façade of jet-black engineering bricks. This heavy aesthetic is off-set by the inclusion of prominent glazed screens and balconies that are highlighted with coloured elements, again in glass.

Crystal, china, and glassware retailer Sinclairs approached architect Project Orange to develop the site of its existing store to include a high-quality residential development as well as a new two-storey shop. Surrounded by architecture of bygone eras, including an Edwardian bank clad in terracotta and 1920s red-brick former municipal baths, Sinclairs is a statement of intent for the area.

Project Orange has designed a strong intervention in jet-black machine-made engineering brick and glass that refers to both the northern industrial aesthetic and the beauty of its client's crystal wares. Other external skins were toyed with – render was considered prone to graffiti, stone too expensive, and terracotta used too often on supermarkets – but black brick and coloured glass, wrapping the residential element, created the most dramatic and inspirational solution.

Above the sheen of the glazed façade on the ground- and first-floor retail and restaurant emporium, the massing of the dark brickwork presents a masculine, protective feel for the apartments. This is interrupted by floor-to-ceiling glazed elements. Deeply recessed into the brick skin to emphasize the inherent strength of the structure, these occur at random intervals, shuffled across the façade. Clear glazed balconies jut out into space above the heads of passers-by and, as a wilful counterpoint to the mass of the masonry envelope, the architect has interspersed vertical strips of coloured glass within each window composition.

The building is an ordered set of contradictions – mass and transparency, dark and light, colour and monotone. It embodies the industrial grit of Sheffield and the delicacy of its owner's fragile merchandise, while creating desirable contemporary apartments in an up-and-coming part of the UK.

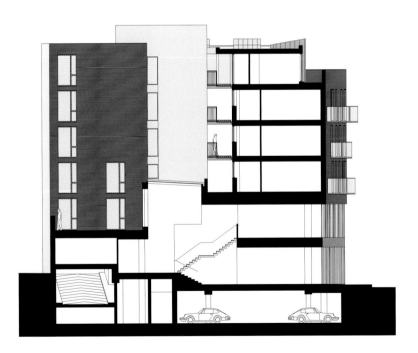

Left The residents' car park in the basement is linked to the apartments via a private elevator in the central core. This is separate from the store's ground- and first-floor circulation and service areas.

Opposite Set in context, Sinclairs is a striking new addition to the traditional aesthetic of Sheffield's Glossop Road. The glazed façade of the store is open and inviting, while above, the heavy, protective brick skin given to the apartments signals private space.

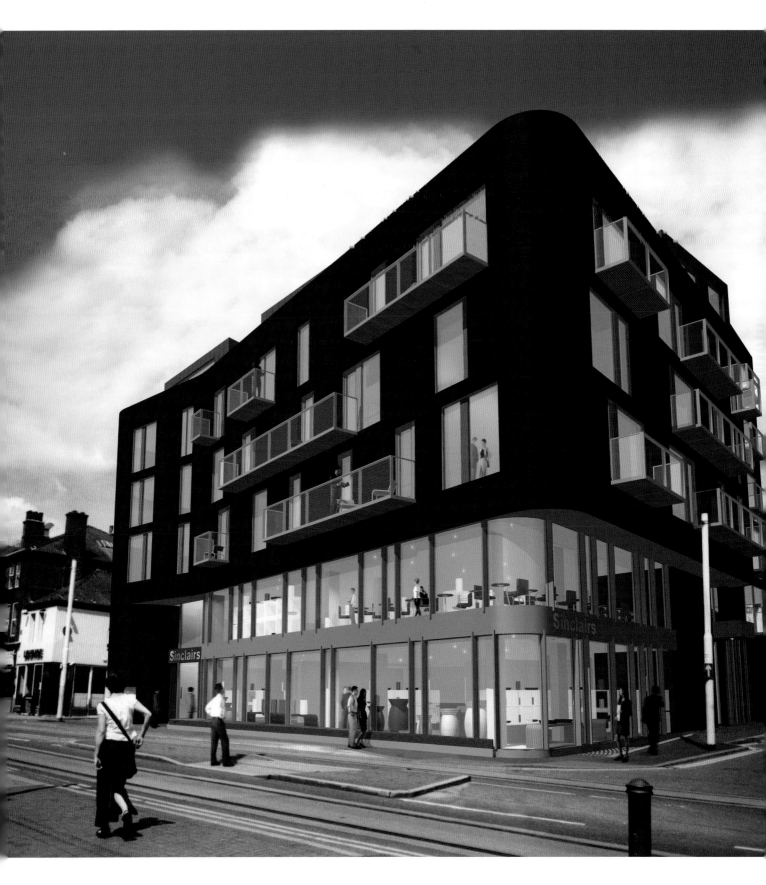

Sued.See

Gerner Gerner Plus | Burgenland, Austria

Husband-and-wife team Gerda and Andreas Gerner have a fascination with steel and glass, citing influences including Jean Prouvé and contemporary Japanese architecture. This obsession has led to the practice's gaining considerable experience in working with the two materials and, as a consequence, its architecture explores the limits to which steel and glass can be taken.

Gerner Gerner Plus's Sued.See house in Austria has been described as a UFO. The main living space is a large raised volume that seems to hover above the landscape. This is thanks to the practice's engineering expertise and knowledge of tolerances; diagonal columns, so slender that they go unnoticed from a distance, support the living space, which, although it looks heavy, is actually designed as a lightweight timber-framed box clad in thin metal panels.

The property is oriented to protect its occupants from the weather and still make the most of the views and sunshine. The entire south-facing façade is glazed, both living and sleeping spaces. Adjustable shading devices to all windows incorporate yachting technology and fabrics, a hint at the sport of choice in the area. In contrast to the south elevation, the timber-framed, steel-clad northern wall is heavily insulated and has only a few small glazed openings, helping to shield the site against bitter winds.

The service wing is situated to the eastern end of the property and partially buried in the landscape. Containing four bedrooms, boiler room, family room, and gym, it is reached via a spiral staircase from the main volume. Eventually it is hoped that a glass-clad swimming pool will be added under the raised living space, to complete Gerner Gerner Plus's machine-aesthetic obsession.

Above The property is split into three zones. On this plan, the left is private space including master bedroom and study spaces; the centre is occupied by an open living space; and at front right are a service wing and further sleeping spaces.

Opposite With its entire south façade glazed, Sued.See is designed to exploit its location overlooking Lake Neusiedl. Water- and wind-proof shades, designed after the latest in yachting technology, can be lowered to screen the windows.

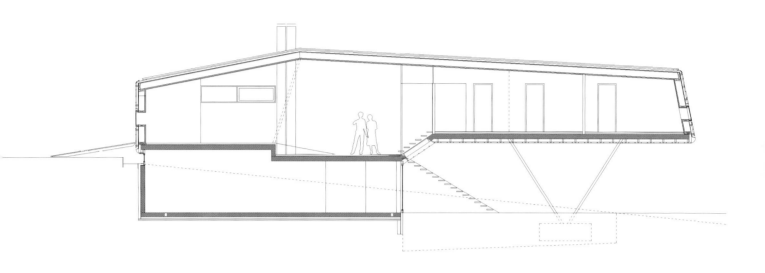

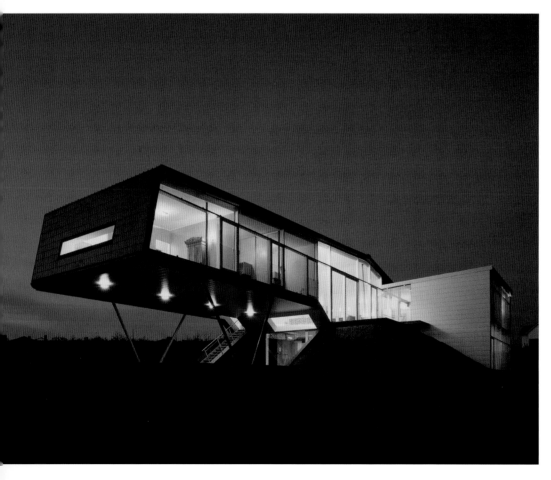

Above The slim profile of the timber and metal structure of the house is clear in this section. Its lack of mass allows for clear open spaces within.

Left The lightweight materials and construction techniques allow for dramatic architecture: a "floating" home on slim steel columns that seems to hover above the earth. A swimming pool is to be installed below this section of the house in the near future.

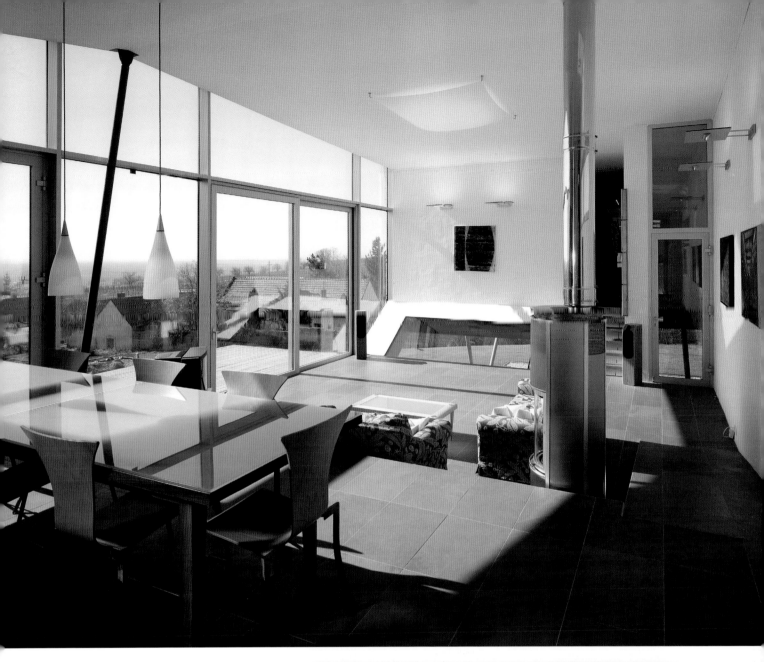

Above Internally, the hard-edged aesthetic is still dominant. Minimal fixtures include steel and glass light fittings and a stainless-steel woodburning stove and flue. These fixtures, together with the glass-topped table, are countered by the warm hues of wooden chairs and soft furnishings.

Right In contrast with the south elevation, Sued.See's northerly aspect is closed to its surroundings. Three windows are the only relief in the horizontally striated steel-façade cladding that protects against the harsh winds that blow across the exposed site.

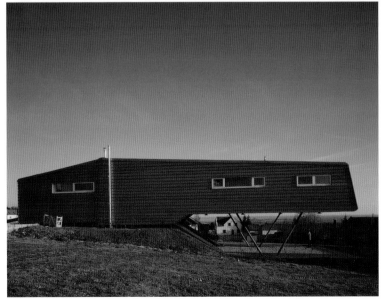

ENVIRONMENT

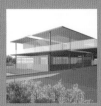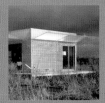

Introduction

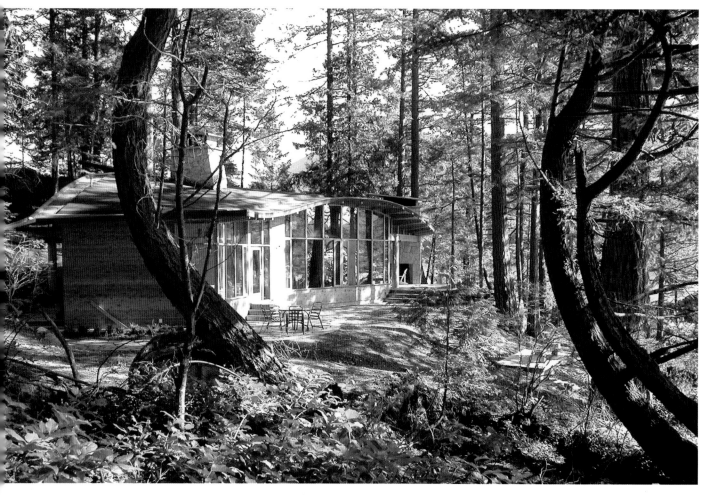

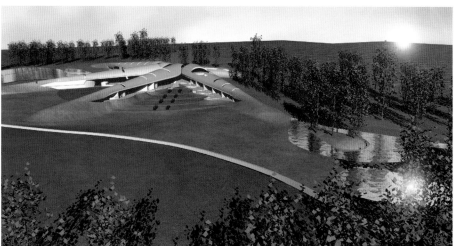

Environmentally sound design and construction probably had its greatest hour without even knowing it, before the Industrial revolution. Buildings were predominantly constructed using local materials, by a resident workforce, producing little or no harmful byproducts. However, since the late 18th century, when small-scale production was overrun by mechanization and factory-based mass production, the Western world has taken great strides in advancing technology, but also in destroying the ecological balance of the planet.

Only in the last 50 years has it become clear what man has done to the Earth. As a consequence, properties are once again being built to environmental designs. A few hark back to pre-industrialization but most utilize both low- and high-tech materials and methods in order to arrive at a solution that has less impact upon the planet.

But what is environmental design? Today's architectural solutions come in many forms and encompass different strategies, techniques, products, and technology. Techniques such as composting and natural ventilation or the harnessing of solar or wind power are obvious environmentally friendly answers. It is when the architect investigates further that the meaning of building to benefit the environment becomes clearer, and also more difficult to achieve.

The use of materials from sustainable sources is now high up on most architects' tick sheets. However, the energy required to harvest and process that material, the fuel burned in its transportation, and the power required to install it are all factors to be considered. This embodied energy should be a crucial factor in the choice of materials and products for use on any project.

Then there is the question of what impact a new building will have on its surroundings. How are materials and labour to be transported to a remote rural spot? What flora and fauna will be disturbed by the work? How long will the building be viable: when will the number of occupants grow too large for it, or tire of the space? Good environmental architecture addresses all of these questions and produces answers that are ecologically viable, whether the project is a single house in the countryside or a new urban development that transforms the lives of those on the lowest of incomes.

Idealistically, every new building would embody all of the above. Realistically, constraints such as costs, a reluctance to try new ideas and technologies, archaic planning laws, and aesthetic considerations all come into play. And so an architect must prioritize in order to design to the optimum within these boundaries.

The architectural projects featured here employ at least one environmentally conscious feature to lessen their impact on, and bring benefit to, their surroundings. Designs by Tim Pyne, Ahadu Abaineh, and Cullum & Nightingale – a mobile home, a mud-walled house, and a luxury beachside property respectively – all have only a minimal impact on their environment. Pyne's m-house can simply be lifted up and taken away. Abaineh's solution for upgrading chronic slums in Addis Ababa uses predominantly natural materials, including live trees, to build good shelter inexpensively, eradicating the costs and energy required to manufacture man-made products. In the Caribbean, Cullum & Nightingale has used local labour and employed local techniques, as well as other green solutions, to build a high-quality private property.

Abaineh's mud-walled houses also present a solution that will enhance the life quality of those who live in them, and so promote a greater sense of ownership and community in a deprived urban environment. This is also true, in a European context, of Dutch practice S333's Vijfhuisen development. Though the designs are radically different from the African architect's, each is attempting to provide simple, stable accommodation that its occupants will enjoy and so look after. This is the goal: a community that cares about where it is living, and so enjoys and preserves it. The resultant decrease in crime, vandalism, and violence is of great benefit to it and the wider community.

In contrast, grand country residences, such as those designed by Robert Adam Architects and Ushida Findlay, are beacons for experimentation in environmental architecture. Just as the country houses of the 19th century championed untried techniques, each of these new projects uses a combination of high- and low-tech solutions to create an outstanding piece of environmentally minded architecture showcasing what will eventually be available for use on less prestigious projects.

The degree of environmental design differs from project to project, but what ties these architects and their creations together is their striving to produce a building that best suits its use and surroundings in an environmentally conscious way.

Ushida Findlay
Chester, Cheshire, UK

Winner of a Royal Institute of British Architects competition to design a country house for the 21st century, Grafton New Hall is innovative biomorphic architecture on a grand scale. The design for this £20,000,000 ($35,000,000) property is based on the British historical tradition of trail-blazing new design ideas when building grand country houses.

To this end, Ushida Findlay's design is no futuristic folly. Every aspect of Grafton New Hall's development has been approached from an environmental perspective. The starfish-shaped building is built into its landscape to lessen its visual impact and to utilize the thermal massing properties of the earth in regulating the internal temperature. Heavyweight floors and walls in the central areas will also help to cool or warm the interior as they vent off at night. Space

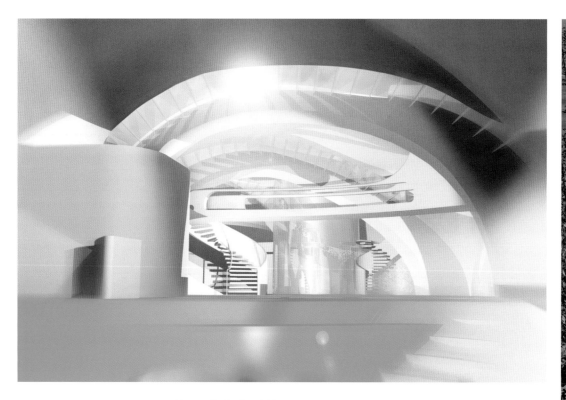

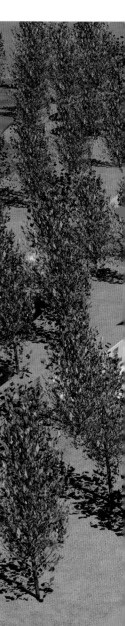

Above Shafts of sunlight penetrate the luxurious interior of the leisure wing. The building's mass is warmed by the sun and the heat is then vented off at night, maintaining the interior at a relatively constant temperature and reducing energy use.

heating and hot water heating are minimized by a good insulating thermal envelope and through use of passive solar collectors.

Water use will be minimized by using intelligent product specification, while rainwater will be recycled to flush the lavatories. A storage pond will collect excess water run off, to be used for irrigation, while waste water and foul drainage will be treated via a constructed wetland or reed-bed system.

The environmental specification of the project goes on – natural ventilation, composting, energy efficient lighting, a wood-fired boiler. On many projects of such high environmental specification the architecture is forgotten in favour of engineering. This is definitely not the case with Ushida Findlay's uncompromising design. Grafton New Hall, like no other, is a design most definitely for the brave.

Below The property's considerable size is disguised by flattening it against the landscape and spreading it throughout four wings. Access is via the entrance dome (left) and further space below ground. This reduces the visual impact on the surroundings and further insulates the house.

Above Here the true complexity of the design is revealed. The four wings are split into a multitude of rooms on both one and two levels. The spread of the layout provides privacy if required, but encourages interaction in the core and in the leisure wing.

Opposite top The leisure wing's curvaceous pool area opens out into the landscape, naturally ventilating the space and allowing in warmth during the summer. In winter time the façade can be closed, creating indoor and outdoor pools.

Opposite The four wings sit low and within the landscape. Each is intended for a different purpose – from top to bottom: leisure area, living quarters, guest wing, and sleeping quarters. Note the corresponding spaces and room heights depending upon activity.

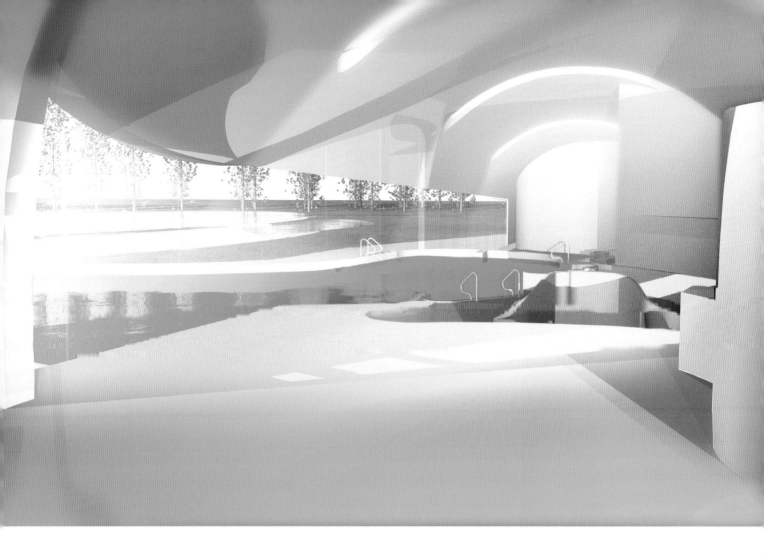

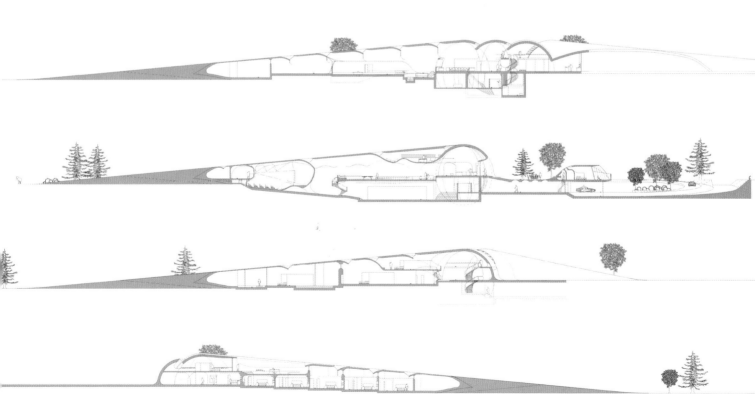

Solar House

Robert Adam Architects | Wakeham, Sussex, UK

Robert Adam is renowned for his classically styled architecture. He has taken a step further at Solar House, to include a passive solar energy régime that shows how new principles can be integrated into a very traditional aesthetic.

No active solar collection is employed on the project. The building is designed to collect its own energy and to be lived in differently according to the seasons. More than 60 per cent of the south elevation, which features a full-height portico, is glazed. The portico acts as a shade in the summer, and via its broken centre admits sunlight deep into the interior in the winter.

Inside, rooms are set around the central circulation and reception area. This features a double-height atrium with a barrel-vaulted roof and cornice. In winter the atrium is heated directly by the sunlight and energy stored in the heavy black slate floor. Excess warm air circulates naturally, aided by tall pedimented wind towers. In summer, shaded by the portico, the atrium remains a cool sanctuary.

The house is highly insulated and internal walls are lined with an impermeable seal to prevent heat loss. Windows are triple-glazed and there is little glass on the cold north elevation. All the ground-floor rooms, including kitchen and study, are surfaced in black slate to attract and retain daytime heat. The house even has a solar-heated swimming pool, and, outside, a new wild-flower meadow.

Solar House showcases the compatibility of classical architecture and solar innovation. Adam sees it as a blueprint not restricted to residential projects, the principles used being easily transferable to offices, hotels, and other buildings.

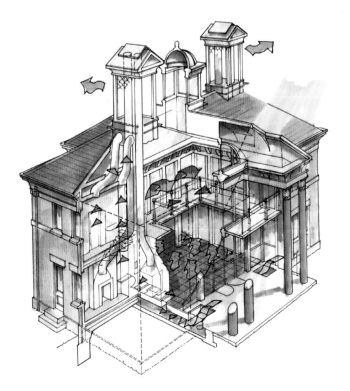

Left This diagram shows sunlight streaming through the extensively glazed south elevation to warm the heavy slate flooring. Heat is then distributed naturally throughout the house as large volumes of air circulate slowly, aided by the two pedimented wind towers.

Opposite The large broken portico on the south elevation allows maximum low-angle sunlight to penetrate the house in winter, while shielding the interior from the higher summer sun. Black slate flooring extends from the interior to form a heat-absorbing portico floor.

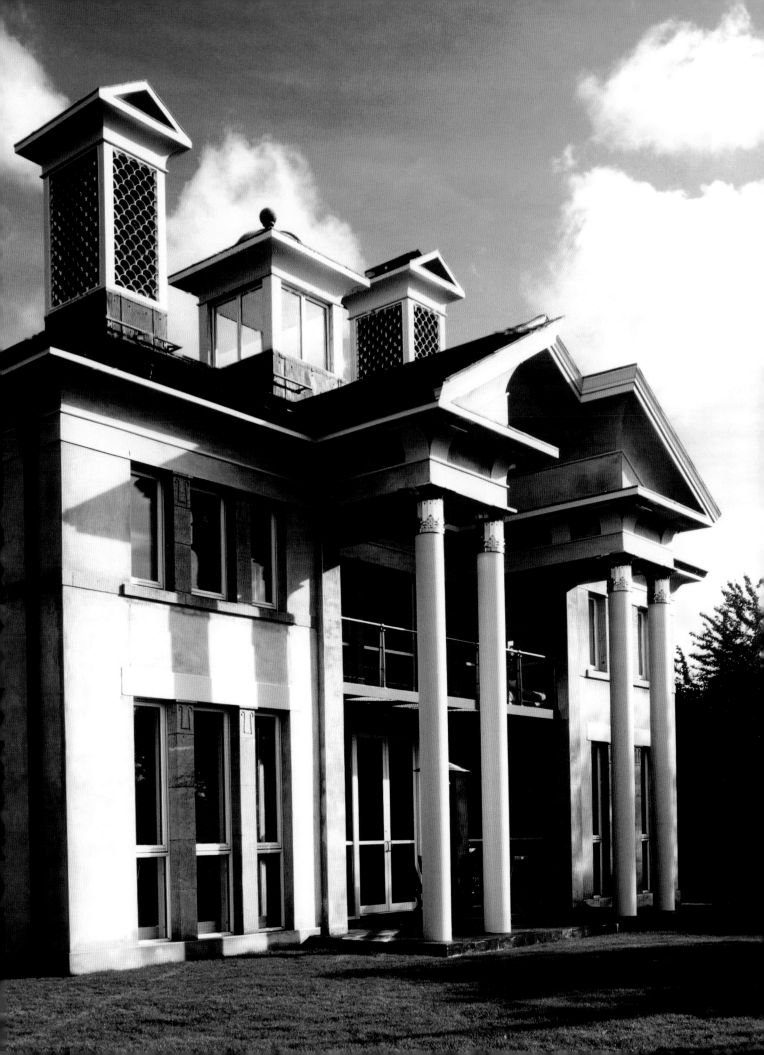

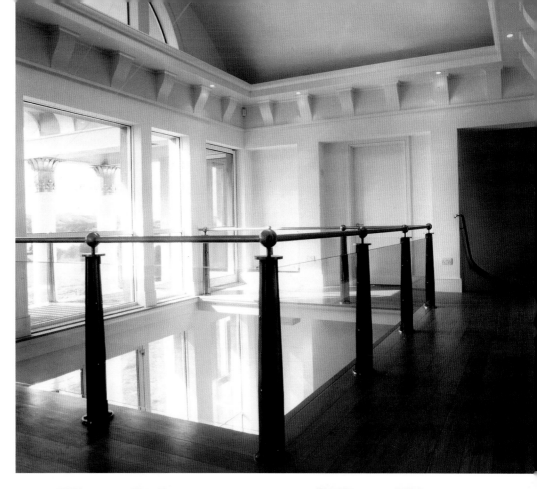

Above The grand living space is two storeys high, bordered by a balcony. A classically inspired design makes for an aesthetically pleasing space that is also architecturally innovative, as it assists in allowing free air-flow from ground to first floor.

Right With this view on to rolling hills through the extensively glazed southern façade, the image of the English country house is complete. However, this house works harder than most to ensure that it works in tandem with its environment, rather than overriding it.

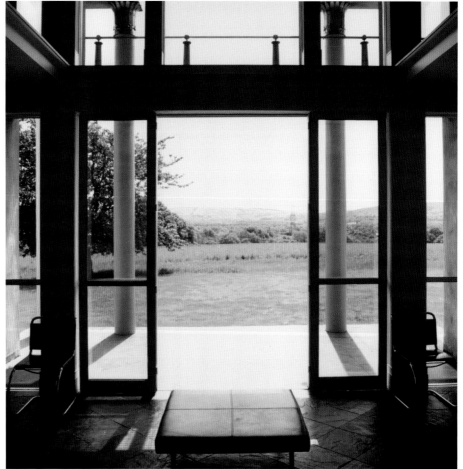

Left The imposing black slate floor is laid through the majority of the ground floor of the property. As well as being instrumental in the architectural design – operating as the house's chief passive heat collector – it also adds to the high-quality ambience.

Below The north elevation of Solar House is more protected, featuring only minimal glazing to lessen heat loss. The exterior is clad in natural-coloured stucco, providing a clean, low-maintenance finish that is in keeping with the classical design.

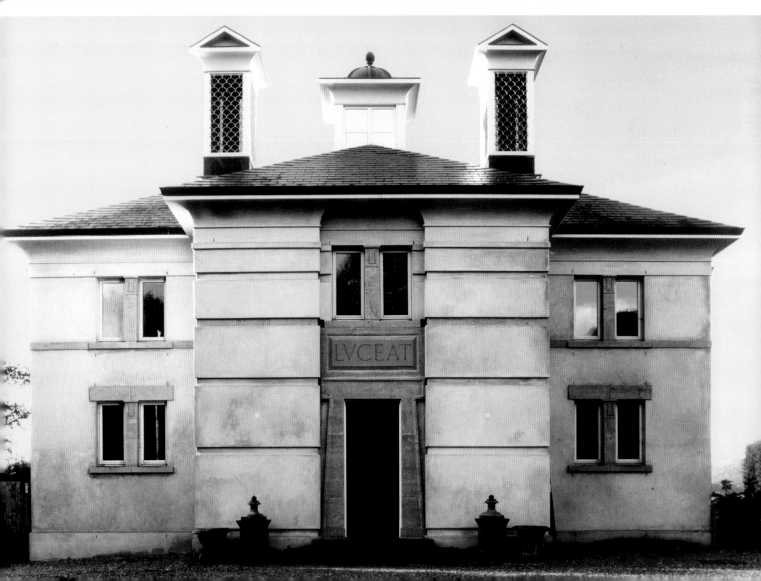

Growing House

Ahadu Abaineh | Addis Ababa, Ethiopia

Above Branches lashed together make a simple stairway. Behind, the foundation of the mud wall is a curtain of smaller timber tied to a diagonal framework. This pattern helps the mud infill to adhere as it bakes hard in the sun.

Right The framework for the house is also constructed out of timber. The main upright in this picture is a living tree with its roots still firmly planted in the ground: one sits at each corner of the property.

Opposite On completion, the houses are extremely substantial, with a ground and a first floor, pitched corrugated-iron roof, and even a sun terrace. Trees shade them from the worst of the heat and all properties are raised off the ground to avoid flooding when torrential rains darken the sky.

Housing and shelter are a constant concern in urban areas of economically developing nations. To tackle the problem of providing affordable, ecologically appropriate housing, architect Ahadu Abaineh has designed and built a test house almost entirely out of local, natural, and essentially very inexpensive materials.

The most important of these materials is the structural frame: live zigba and wanza trees act as columns at the four corners of the house. These native trees provide vertical structural members and ample shade, while also greatly improving the urban ecological balance.

Untreated timber poles form a frame between the trees, and the walls are infilled with mud to traditional techniques. The only factory-made materials used are sheets of corrugated metal for the roof. These protect the mud walls from the rain, while channelling it to the house perimeter to irrigate the trees.

This type of building eradicates all major construction costs. Manufactured materials, such as concrete or brick, are not used; professional requirements are reduced to a minimum, as are transportation costs because the materials are grown or excavated locally.

The first of these unique houses has been erected on the outskirts of Addis Ababa. It took six weeks to construct and is now being lived in. The occupants are being interviewed regularly and the house inspected and monitored. This evaluation will be collated and presented to government and charitable aid bodies in the near future as a viable scheme to lessen housing shortages.

The skills learned by local people on the project are already being reused, and groves of zigba and wanza trees have been planted in anticipation of further demand.

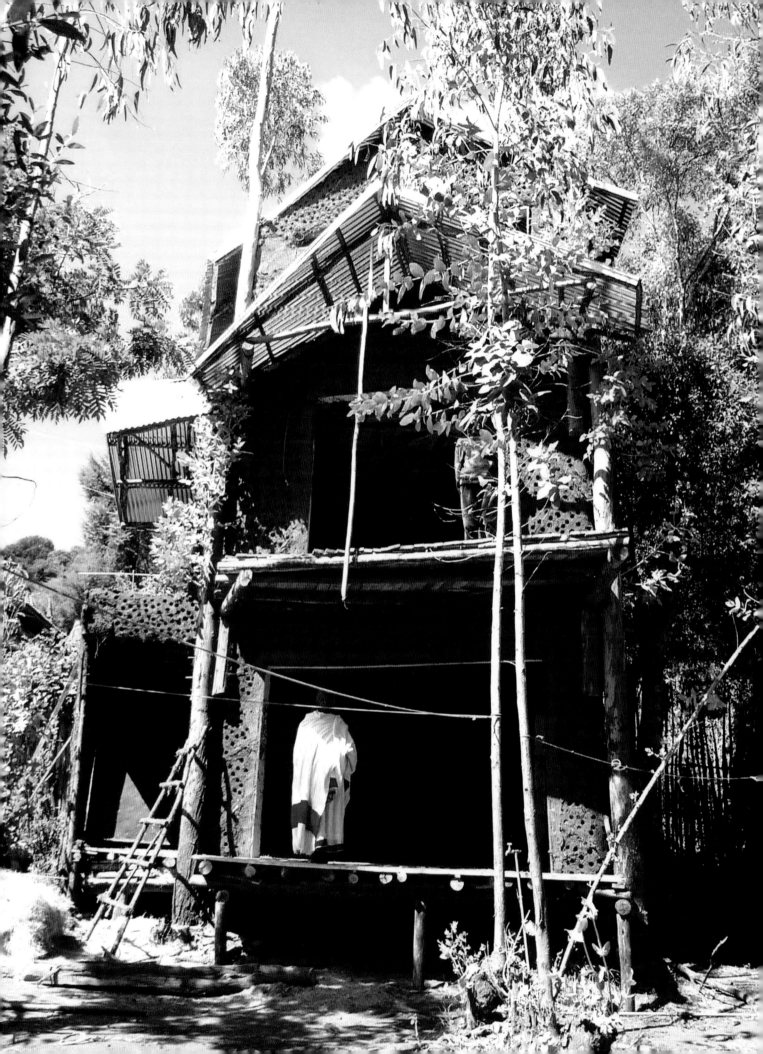

Bloembollenhof

S333 | Vijfhuisen, Netherlands

To many people, environmentally conscious construction means solar panels and wind turbines. However, in the context of urban housing schemes that will be successful in the future, "environment" means a whole lot more. It means making the space enjoyable to live in, giving occupants true ownership of their dwellings, and creating a community. And it is this that S333 has achieved on its Bloembollenhof mass-housing scheme in Vijfhuisen, Netherlands.

The design is a dense estate of homes that challenges the traditionalist's perception of urban design on every level. Where others have built high-rise towers, S333 has created four low-rise building forms from which can be designed 52 different shapes of home – from large single dwellings to smaller social-housing blocks. The properties are simple gable-ended volumes that feature large skylights and dormers. Clad in grooved cumaru planks and profiled steel sheets, the façades are kept very simple – even rainwater gutters are hidden. Some properties have large loft rooms while others include first-floor balconies or double-height spaces, and there are garages and gardens too.

These varying building types are mixed freely across the site. Views from all dwellings are carefully considered, and, best of all, the occupiers have been left to their own devices, and even encouraged to stamp their own personal mark on the properties.

This social consultation – starting with the shape of the property if bought before construction starts – has encouraged personal additions such as greenhouses, ad hoc extensions, hanging flower baskets, and name-plates. The project oozes individuality, feeling more like an extended cluster of rural farm buildings than an urban housing project. This diversity – this individual approach to mass housing – is what makes S333's Bloembollenhof scheme work.

Above The land surrounding S333's Bloembollenhof affordable-housing scheme is left for house owners to landscape. This allows the occupants to develop it to suit themselves, whether privately or communally, fostering a sense of ownership and community spirit.

Left Exciting and varied layouts make each home feel unique and special to its owner, even though the development is designed around just six property types and a limited kit of architectural parts.

Opposite A simple palette of materials, including grooved cumaru wood panels, corrugated steel, and back-painted glass, is relatively low in cost. None the less, the materials exude quality and, together with innovative design, make homes that people feel good about living in.

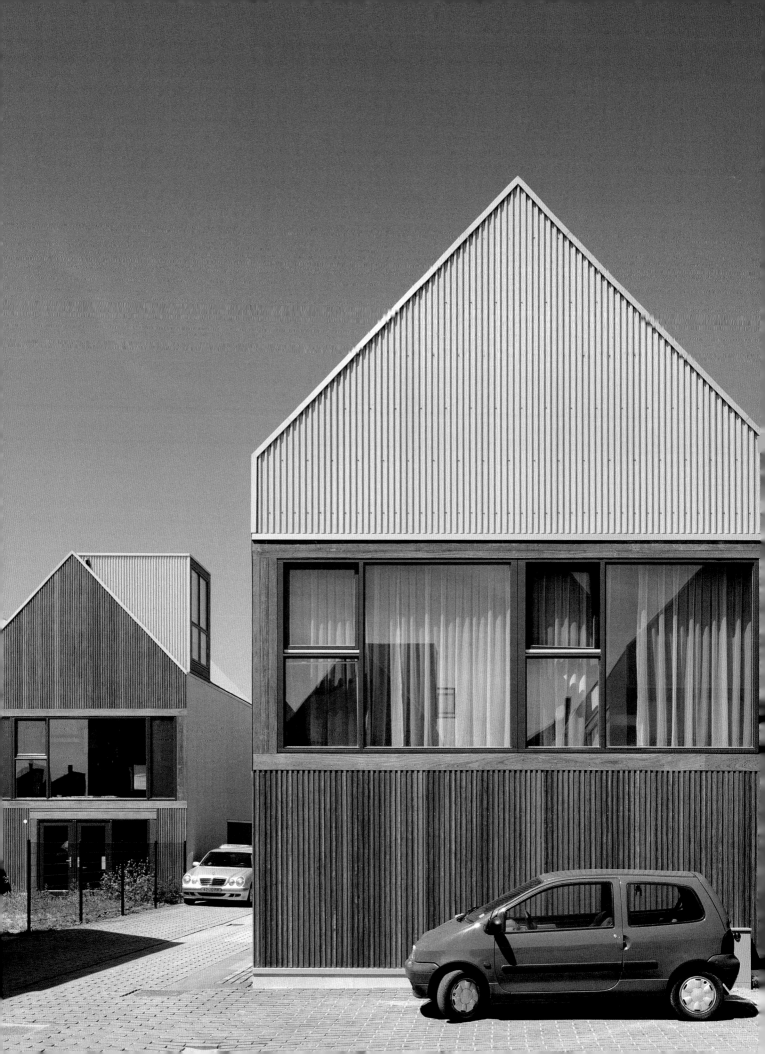

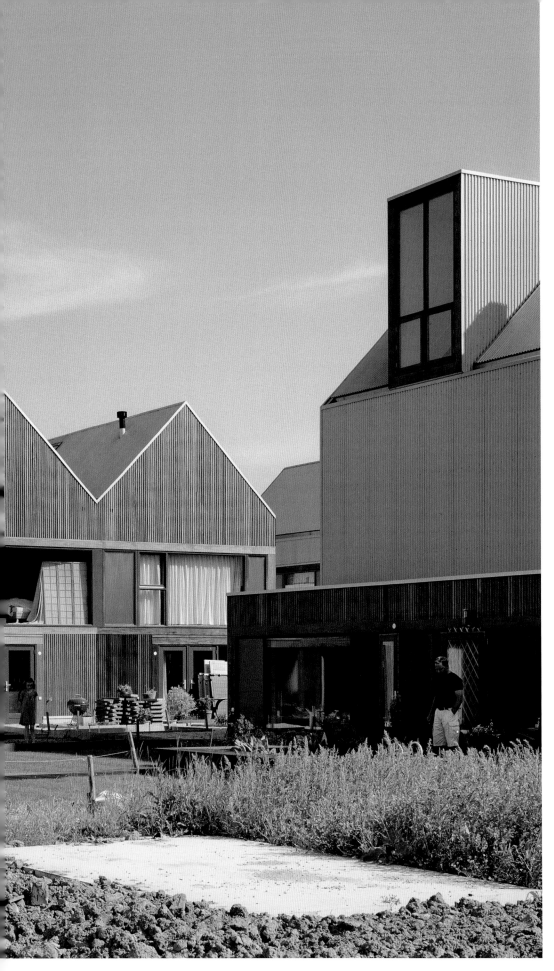

Left Spaces between the properties are open and varied. The environment is one of inclusion and interaction, promoting good relations between occupants on this dense but seemingly spacious housing development.

Opposite top Shirking the universal trend for rows of identical dwellings that line the road, Bloembollenhof includes six different dwelling types, from small apartments within a larger block to large independent family homes, positioned at opposite angles to each other.

Opposite Spatial representations of the site illustrate the design strategy. From left: built elements; land apportionment; simple property boundaries; and main sight lines from properties which avoid looking straight into other dwellings.

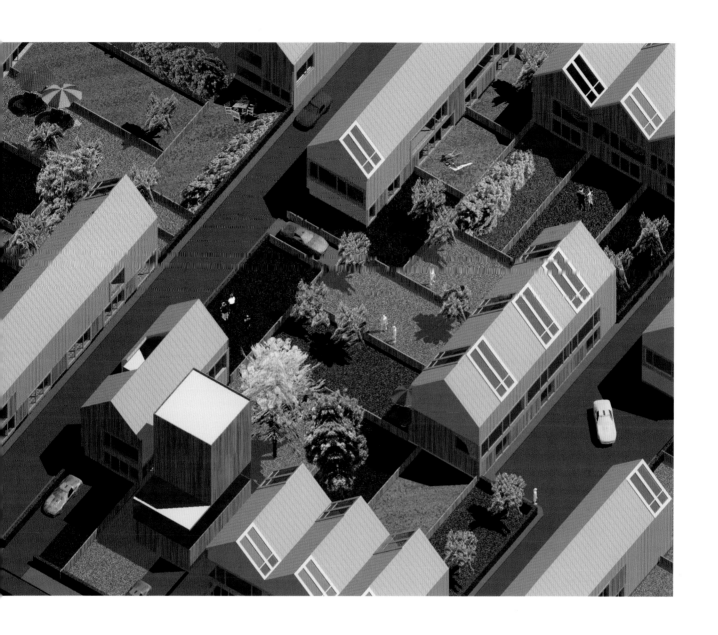

Eldridge Smerin
Staplehurst, Kent, UK

Set within an existing plant nursery, Eldridge Smerin's modern country house is an important element within the practice's master plan for the entire property. The 1000 m² (10,765 sq ft) house is a linear volume of concrete and glass that is elevated on pilotis above an existing reservoir and land. The effect is that of a floating presence with a continuation of the landscape underneath.

Conforming to strict UK planning guidelines for houses in the countryside, Iden Croft has been designed to include a host of environmental benefits. Passive measures include the use of the thermal mass of the concrete structure to regulate the interior temperature of the building, and a green roof, to be planted by the nursery, that will provide a high level of thermal insulation. High-performance glazing to a large percentage of the walls will maximize natural daylight while minimizing heat gain, and surplus water from the roof will be collected and used for irrigation in the grounds.

Photovoltaic cells are to be encapsulated in an interlayer of the glazing to the roof to provide power for the lighting. Sewage will be dealt with by a grey-water handling system, which will reduce mains water usage, and a reed-bed system.

Entrance to the house is via a dramatic ramp that echoes Le Corbusier's Villa Savoye. This cantilevers out over the reservoir before turning back on itself towards the house at first-floor level. The space under the house at ground level provides a covered external area that the owner envisages using for public events connected with the nursery.

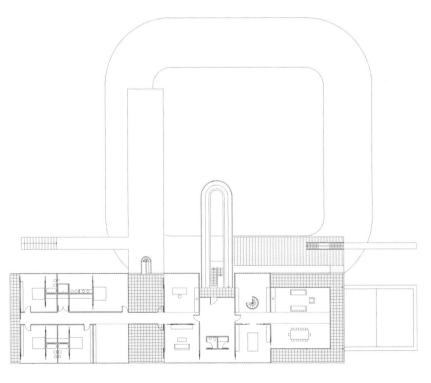

Left The first floor of the property contains the main living spaces and gives views out over the rural surroundings. The true size of the reservoir can be seen here, along with the extent to which the ramp loops out over it.

Opposite centre The house's extensively glazed façade renders it semi-opaque and lessens its visual impact on the landscape. The large wooden decked area leads visitors between swathes of green and blue to the main entrance.

Opposite Even though the property is two storeys high and supported on pilotis, it seems to hug the ground. As it matures, the planted roof will further disguise the property from the air, as well as bringing savings thanks to its insulating properties.

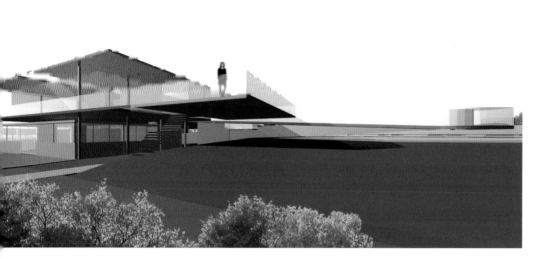

Left Iden Croft's *in situ* concrete construction provides good passive temperature regulation via its thermal mass. It also allows the architect to indulge in a huge ramp and first-floor terrace, cantilevered dramatically over the lawns and lake.

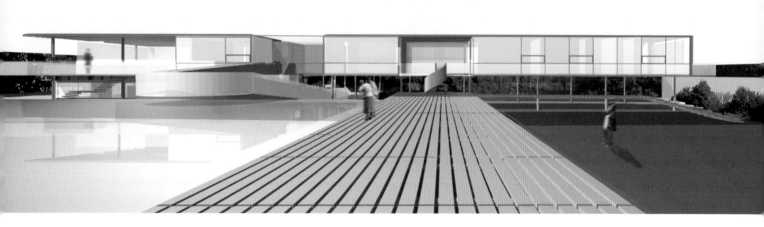

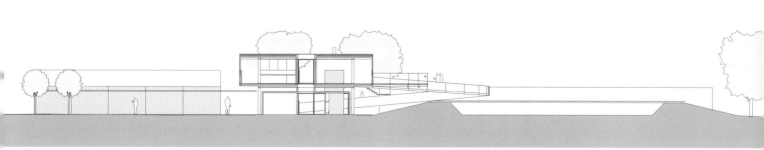

m-house

Tim Pyne | Non site-specific

Every property type has some degree of impact on its environment; some, however, have far less than others. Tim Pyne's m-house takes the principles of prefabricated construction and combines them with elements of mobile-home design, to produce a living space that is as light on its surroundings as it is on its feet.

After becoming frustrated with UK planning restrictions and construction constraints, Pyne developed a high-specification property that can be sited anywhere. Because it is designed to mobile-home standards, normal planning restrictions do not apply. This means that the m-house can be situated in a back garden or on a flat roof; it can even be floated. While this all sounds fun, it means that the property can be moved when its occupants want to move, rather than the owners leaving it and buying another house, rebuilding and converting, and as a consequence using more energy.

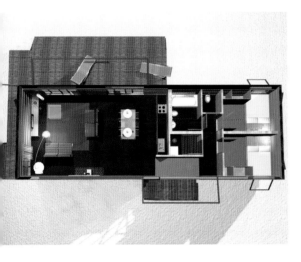

Above A simple, compact design of living space with a kitchenette/dining area, two bedrooms, WC, bathroom, and storage, is complemented by the outdoor sheltered deck area. M-house has all the trappings of a conventional living environment.

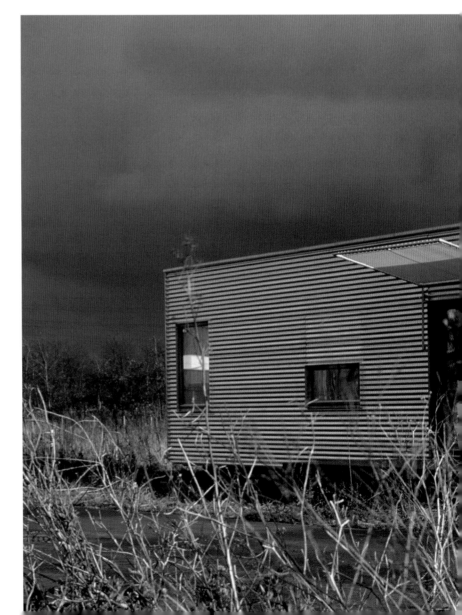

This ability, above all others, gives m-house the environmentally conscious tag. Compared to a conventional newly built property, the associated energy requirements of the factory-built m-house are minimal, especially when its manufacture, transportation, and assembly are taken into account. The property is available to order with a range of internal and exterior finishes, and after delivery to site in two pieces it is ready for occupation within 24 hours.

M-house is fully insulated to well above UK building regulation standards. Underfloor heating and high-specification windows and doors make it very inexpensive to keep warm. External cladding materials do include aluminium, but for the more environmentally conscious, sustainable cedar strip or shingles are available.

The product is currently marketed in the UK and USA; interest from Slovenia means that eastern Europe may be the first to see a mass m-house development.

Below Creating a striking addition to the landscape, m-house is a progression from the traditional static caravan. Its mobile-home-like design and light environmental impact make the property a viable proposition for sites where planning permission is difficult to obtain.

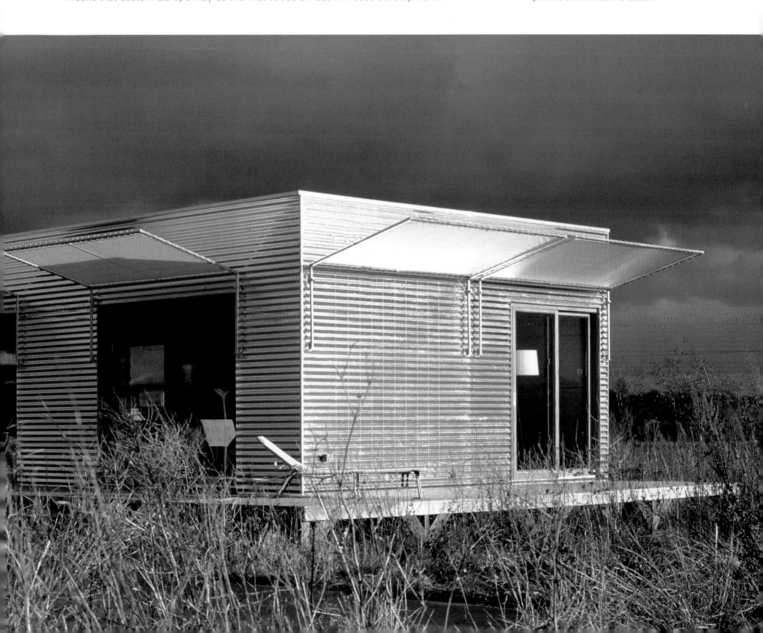

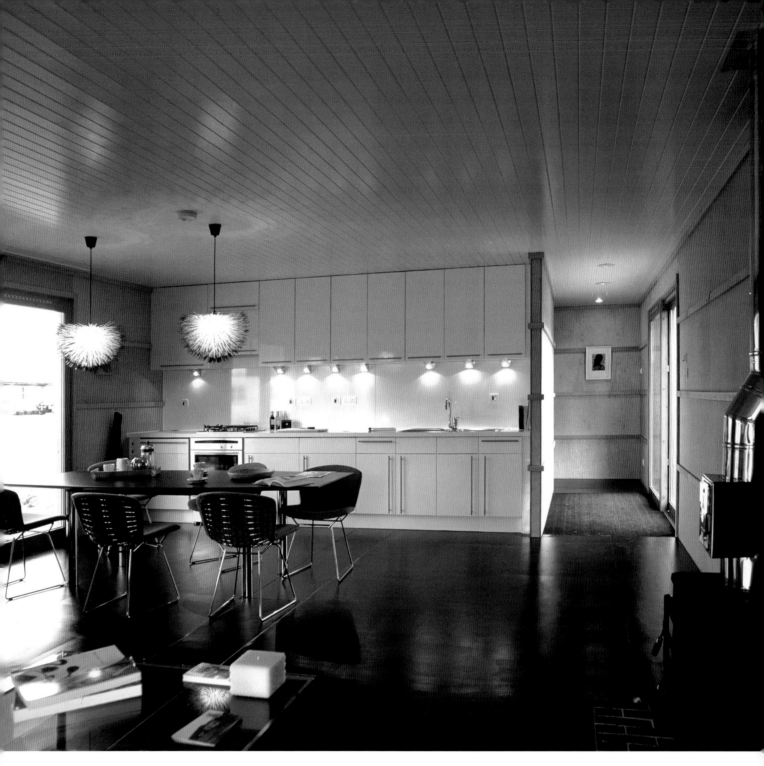

Above The main living area is large and open, increasing the illusion of space. Highly insulated walls are undecorated and clad in polished plywood; a woodburning stove completes the homely feel.

Facing page M-house's potential is not realized until its ability to be located anywhere is appreciated. From the rooftop of an urban warehouse apartment to mud flats in a coastal estuary – it will even float – m-house makes good use of previously non-developable sites.

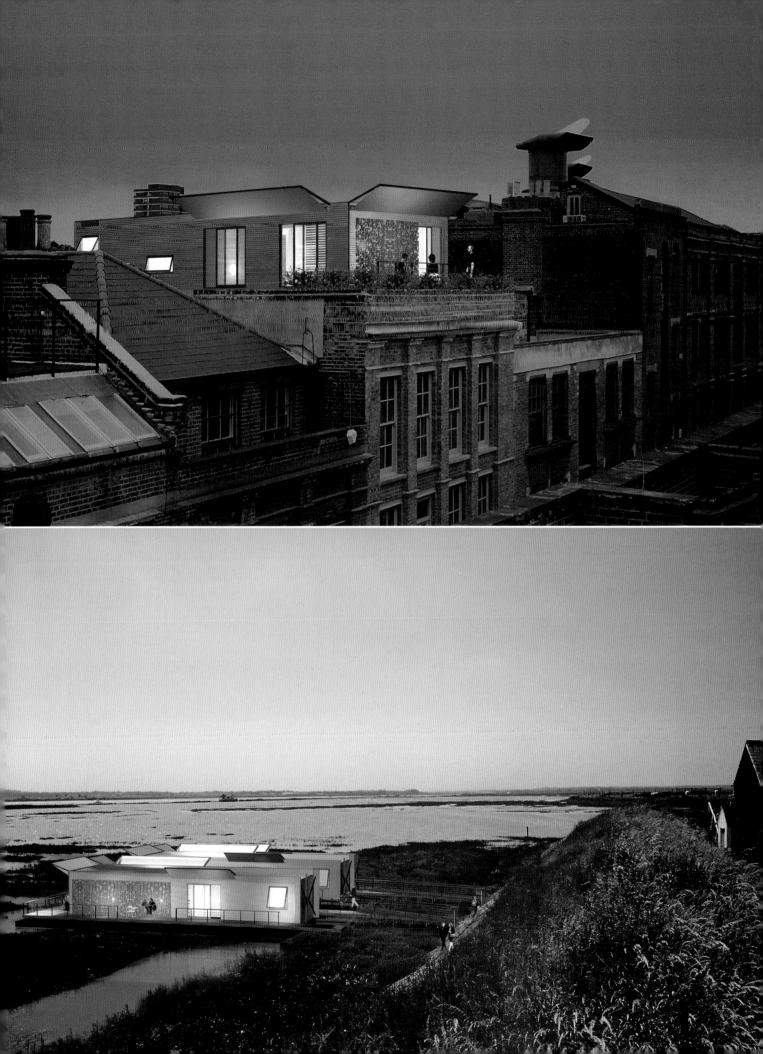

Murphy House

Blue Sky Architecture | Gambier Island, Canada

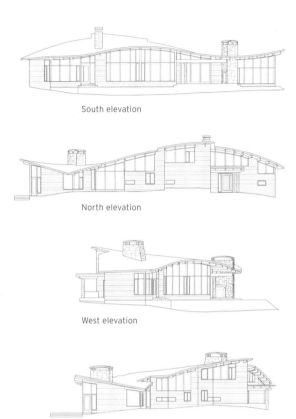

South elevation

North elevation

West elevation

East elevation

With no direct ferry or vehicular access to Gambier Island, off the coast of British Columbia, Blue Sky Architecture partners Bo Helliwell and Kim Smith had literally to work with nature to create the wonderfully organic Murphy House. The property nestles, facing south, set back from the shoreline and partially hidden within a conifer forest that touches the water's edge in this pristine wilderness.

Both the design and the materials used on the project aim to integrate the house with its local environment, with as little visual or ecological impact as possible. The pared-down Modernism of Murphy House is indicative of the architect's and client's wish to bow to the beauty of the setting. The property is constructed almost entirely of local Douglas fir, much of it machined from trees cleared for the site. Stonework, used for two chimney stacks, is also local.

The house makes little impact on its environment. The deep eaves overhang, which, together with the forest canopy, protects the property from undue heat gain in the summer. During the winter, underfloor heating is fed via a specialist geothermal heat-exchange system from Earth Source Energy. This uses the constant temperature of the water 20 m (65 ft) below the surface of Howe Sound to regulate a conductive fluid in 700 m (2,300 ft) of sunken piping to a constant 10ºC (50ºF). When passed through a heat exchanger, the temperature is boosted to 50ºC (120ºF) to heat the property and domestic hot water.

The shape of the property is also inspired by the rugged, undulating nature of its surroundings. Both the roof and the south elevation curve in tune with the landscape, while the linear plan is organized to orient guests towards the glazed south elevation, so as to feel like a walk through the woods.

Above These elevations illustrate the undulating nature of the property, a design that responds to the uneven site and the formation of the wider natural environment.

Right Using stone and timber from the site not only blends the construction into its surroundings, but also greatly reduces the embodied energy expended in the transportation of materials and construction of the building.

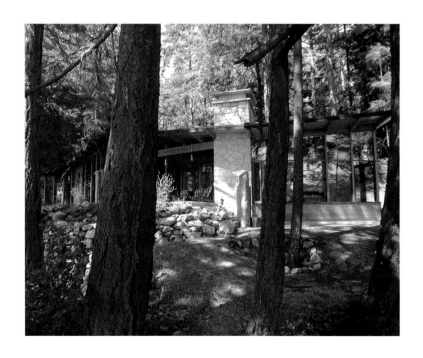

Right Hardly visible from Howe Sound, the property's form touches only lightly on its environment without disturbing the natural equilibrium. As a consequence, the forest seems to envelop it and embrace, as if the house had always been there.

Below Murphy House is perfectly integrated into its location, both visually and ecologically. A variety of environmental measures means that it has relatively little impact on the environment.

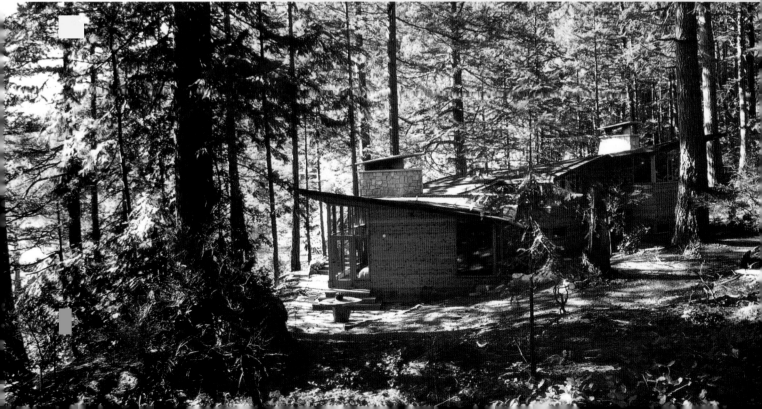

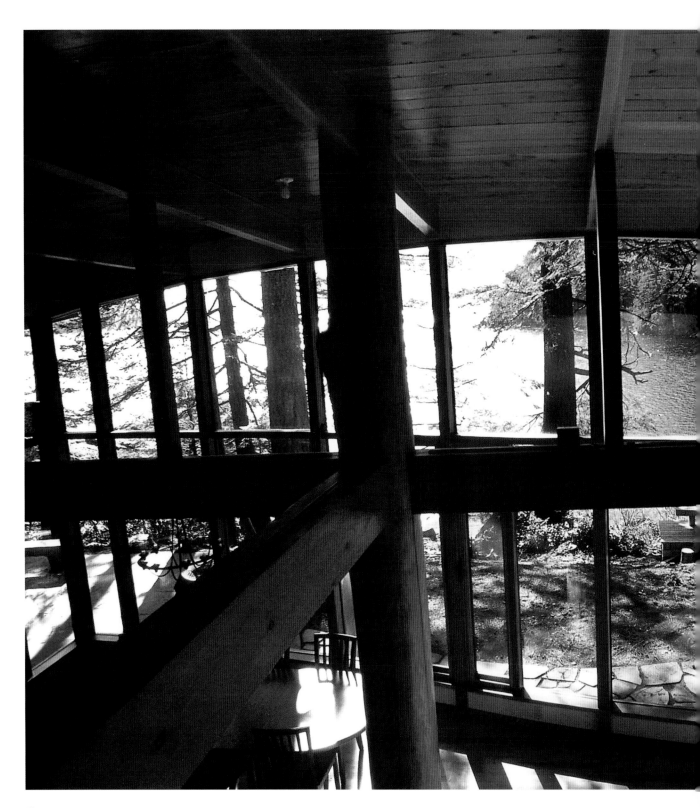

Above The high, open spaces of
the interior echo the vast wilderness
outside. Massive cylindrical wooden
columns intentionally mimic the
trunks of the trees around the house
so that occupants never lose touch
with their surroundings.

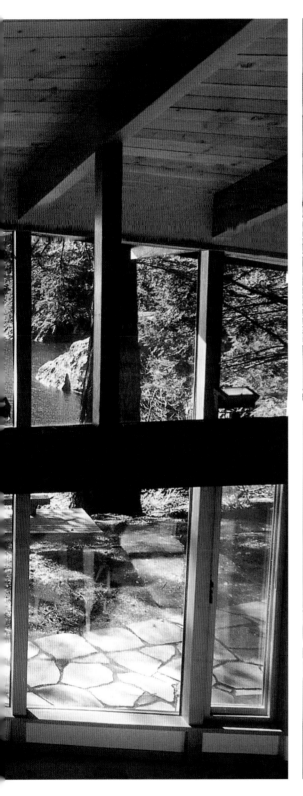
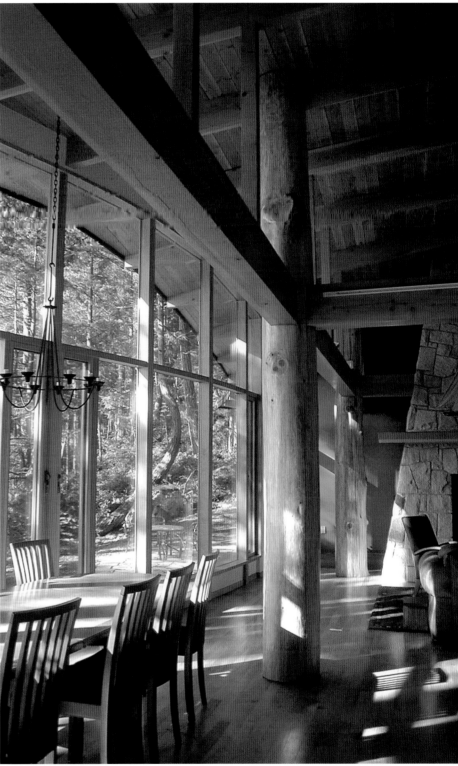

Above Although extensively glazed, the property is adequately warmed using underfloor heating fed by an underwater heat-exchange system. This method is ultra-efficient and has less environmental impact than conventional techniques.

New Eden House

Cullum & Nightingale | Bequia, Caribbean

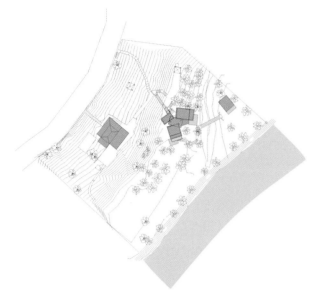

On the small island of Bequia in the eastern Caribbean, one of the islands constituting the country of St Vincent and the Grenadines, Cullum & Nightingale's beach house is a lesson in the reinterpretation of vernacular construction with an environmental conscience.

The house, set amid a coconut palm grove on the edge of a beach, is designed to blend into the landscape. It forgoes the strong cuboid form of conventional properties, instead being split into two wings around an open connecting stairway. This performs the multiple functions of breaking up the building's outline, allowing views through it, and providing maximum exposure to the cooling breeze.

Natural ventilation is capitalized upon in every living space. Large areas of seaward-facing walls throughout the house feature sliding screens – some glazed, some mesh – to encourage a through-flow of air. However, while the house attracted local attention for its form, the materials used are all familiar. Sourced from St Vincent and Trinidad, such elements as the monopitch corrugated roofs are a mainstay of Caribbean buildings, as is the extensive use of timber: greenheart here, because this dense wood fares better than metal in the harsh coastal atmosphere.

As Bequia does not have running water, rainwater is collected from the roofs and stored in a large tank dug into the hillside. Water is heated using solar panels, and after use in the house it is reused to irrigate the garden.

The property makes subtle reference to its Caribbean location in many ways, from hints of the bright colours that are apparent everywhere, to casts of palm fronds in the concrete ceilings. Essentially though, Cullum & Nightingale's house bows to the beauty of its environment, and for that reason it is truly successful.

Above New Eden House is situated at the foot of a steeply graded site that also includes the original colonial-styled Eden House. However, the new property borrows from local architectural tradition, rather than importing English style.

Below The new addition to the site is a multilayered exercise in semi-open spaces and verandas. A bridge and drawbridge allow access to upper levels that sit within but not above the existing foliage.

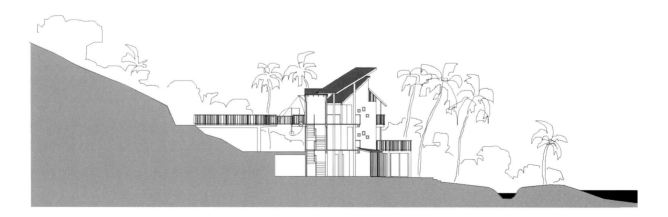

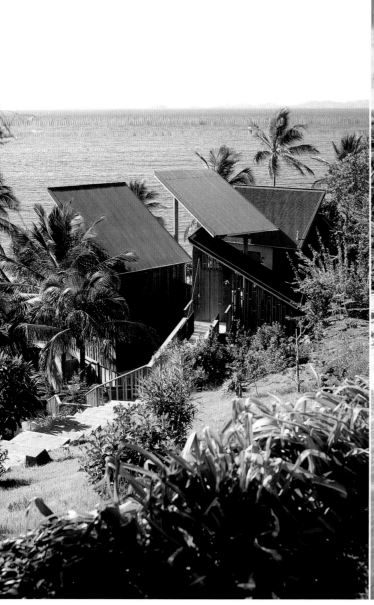

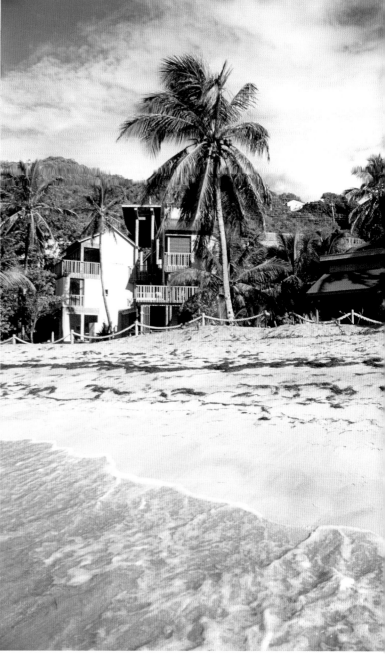

Above The numerous overlapping single-pitch corrugated roofs drain into a large tank, collecting rain-water for use around the property as there is no mains supply on the island.

Above While New Eden is virtually on the beach, it does not encroach on the idyllic scene: the house's unique design breaks up its outline and helps it to blend with the natural surroundings.

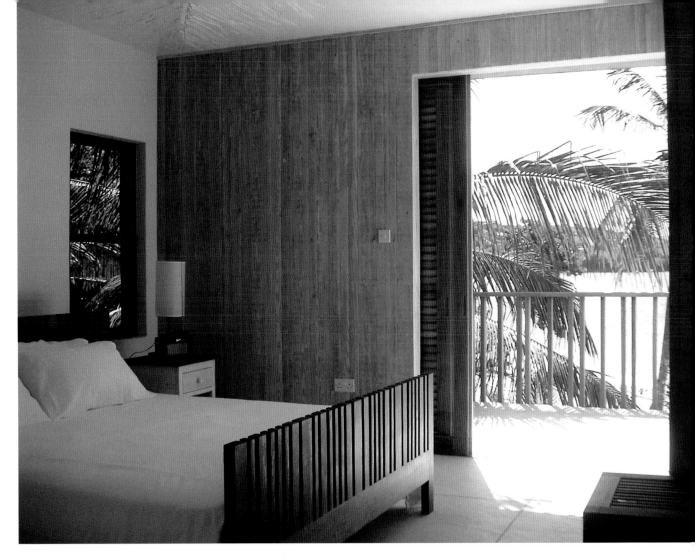

Above All rooms are open
to the elements. The architect
refused to use environmentally
detrimental air conditioning, and
so cooling breezes off the ocean
must be allowed to percolate
through the property to regulate
the temperature.

Left The house is built within
and around nature. Great care has
been taken to integrate it into its
island setting, rather than imposing
a new element upon the pristine
surroundings.

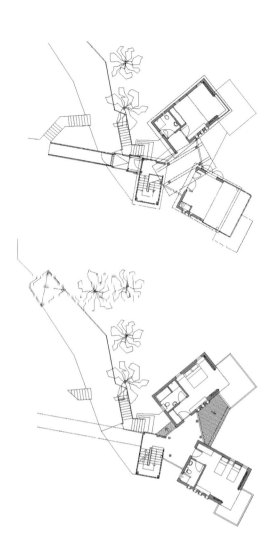

New Eden House

Above Splashes of colour hint
at Grenadian architectural tradition.
This is also true of the corrugated
steel of the roofs and the extensive
use of local timber.

Left The property is split into
two three-storey towers, linked by
external landings. A bridge provides
access to the second-floor bedroom
and veranda. On the first floor are
two more bedrooms, while at
ground level are the kitchen, the
dining and living rooms, and an
outdoor terrace.

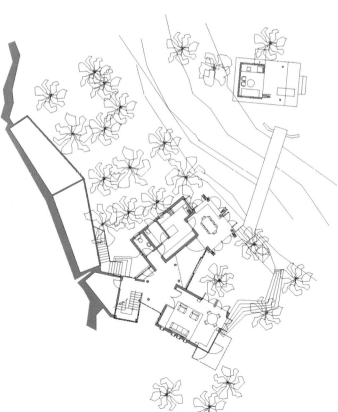

BUDGET

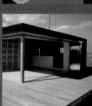

Introduction

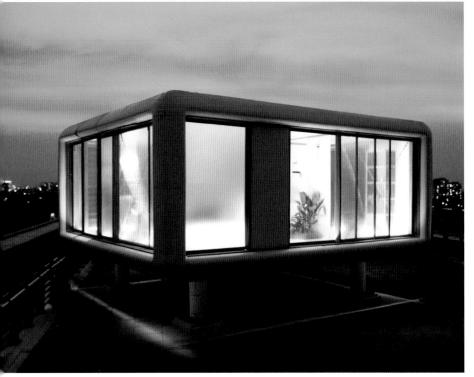

Left Loftcube, non-site specific
(pp. 116–119)
Below Elemental Housing, Chile
(pp. 124–127)
Bottom Rural Retreat, South
Devon, UK (pp. 130–131)

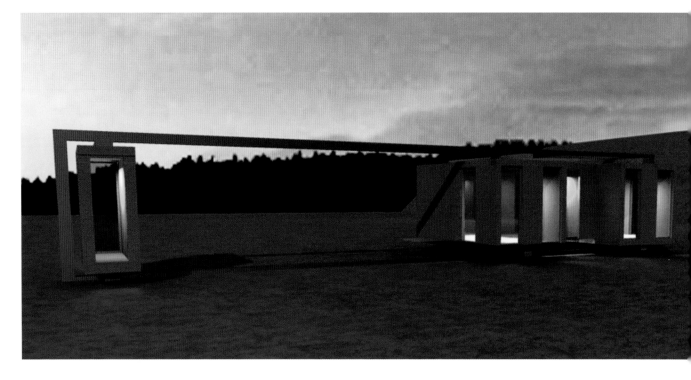

Above Heeren Shophouse, Malacca, Malaysia (pp. 112–115)

The budget is so often viewed as a negative aspect of a project; the limiting factor forced upon a design. Instead, it should be seen as setting challenging parameters within which a solution must be found. Large or small, it is a guiding hand for the architect; one that may throw up obstacles, but that more often than not serves as the catalyst for a highly innovative solution.

Ever since trading became an integral part of society, people have striven to get the most for their money. Whether it is buying food, purchasing a holiday, or designing and building a home, the driven individual will try to realize the full worth of his or her outlay. In architecture this means that designers are pushed to innovate with materials and techniques, to investigate new and different solutions to common problems, and to explore radical and diverse alternatives.

Today, in developed countries, the high cost of the production of building materials makes every construction project an expensive gamble. Couple this with escalating land and property prices, and many people can not afford to build or buy a conventional property. Architects are now responding to this with the design of micro-flats – small, versatile living spaces – and low-cost, low-impact living units. Inventive use of space and materials can create a workable living solution that, while it costs a fraction of a traditional house, still maintains extremely high design ideals and top-quality finishes.

Studio Aisslinger and architect Kaufmann Kaufmann have designed the Loftcube and SU-SI respectively. Each is an inexpensive living unit that can be erected quickly and moved easily from location to location as its owner requires. Where budgetary restraints have limited the amount of space available, they have given rise to the realization that a small property is one that does not have to be anchored to the earth. What initially was an obstacle has now spawned an entirely new idea.

Both these architects have grasped this idea, swiftly expanding it and their mobile home unit designs into spaces that can be adapted for living, working, or exhibiting. This versatility and ease of adaptation is crucial, too, for Dutch practice ONL's Elemental mass-housing project in Chile. Here, social and economic deprivation has prompted the architect to investigate extremely low-cost solutions to chronic housing shortages. The answer is a mass-produced yet versatile system of building that will provide many homes in a small area, without creating a depressing, cell-like neighbourhood.

Mass production is a widely recognized method of saving both time and money. With the realization that homes could be constructed from factory-produced parts, architects including Walter Gropius and Le Corbusier revolutionized the architectural aesthetic. They did it in the name of Bauhaus and the Modern movement, but they also did it because it made financial sense at a time when money was often scarce and housing in short supply.

At the time, their architecture shocked the world. These new, edgy solutions were so radically different from what had gone before that many reacted against them. But this reaction brought new excitement into architecture. The restrictive forces at work had created something new and challenging. And this can clearly be seen in SCDA's Malaysian project, the Heeren Shophouse. Faced with a difficult site and a low budget, the architect has resisted the temptation to follow the norm and has instead reinterpreted the space, creating exquisite architectural jewels within the larger enclosure.

Such a reinterpretation of space is a solution common to many financially restricted projects. Quite simply, we are back to the old quandary, how to get the most for our money? As property prices soar at what seems an exponential rate, architects are going to be asked this same question more and more often.

One solution is to build upward, to make use of the building sites above our heads. British architect Theis & Khan is currently designing an extra living space on top of a five-storey warehouse in London. The owner requires more room; he cannot expand outward and does not want to relocate. The architect has investigated the options and come up with a prefabricated design, complete with grass roof, that can quickly be lifted on to the rooftop and erected in less than two weeks.

This bespoke version is very similar in rationale to Kaufmann Kaufmann's and Studio Aisslinger's mobile units, a cost-effective, easily buildable but at the same time highly innovative solution. This is what the budget does for the architect: it sets ground rules and creates difficulties but it also inspires the imagination and innovation needed to push the profession forward.

Heeren Shophouse

SCDA Architects | Malacca, Malaysia

The shophouse was an extremely common building type in Asia until recently: houses of two or three storeys with long thin plans and a shop situated to the front. When SCDA was approached by a client with just such a derelict site (69 x 6 m; 226 x 20 ft), the practice harnessed both tradition and contemporary design to create a series of boxes or pods within the existing structure.

Renovation work is minimal, as costs prohibited it: party walls are shored up with rectangular C-section steel frames to avoid inward collapse, and dangerous roof members simply removed, opening the property up to the sky. SCDA has inserted four flat-roofed modernist boxes into the space. A wooden sleeping box is suspended on the steel frame above a pool; a masonry meditation box and a service box are at ground level; the living box is suspended high at the entrance. The remainder of the ground floor is given over to a bamboo garden and a 15 m (49 ft) pool.

These simple boxes are exactingly constructed, creating a distinctly different feel from the run-down, ruinous aesthetic of the pre-existing walls. The architect has emphasized the contrasts, leaving evidence of wear and previous occupation – mould, cracked tiles, plaster panels – as references to the building's history.

The existing space and new additions seem to lead the visitor on a magical journey through forests and across lakes looking for the next prize, in this case a box. The extreme contrasts between old and new, natural and man-made are exploited to their full. In so doing, SCDA has designed one of the most subtle and yet creatively outstanding living spaces imaginable on an extremely tight budget.

Above The building's original façade disguises the fact that new works have been completed within. Behind this semi-derelict street aspect SCDA has inserted a series of modernist boxes, positioned according to the property's traditional layout.

Right The long, narrow site, bordered on both sides by similar properties, is stabilized using large steel beams. These stiffen the perimeter walls and provide support for the new raised living quarters. Two beams can be seen towards the front, one full-height at centre, and two more towards the rear.

Opposite A small grassed garden area separates the study at the front of the property (not pictured) from the master bedroom box: this rests on steel beams above the pool. The overhanging flat roof protects the less than watertight box from downpours.

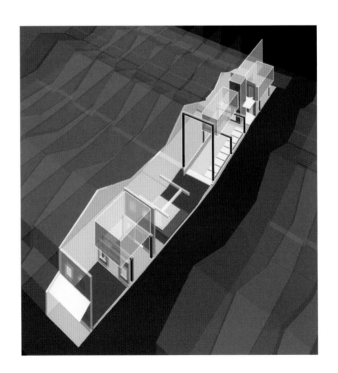

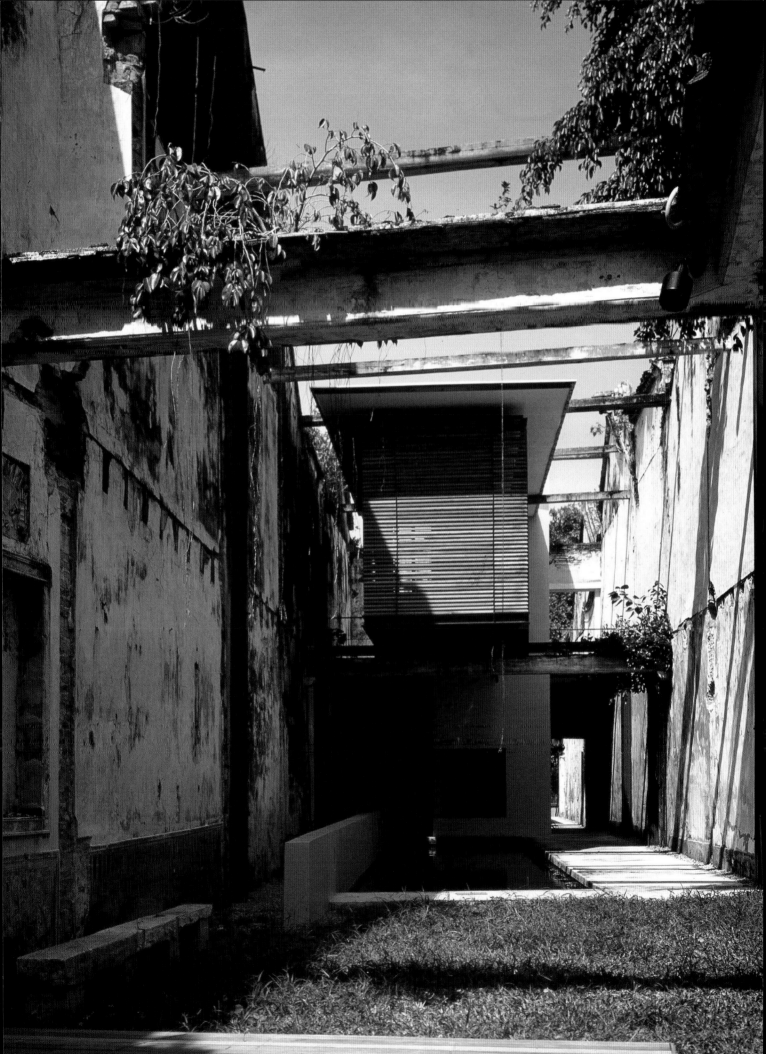

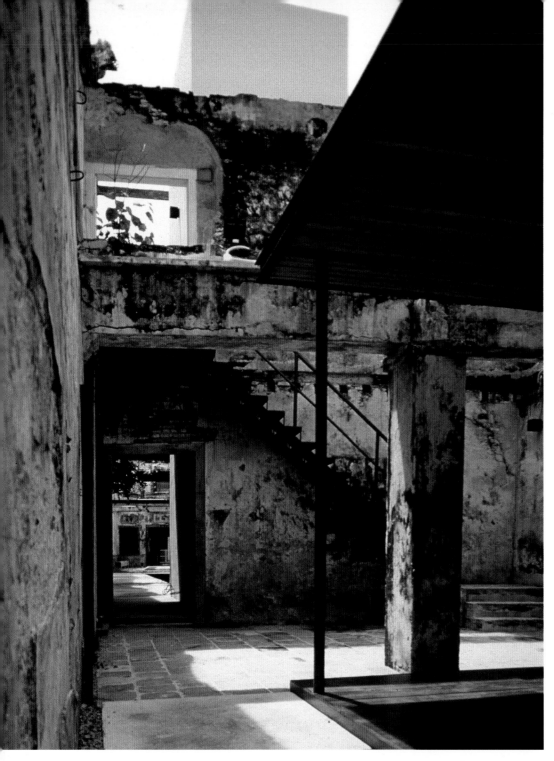

Left The extremely light architectural intervention floats within the remains of the original shophouse walls. A limited palette of concrete, timber, and metal ensures that reminders of the past are not drowned out, while providing an easily readable aesthetic.

Left bottom SCDA's new residence uses separate living boxes to formalize this unusual site. A study and two bedroom units hover at first-floor level (bottom), while kitchen, dining area, and outdoor spaces are at ground level (top).

Opposite top The master bedroom is a box clad in slatted timber. Internally, it features only a wooden sleeping platform. This space, as with all others in the house, is stripped back to its primary function to preserve the property's original atmosphere.

Opposite Below the master sleeping box lies a 15 m (49 ft) long pool, its smooth concrete surround contrasting with the dilapidated walls. Water is believed to bring tranquillity to a space: its position under a sleeping unit is considered and deliberate.

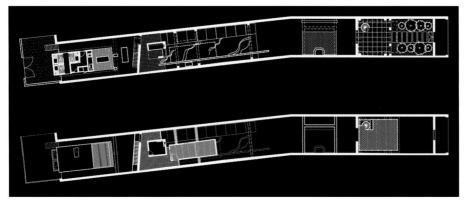

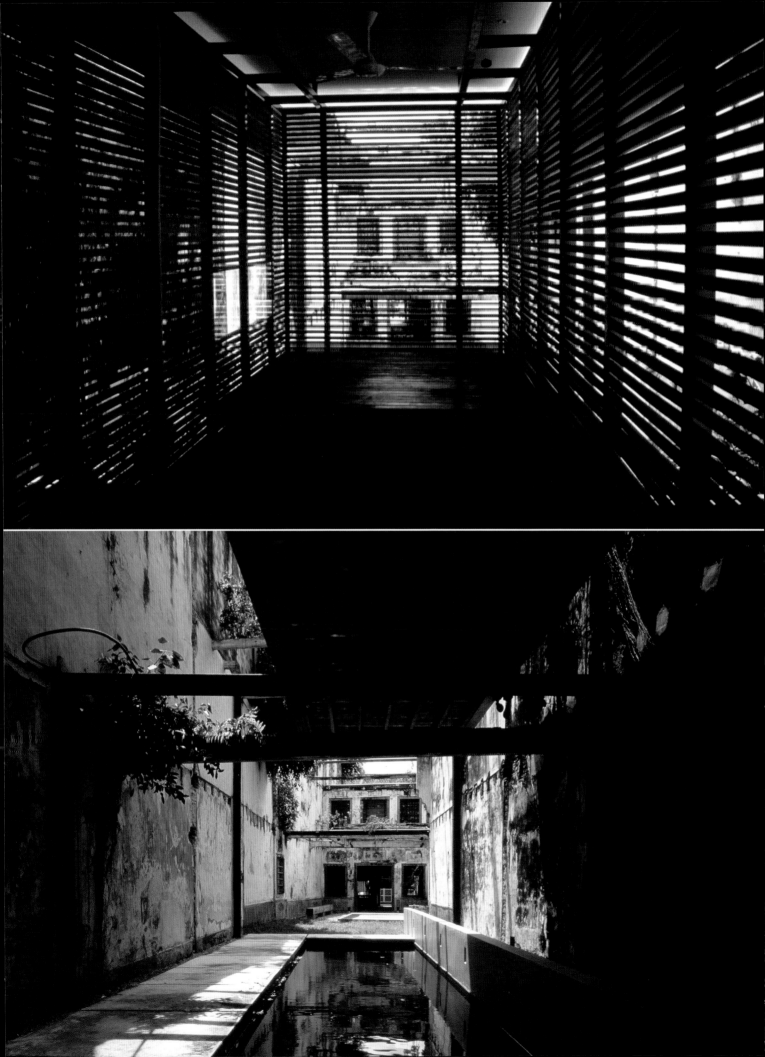

Loftcube

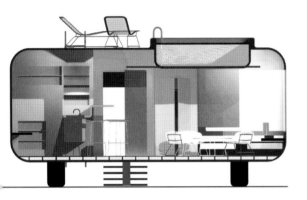

Loftcube is an exploration of new home visions for an increasingly mobile society. Architect Werner Aisslinger realized that by developing a mobile living capsule he could provide city dwellers with valuable private space and exploit prime sites in the heart of the urban environment, namely rooftops.

The "cube," 36 m² (390 sq ft) in area and 3 m (10 ft) high, has wooden-framed outer walls of honeycomb plastic laminate. These are available as individual segments in translucent or closed versions. Louvred windows provide ventilation, acrylic "glass" panels are windows, while fixed and sliding panels provide partitioning of the interior space.

The interior is split up into four areas – living, sleeping, bathroom, and kitchen. The dividing partitions are formed from Corian and feature innovative double-

Above The compact cube has four open-plan yet distinct living areas and a loadbearing roof deck. This view shows the living room and kitchen, more than half of the 36 m² (390 sq ft) internal space. The unit is raised 1.2 m (4 ft) from the ground on adjustable supports.

function elements, including a water tap that is manoeuvrable for use in the kitchen sink and in the bathroom washbasin on the reverse side of the partition.

Loftcube is designed to be demountable, allowing it to be dismantled and reassembled relatively easily. It can also be transported while assembled and Aisslinger even suggests helicopter transportation from roof to roof. Its cost of around £40,000 ($70,000) makes Loftcube affordable as a second house or guest living space, and the architect is currently talking to interested parties about potential rental sites for multiple units on urban rooftops.

Loftcube is available in both living and office formats and, located on a company's rooftop, the unit provides a home from home that is preferable to any hotel.

Below A glowing homestead, sited here on a rooftop above Berlin. Loftcube is an executive crash pad or inexpensive city rental space. All that is required is access to a roof with adequate guardrails at its perimeter and connection to water and power.

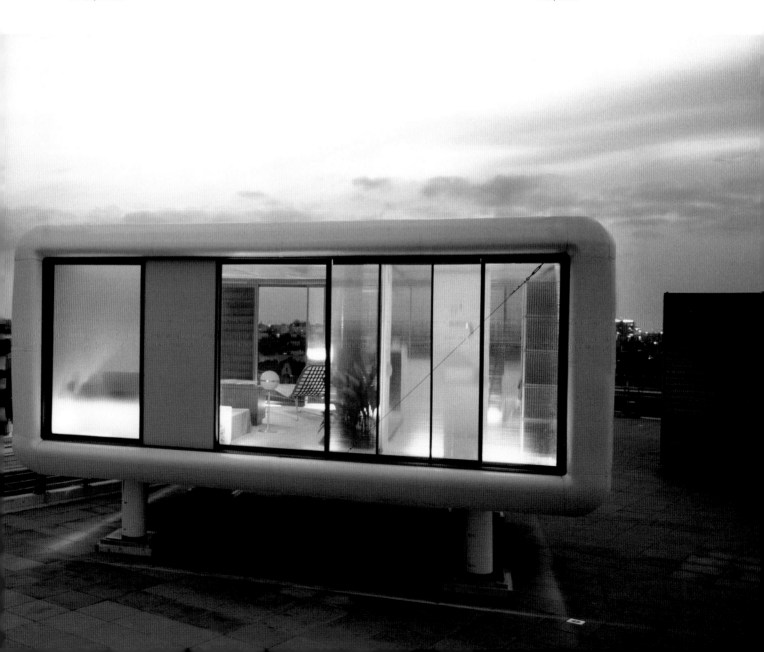

Right The imaginatively designed open-plan shower area. An integral Corian shower-tray and wall includes a manoeuvrable shower head that tilts through 180 degrees for showering and watering the plants on the other side of the wall.

Opposite top Loftcube has a choice of façade elements, according to the buyer's specification: solid plastic sheets; acrylic glass in matt or orange-brown or light-blue tint; and here, louvred windows with wooden slats.

Opposite bottom The interior is surprisingly spacious, its open-plan design offering views out on all sides. In the foreground are the living and sleeping areas, to the rear is the kitchen (left) and the bathroom, with orange shelving unit.

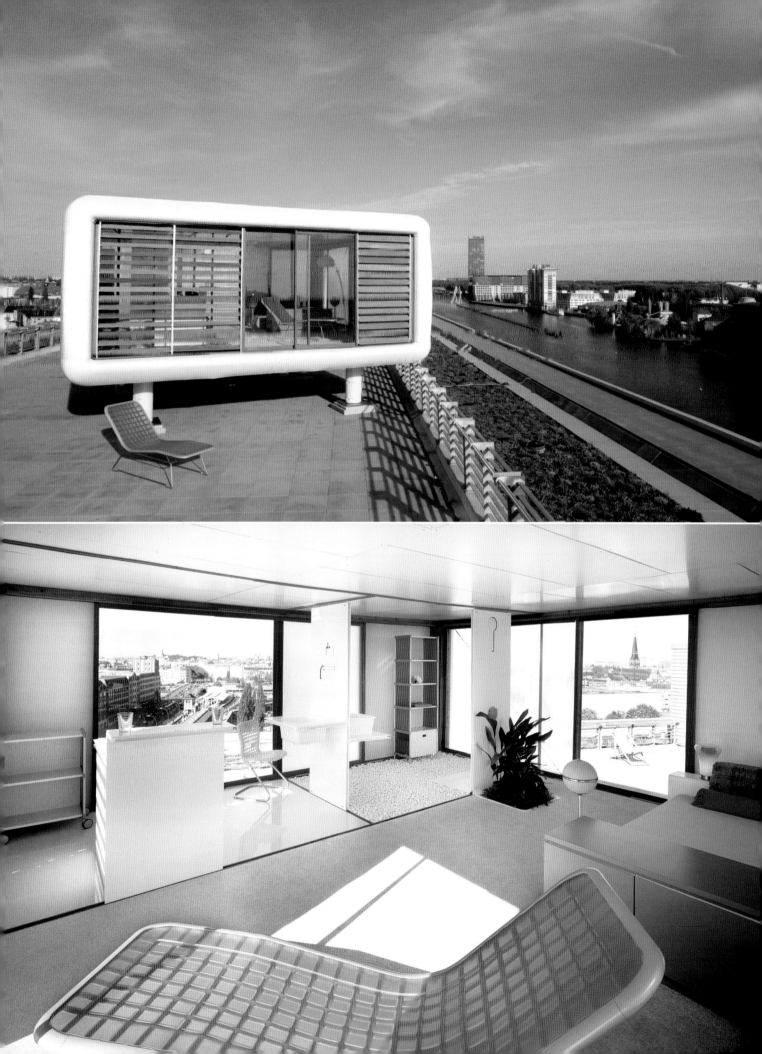

Steve's Retreat

Creating a bolt-hole or retreat within London is not an easy job, but architect Theis & Khan has designed a quirky cabin on top of a four-storey warehouse block that will give its owner, designer Steve Edge, a precious sanctuary in the midst of London's bustle without breaking the bank.

Sitting on a large flat roof, Steve's Retreat is a lesson in the inventive use of materials. The one-storey addition houses a large bedroom with en-suite wet room, and a main living space. Both bedroom and living area have balconies, and translucent glazed walls can be drawn back to allow views through the property.

Internally, a simple white plasterboard ceiling plays foil to walls clad in western red cedar planks and a smokeless woodburning stove. The timber wraps from the interior on to the external façade, creating a log-cabin feel, reducing the material palette and keeping costs down. The roof is to be planted with grass, creating a garden while insulating the cabin. This lawn slides seamlessly down the sloping bedroom wall and offers access to the roof via stepping stones across a pond.

Once on the roof of the apartment, privacy is guaranteed by the introduction of a white cylindrical sun-trap. Inspired by the architecture of Le Corbusier's Villa Savoye, the curved plywood sun-trap is a high-impact, low-cost addition that will rotate to afford the best sun bathing and to deter the prying eyes of London's ever-present overlooking neighbours.

Below This simple plan maximizes the roof space, including both internal and external areas. A bedroom is screened from the main internal space by a stair from below and wet area. The main area can be opened at both ends via folding partitions, while outside the deck includes a pool and al fresco shower.

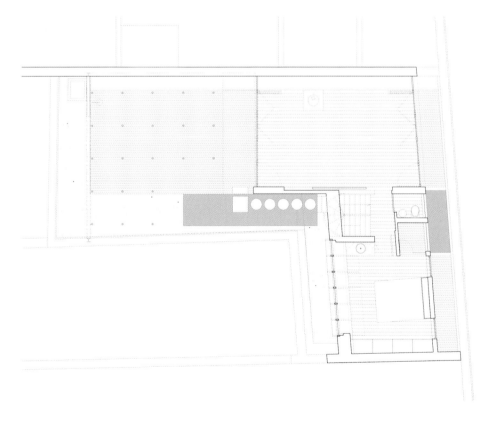

Above This relatively low-cost design is invigorated by interesting architectural thinking. The rectilinear pool has stepping stones that lead to the sloping bedroom wall/access to the grassed roof. Here, a Villa Savoye-inspired sun-trap revolves to catch every last ray.

Left The inspiration for the urban retreat came from an ad hoc cabin that the client already owned. Escape is not always a second home in the countryside.

Rubber House

Simon Conder Associates | Dungeness, Kent, UK

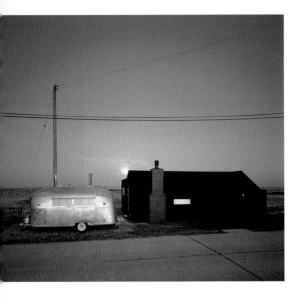

Above Simplicity is the essence of Rubber House. This converted fisherman's hut is a low-cost, high-impact addition to the surreal landscape of Dungeness.

The largest area of shingle in Europe is the site for Simon Conder Associates' black rubber beach house. This vast wasteland in the south-east of England, known as Dungeness Beach, is speckled with ad hoc fishermen's cabins and small cottages, most thrown together over time. And this is how Conder's beach house started life.

The original construction, built as a fisherman's hut in the 1930s, was stripped back to reveal its timber structure, before being extended to the south and east and clad both internally and externally with spruce plywood. The plywood to the interior has been left exposed, creating a warm, natural feel. The architect has clad the exterior in a black synthetic rubber to provide waterproofing.

This rubber coat is reminiscent of the external aesthetic of its ramshackle neighbours, which have been weatherproofed over the years with layer upon layer of tar and asphalt. It is also utilized in the passive heating of the building. In winter, the black covering acts as an effective heat sink, passively warming the house. In summer, the large glazed areas of the property are thrown open to allow a through breeze and so cool the house.

From within, the views of the vast exterior expanse are expertly framed to be interesting rather than overwhelming. Features including a bath cantilevering out over the beach, and the adjacent fisherman's shed that acts as the main entrance, make this a quirky yet livable property.

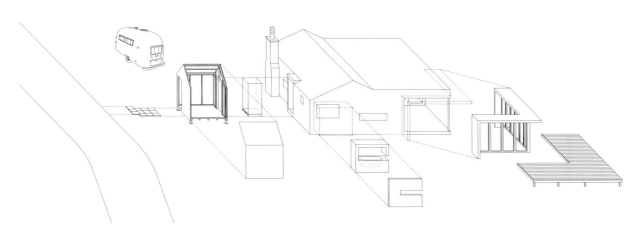

Above This exploded diagram highlights key elements of the building, including part of the original cabin (left), now used as the entrance; and the bath box, a cantilevered addition with corner window, in the foreground.

Opposite top Rubber House is a versatile holiday home where low-cost materials, including rubber and plywood, are put to imaginative use. The property is warmed by heat absorption in winter and cooled via the opening façade in summer.

Opposite left The thoughtful placement of a window creates a framed view of the vast shingle beach and other scattered properties at Dungeness – it also means that you don't have to buy pictures for the walls!

Opposite right The interior is clad in plywood. Lacquer-sealed for protection, this undecorated finish is hard-wearing and cost-effective, while also in tune with the wider setting and aesthetically pleasing to those with minimalist tendencies.

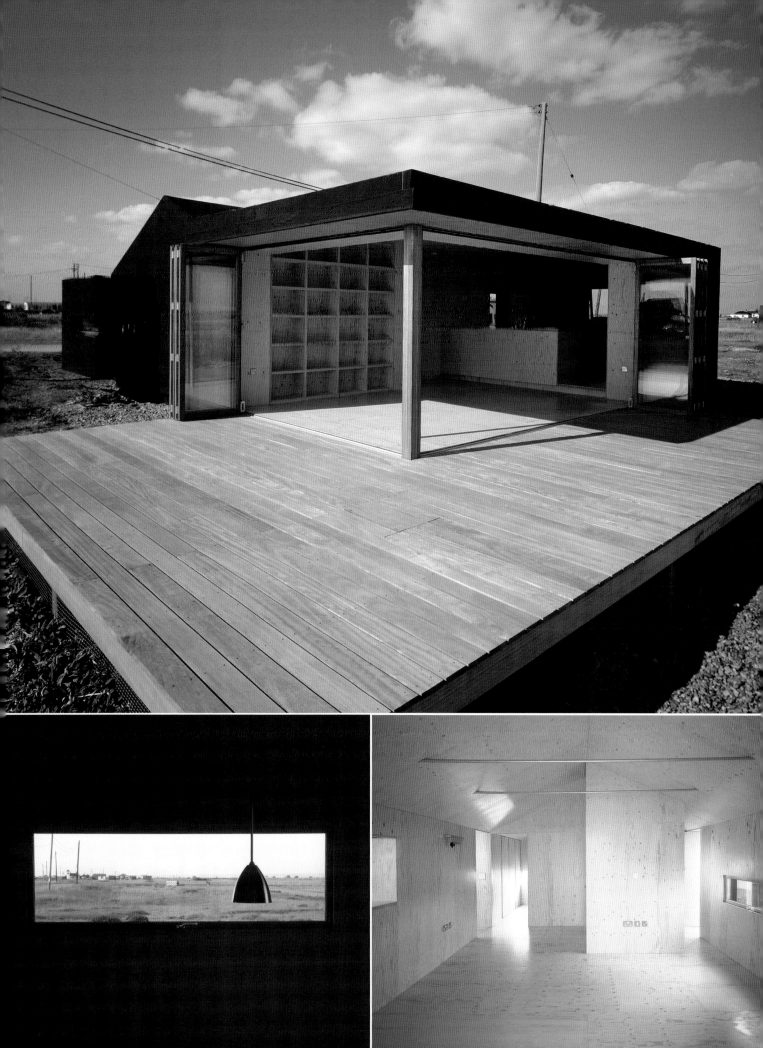

Elemental Housing

This proposal for low-cost housing in Chilean urban slums responds to its function in much the same way that a similar project would in the Netherlands or the United States. However, here the basic requirement is that of adequate shelter and clean sanitation, and so simplicity is of the essence.

Elemental, by Dutch practice ONL, is designed as 11 fluid linear elements that will create diverse neighbourhoods and promote sustainable future growth. Rows of housing units are made up of basic and bridge units. These "building blocks" are based on a structural system of triangulated "mega-beams" that increase the stability of raised "bridge" sections. The steel structure sits on a concrete ground floor, and concrete walls separate dwellings and reduce noise transmission. Partition walls within the units are constructed from sandwiched wooden panels, and façades are of sliding wooden panels of differing colours.

This dense housing solution keeps cars to its periphery. Occupants pass between the rows of dwellings under the elevated living spaces. As with any inner-city development, the population will grow with time, and Elemental is designed to expand with it. All properties are extendable vertically with access via external stairways.

Spaces between the units will be largely semi-public, but the architect recognizes that the inhabitants will be allowed to colonize and personalize their immediate neighbourhood. This is also true of the housing units, which can easily be populated by small businesses such as local stores or workshops.

Right The Elemental solution is ultimately extendable, both horizontally and vertically. The initial scheme (bottom) consists mainly of single-storey dwellings. It can grow uniformly or randomly as new dwellings or extensions are tacked on (middle). Eventually the scheme can double in size, featuring multiple-floor dwellings connected by passageways and bridges (top).

Opposite This modern take on the residential terrace rationalizes accommodation in slum areas. Basic dwellings are easily buildable and create streets, which are linked via open spaces and walkways. Pedestrian-only access encourages ownership and utilization of semi-private spaces within the built area.

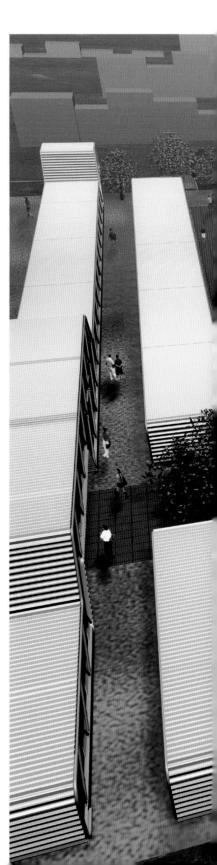

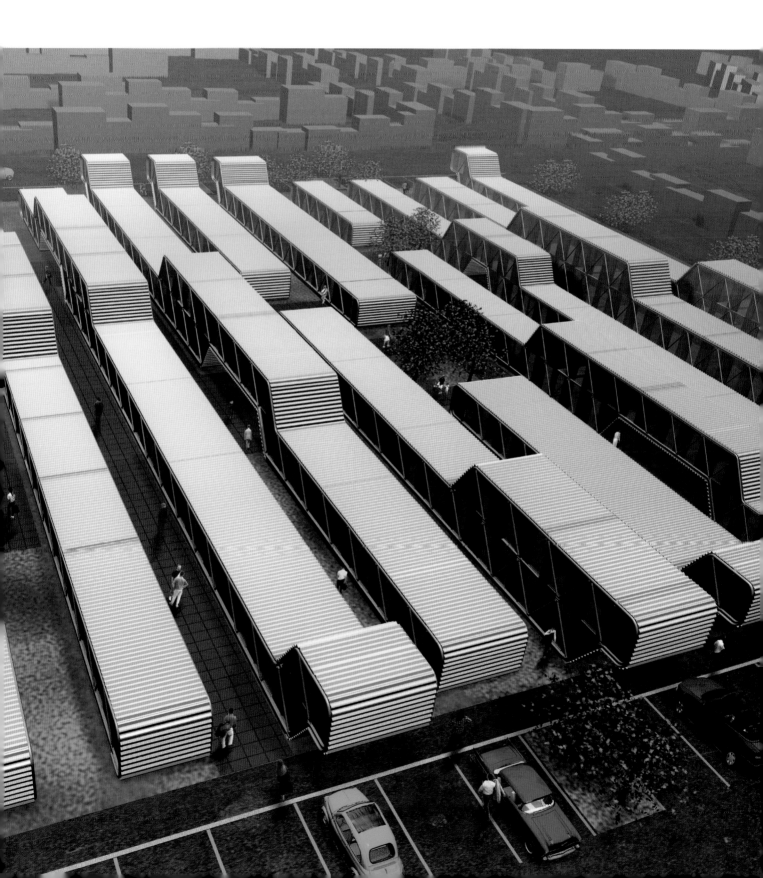

Left top Open spaces within this modular development are intended to promote interaction and a sense of community. These spaces are vitally important to occupants of extremely low-cost housing developments as areas to escape and relax.

Left To the perimeter of the development are car parking areas and commercial activities. Cars are kept out of the areas between the dwellings to promote safety and minimize pollution within the densely populated terraces.

This page Elemental Housing is designed as a kit of parts. Seen here are single- and double-storey living units. Clockwise from top left: double-height family quarters; a single-storey mid-section; an end unit; a double-storey elevated end unit (large image); and an elevated mid-section, used to allow a ground-level walk-through. All elements are constructed from low cost materials including timber and corrugated steel sheet. Diagonal braces stiffen the structure and louvred openings allow ventilation of the interior.

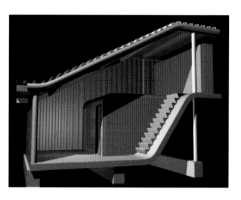
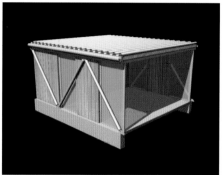
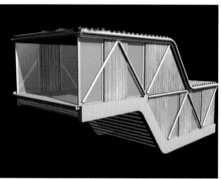
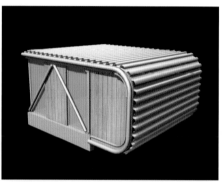
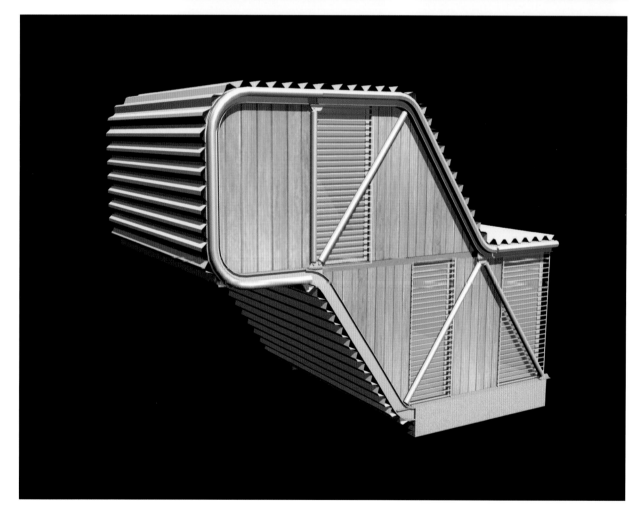

Birds Portchmouth Russum Architects
London, UK

Mike Russum, partner in architectural practice Birds Portchmouth Russum (BPR), is converting a period property in a suburban setting into a new home for himself and his family. A modest budget meant that the architect opted to remodel an existing house, rather than build a new property, in order to create a home that takes full advantage of its environment and natural light.

The design takes the usual ground-floor living/first-floor sleeping convention and turns it upside down. Bedrooms are below street level, opening on to the rear garden. Another bedroom, a study, a reception room, and a shower room make up the ground floor. It is on rising to the first floor that the design comes into its own. The living area is double height and encased in a curvaceous stainless-steel and aluminium-clad skin, not unlike the hull of an upturned boat.

This crowning element of the property is designed to be prefabricated off-site using boat-building techniques, reducing labour costs, and avoiding the wastage associated with conventional construction techniques. It also lessens disturbance to nearby properties and provides a high degree of accuracy in manufacture.

A single space stretching from front to rear contains kitchen, dining, and living areas. From here occupants can climb the stairs to a balcony level overlooking the living area, and out on to a front balcony or round into a "crystalline" conservatory at the rear, a space that is fully glazed to walls and roof.

This model challenges perceptions of how a property should be ordered and built. And in London, where labour and material costs are prohibitive and sunlit relaxation space is at a premium, Russum's design makes perfect sense.

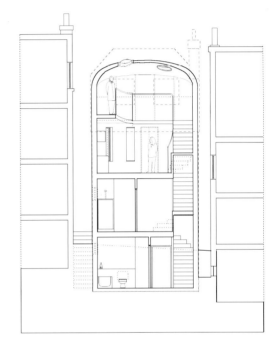

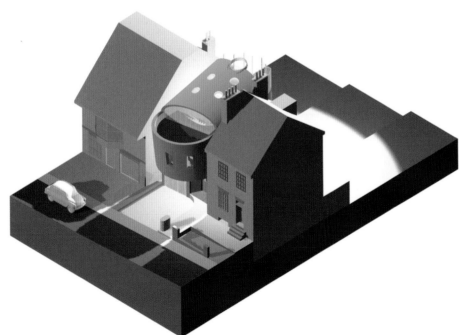

Above This section highlights the house's unconventional layout, which features living areas to the top of the house and a semi-basement-level bathroom. Also marked is the roofline of the original building, showing that the new intervention does not exceed previous height limits.

Left Russum's striking design makes a bold statement in the suburban street. An open balcony overlooks the road, and circular "porthole" skylights allow light to pour into the living spaces.

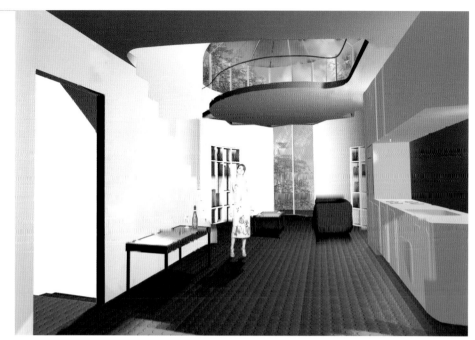

Left At first-floor level an open-plan kitchenette and living area is naturally lit from roof level, thanks to the removal of most of the second floor. The continuation of the glazing from the conservatory on the second floor provides views to the garden.

Below Occupants will climb an open stairway to the second-floor balcony, leading to the conservatory space. Multiple flat panes of glass make up the glazed wall and roof – this is less expensive than the equivalent curved glazing.

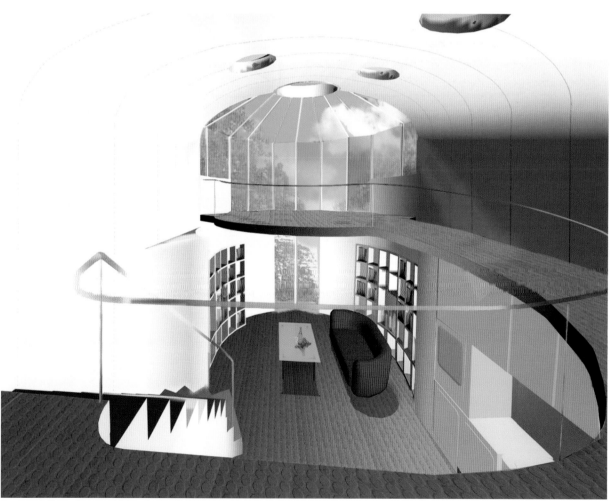

Buckley Gray
Dartmoor, South Devon, UK

Above A covered courtyard area between the two living units is the primary activity space in Buckley Gray's Rural Retreat. The retractable roof is transparent, allowing in light even when the weather does not permit it to be opened. The steel floor deck is raised on the services frame and short legs. This prevents flooding and wet feet in inclement weather.

Right The different elements of the Rural Retreat – living, sleeping, courtyard, bathroom, and storage – are all fixed within a steel frame. This stabilizes the units and also carries electrical and wet services, which are simply plugged into the site supply.

Opposite, top to bottom
The Rural Retreat is sited on a concrete plot (top). It is easily manageable and secure, with space within the services frame for adding extra units (middle). The architect believes that the Retreat will appeal as a design-led alternative to the static caravan, for city-dwellers who want a picturesque weekend bolt-hole on a professionally managed site (bottom).

Buckley Gray's reinvention of the caravan is a response to public demand for a second or "country" property. But house prices in rural areas have escalated, pushing that dream out of many people's grasp. The architect's Rural Retreat takes a caravan as its raw material and reworks it to produce a high-quality solution for those with an adventurous spirit and modern design ideals.

For costs equivalent to that of buying and transporting a standard mobile home, this architecturally designed dwelling boasts two 6 x 3 m (20 x 10 ft) units, spaced apart from each other to form a private courtyard. The units meet all regulations for standard mobile homes. However, they are installed within a steel frame that also serves as a service core, containing power, water, and drainage. The units contain living or sleeping space: one with kitchen and living room; the other with one to four bedrooms and a bathroom. A retractable roof covers and weatherproofs the courtyard. This, along with the floating steel floor deck, also folds up to cover the windows when the retreat is vacant.

Set on an 18 x 6 m (59 x 20 ft) plot around its own private courtyard, each retreat has a degree of privacy that the static caravan cannot offer. This is the key to the success of the design – giving families their own secluded retreat even on a communal site. The project will eventually see 300 retreats set in woodland. Buckley Gray's product has retained the financial advantages of the caravan while creating an adaptable, design-led home from home.

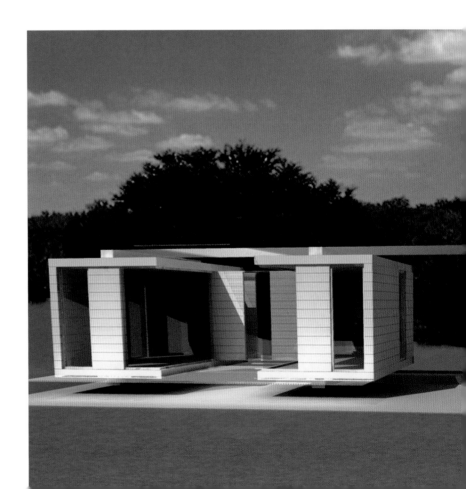

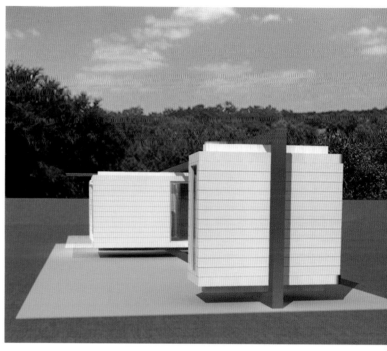

Above A plan view details a two-bedroom Rural Retreat. The left unit houses kitchen and living space; the right features a central bathroom pod and two double bedrooms. This configuration is adaptable, as is the number of units housed within one steel services frame.

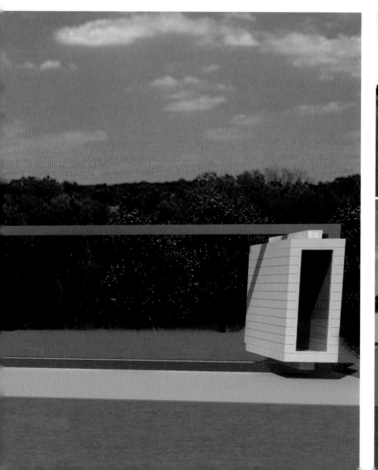

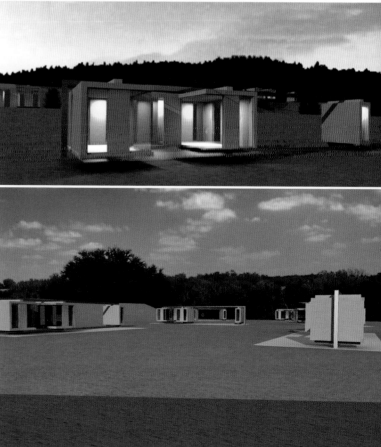

SU-SI

Kaufmann Kaufmann | Non-site specific

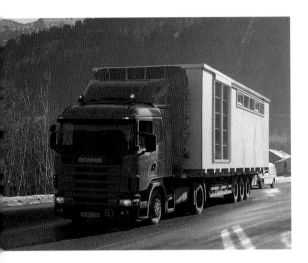

Above SU-SI is in essence a simple low-cost container for living. Delivered on a single lorry, the dwelling can be ready for habitation a matter of hours after it has left the factory where it was manufactured.

Right The interior is simple, open, and at the same time stylish. The structural timberwork of the walls doubles as shelves and the clean plywood interior needs no further decoration.

Opposite This entirely open-plan example of SU-SI is designed as a show space to illustrate the product's versatility. Partitions can be added to create a more conventional dwelling. SU-SI can also be loaded quickly back on to a lorry and transported to a new site.

Winner of numerous European design awards, SU-SI by Kaufmann Kaufmann, is designed as a transportable structural unit. Its designers see it as any building type that you want it to be – a one-person home, extra space for a large family, a studio, an office, or an exhibition space.

SU-SI is supplied on site completely finished to the client's specifications. It is delivered on a crane lorry and positioned on stacked wooden supports or a concrete base. If connections to electricity and water supplies and sewage disposal are prepared, the on-site installation takes only five hours.

This lightning-speed installation is as near to a conventional mobile home or static caravan as SU-SI gets. Architecturally and aesthetically the design is less caravan, more designer apartment. Insulation and energy requirements meet and surpass current German construction standards. However, style has not been forfeited: one side of the 12.5 m (41 ft) long unit is fully glazed. Occupants appreciate this influx of natural light through a structural timber framework that also acts as a shelving system. The interior is clean, spacious, and easily adaptable to whatever use the unit is put.

The architect believes that while SU-SI can be a residential property, it is the requirement for flexible working that will make it a success. To that end, affordable transportation, location, and relocation of SU-SI has been the driving factor behind the design – being able to move to a new construction or exhibition site as quickly as possible without packing up an entire office and without losing your familiar surroundings: this is the maxim.

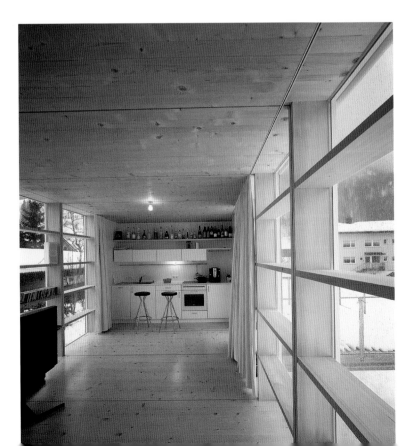

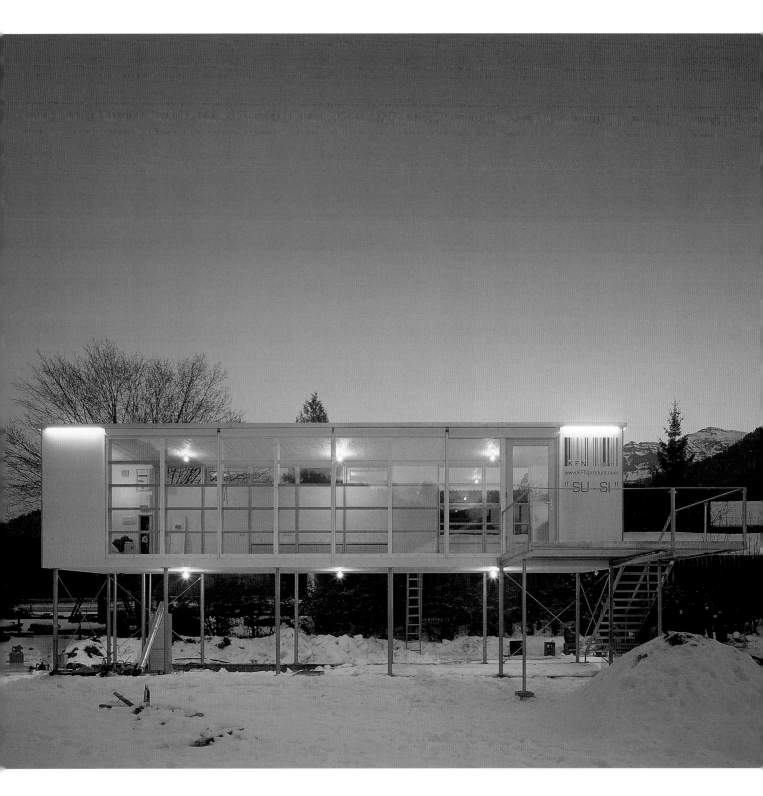

AESTHETICS

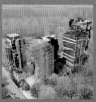
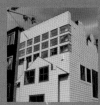

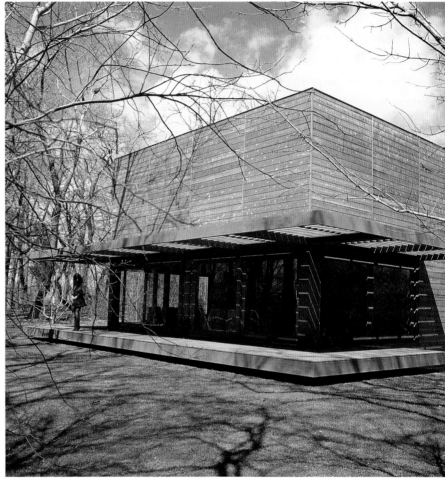

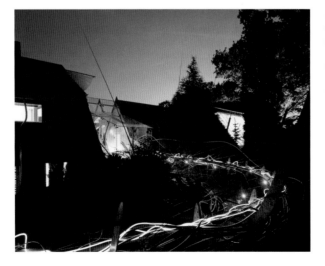

Above left Avant-Garde
residential complex, Moscow,
Russia (pp. 148–149)
Above Piano House, The
Hamptons, USA (pp. 144–147)
Left Butterfly House, Surrey,
UK (pp. 138–143)

When the influential American architect Louis Sullivan (1856–1924) said that "form follows function", was he stating a fact about his work, or hiding behind words? Because if architecture is examined purely for its aesthetic value then it can be considered an art form. But in allowing the discipline to be labelled in this way, the architect must consider the weighty burden that accompanies such a statement.

The creation of a building can be attributed to multiple reasons or "functions" – the provision of a protected environment, the creation of a vessel in which to house one's possessions. However, when the architecture is thrust into the realms of art, this pragmatic reasoning is stripped away, leaving nothing to consider other than the aesthetic quality. Also, art is more often than not neatly packaged in a gallery, displayed at its best to art lovers while boxed up away from detractors. Architecture is not afforded this privilege. It must be robust enough to weather opinion and criticism from both those who want to see it and the majority who quite simply have to live with it every day.

This section of the book will investigate architecture that prioritizes aesthetics. While every project reviewed considers function and treats it with great importance, in the end it is the look of the building that the architect is using to make a statement: after all, sight is the most dominant of human senses.

Two American architects have created radically different properties for essentially the same ends. While Rafael Viñoly's Piano House is a private recital space and the DoMa Gallery by W Architecture is an annexe to display visual artworks, both are designed to be spaces that are visually perfect for the function that takes place within them. The aesthetic considerations in each design highlight and add to the functional properties of the building.

Conversely, such projects as those of the UK's Alsop Architects and FAT use the visual dominance of the human senses to scream a message, to make a statement. While some would claim that Will Alsop's fascination with primary colours and simple shapes is an extension and consequence of his artistic leanings, the architect will trumpet his designs as a bold new architecture that is released from the shackles of history and allowed to grow in the now. Blue House by FAT is instead a battle cry against what designer Sean Griffiths sees as the monotony and blandness of today's architecture. He yearns for design to return to the days of Post-Modernism or even historic styles such as Gothic, when buildings were celebrated with a riot of artistic expression.

The need to add artistic touches to architecture was largely stamped out by the Modern Movement. Visionaries including Mies van der Rohe and Walter Gropius, founder of the Bauhaus School, preached a stripped-down, pared-back aesthetic that represented a uniformity, an architectural communism. While a progression of this style is still very much evident in today's architecture, designers are now bombarded by and take inspiration from a wealth of artistic sources. Erick van Egeraat's Avant-Garde residential complex, currently being built in Moscow, makes direct reference to particular avant-garde paintings, while Thistle Star, by Hays Associates, pays homage to the Arts and Crafts Movement with exquisitely worked designs and an abundance of the owner's eclectic taste in artworks. It is instantly evident that both projects lean heavily on their respective sources of inspiration and, while the latter literally returns to a "better time", the Moscow scheme is a lesson in realizing the aesthetic qualities of a two-dimensional image in three dimensions.

Inspiration can come in many forms, and the way in which it evolves into the built form is a personal journey. Designing a house lends itself perfectly to such an intimate ideal, and when someone wants to unleash their inner feelings almost anything can be created. This is how Laurie Chetwood sees the creation of his Butterfly House. Designed instinctively rather than pragmatically, the property is a wondrous ode to the aesthetic beauty of the butterfly: colours, shapes, movements, and proportions are all in tune with Chetwood's vision of the insect and its life. This truly is architecture for the sake of aesthetics.

While most architects will contentedly form an orderly queue behind Louis Sullivan and his "form follows function" smokescreen, some really do strive to create buildings that have beauty as an aim in itself. But beware: the longevity and the public nature of architecture make it a monumental undertaking as an art form, one that Frank Lloyd Wright understood well and brilliantly understated: "A doctor can bury his mistakes but an architect can only advise his clients to plant vines."

Butterfly House

Chetwood Associates | Godalming, Surrey, UK

Laurie Chetwood sees his architecture as striving to create a sixth sense, a new feeling that encapsulates a building's function while transforming one's perception of it. His startling creation, the Butterfly House, is a riot of unlikely shapes, materials, and textures that play upon and are inspired by the life cycle of the butterfly.

The original property, a converted cedar-clad kit house from the 1930s, sits squarely at the centre of Chetwood's winged architectural narration. Entry into the Butterfly House is via a steel bridge with a curved balustrade that evokes images of the segmented body of a caterpillar.

Once inside the property visitors enter the pupal, or chrysalis, stage of the journey. Here Chetwood uses layering, colour, and intertwining threads – fibre-optic cable, roach fishing pole sections, glass, and shards of Perspex – to envelop and cocoon the occupant: chairs are suspended by "silken" threads, winged tables flap and rise to the ceiling, and gossamer-thin shades sway in the windows.

The crowning glory of the Butterfly House is the transformation from cocoon to butterfly. This is represented by "wings" that unfurl over the conservatory. Two large multilayered coloured canopies open, spreading wide over bespoke stainless-steel frames.

More fibre optics, irrigation pipes, and decorative cable- and metalwork create a sculptural barrier in front of the lower grassed area and act as a frame for flowering creepers and other plant species to populate.

The project encapsulates the life of the butterfly. Chetwood claims to have created instinctively rather than intellectually, and the resulting home for himself and his young family is a triumph of playful artistic exuberance.

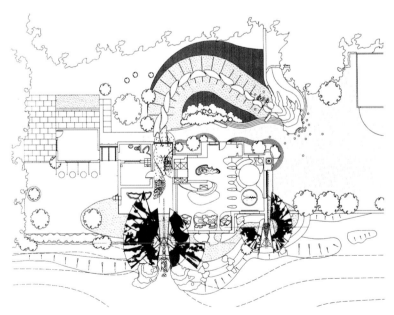

Left Seen in plan, the original property is the central rectangular element, with a small studio space to the left. Chetwood's intervention swoops around it, the caterpillar-inspired element to the top of the image and butterfly to the bottom.

Opposite Internally, the house is a treasure trove of the unexpected. Cables, wires, fibre optics, and even fishing poles evoke the silken threads of a chrysalis, cocooning occupants within. This is a transition between architecture and sculpture.

Overleaf The full extent of Chetwood's artistry is expressed with this exquisitely detailed montage. Caterpillar and butterfly merge with elements of the house, including the ribbed entrance walkway and steeply pitched roof.

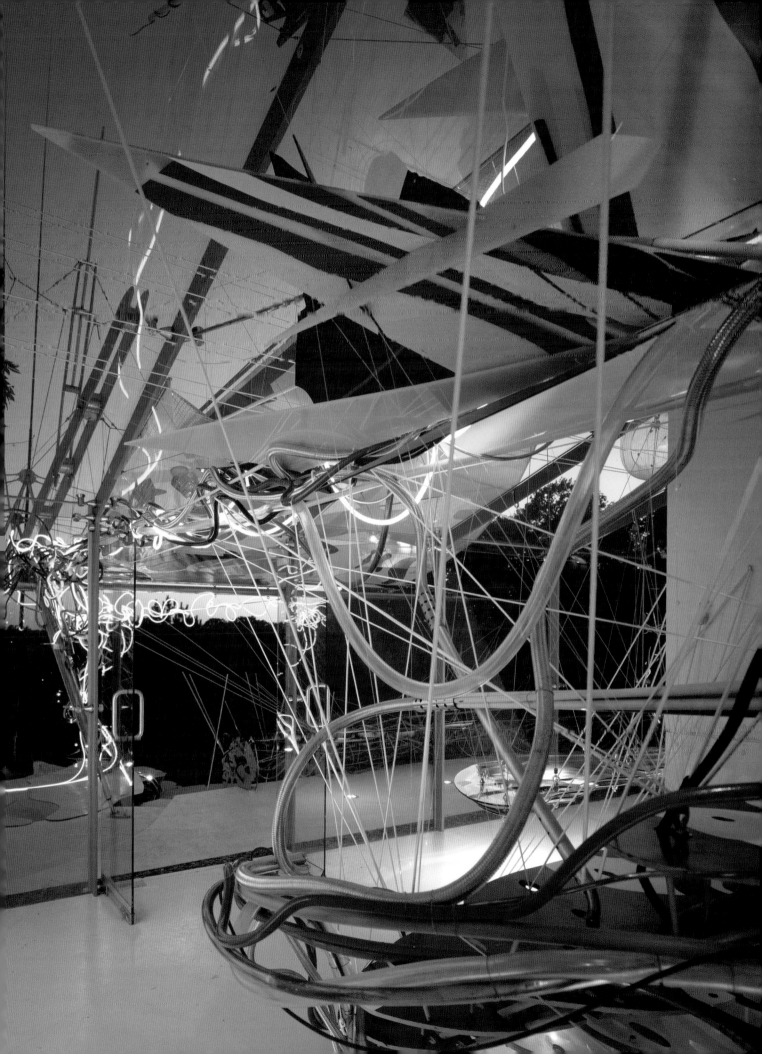

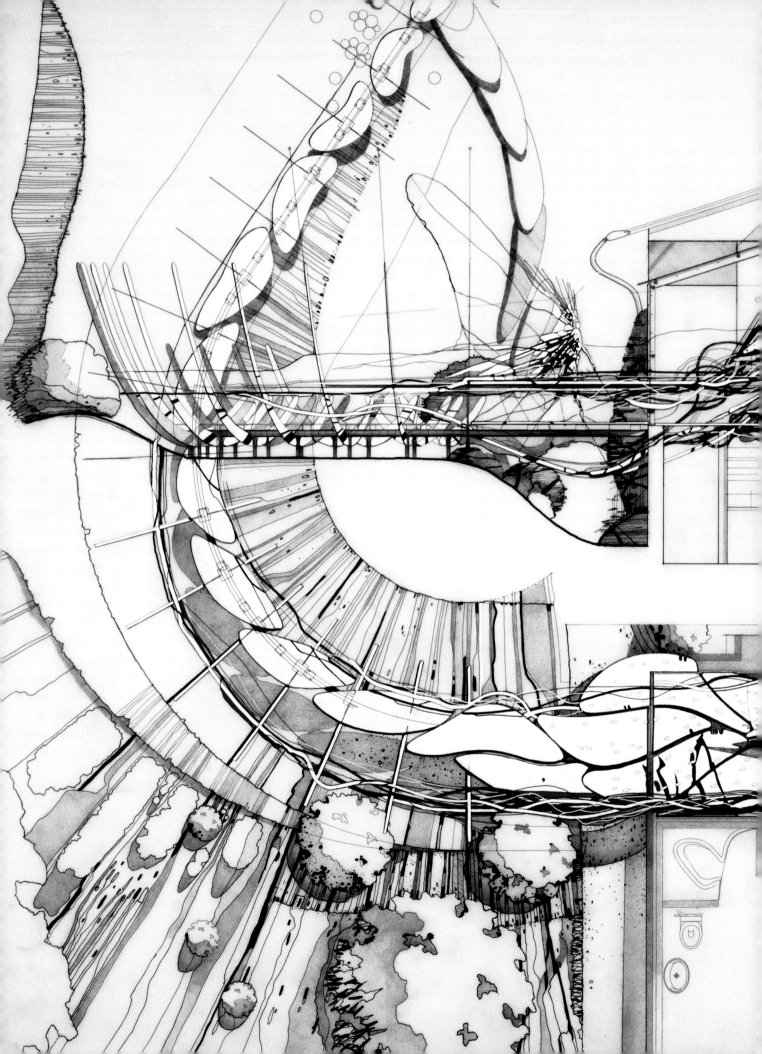

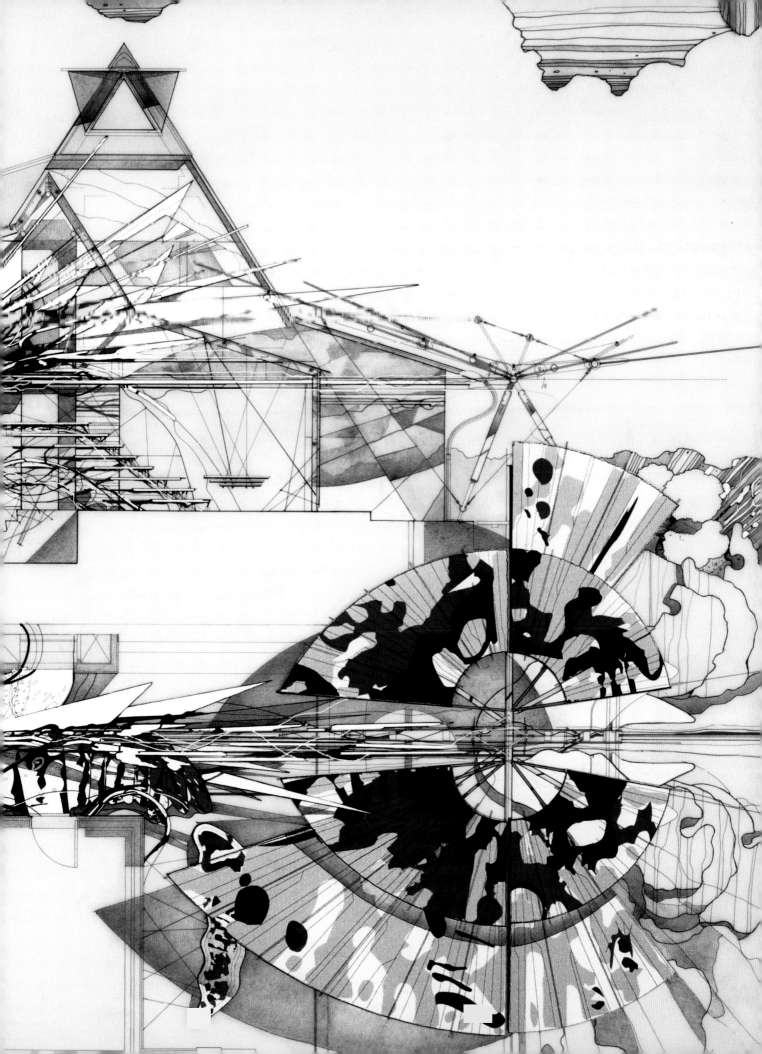

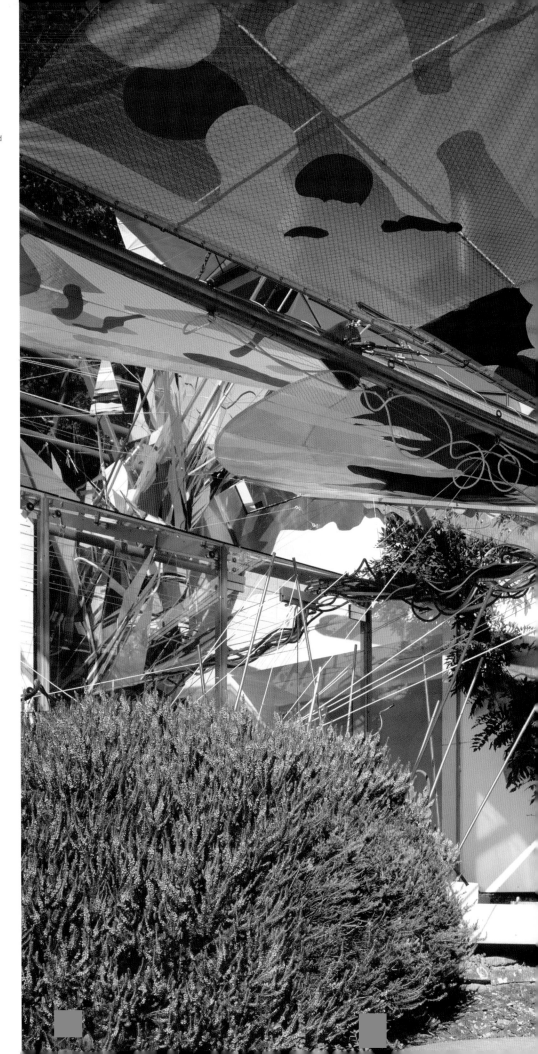

Right The butterfly unfurls over the south-facing garden terrace. A stainless-steel frame supports multi-layered wings which open and retract using technology borrowed from the world of yachting. All around are flowering plants favoured by the garden's real butterfly residents.

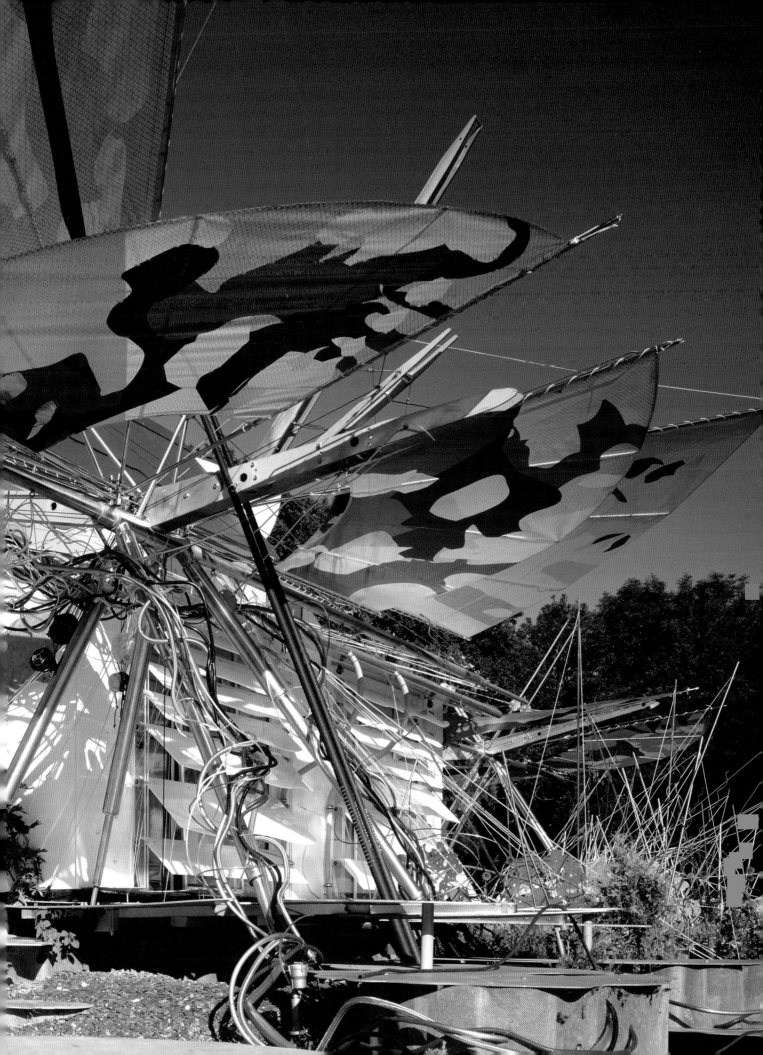

Piano House

Rafael Viñoly Architects | The Hamptons, New York, USA

The ultimate in indulgence, an architectural folly: this is what Rafael Viñoly has created in his back garden. Piano House is a custom-designed piano recital room together with guest apartment. Viñoly, Uruguayan by birth, was raised on a diet of classical music and played the piano to a professional standard.

The main internal space within Piano House is a stepped 25-seat auditorium. A mezzanine or study is accessible via a concealed staircase. In the basement, a guest apartment includes a bedroom and bathroom, with a window on the elevation not cut into the earth. Externally, a large *brise soleil*, or ribbed soffit, cantilevers out precariously over a cedar deck, providing shade to the interior.

The cube-shaped building has a steel-frame structure, clad externally in cedar, while maple is used on the interior. Great attention has been paid to acoustics, the sloping roof planes and soft internal fittings both contributing to creating the best possible musical experience. Yet while the average practice room or recording studio is an inward-facing box filled with technical wizardry, Piano House warrants recognition for its architectural integrity as well as its acoustic performance.

Viñoly, inspired by his own artistic fervour, has been clinical yet expressive in creating the building's form. The simple box-like structure sits serenely in the grounds of his American home, blending with the colours of the seasons. Piano House is defined by its simplicity. This is what Viñoly wanted: an almost meditative space in which to practise his art and to relax.

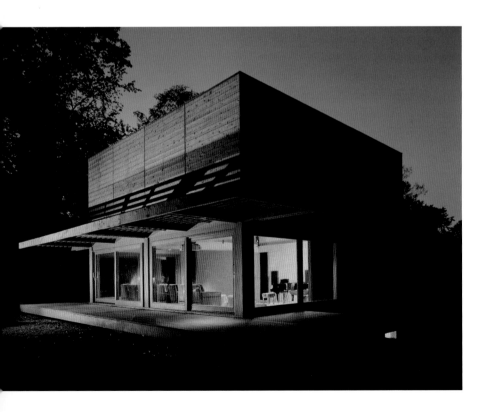

Left Externally illuminated at night, the cedar cladding of Piano House glows golden against the dark sky. The wide veranda of this lesson in aesthetics makes the building seem to float slightly above the earth.

Opposite top The sloping site on which Piano House is set has allowed Viñoly to include a guest apartment in the basement. The compact quarters are tucked away directly under the recital stage. They are secret, offering no hint of their existence other than the window at lower ground level.

Opposite The property is large and bulky but it sits within the landscape with a surprising lightness. The weathered cedar cladding blends with the natural surroundings, disguising the building's presence.

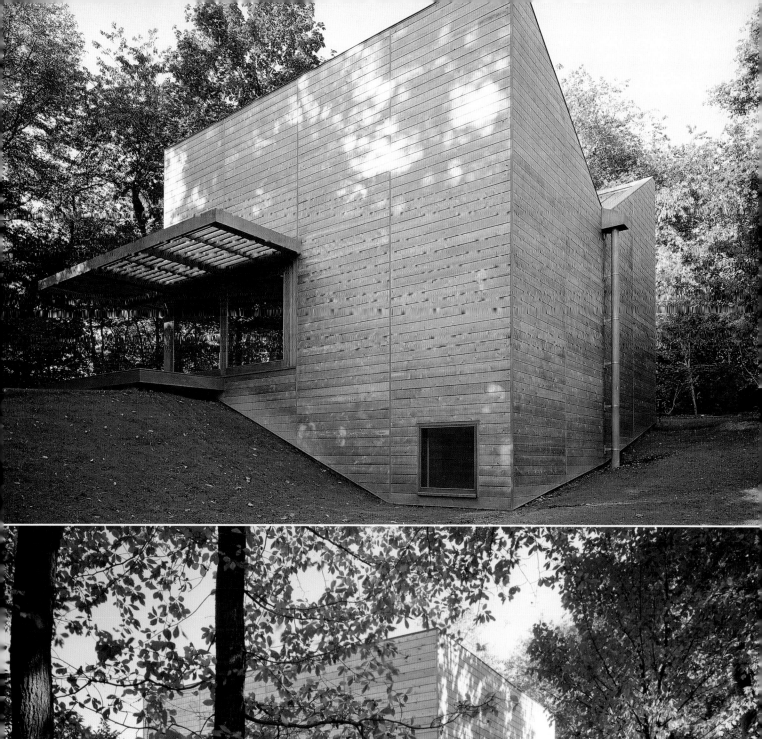
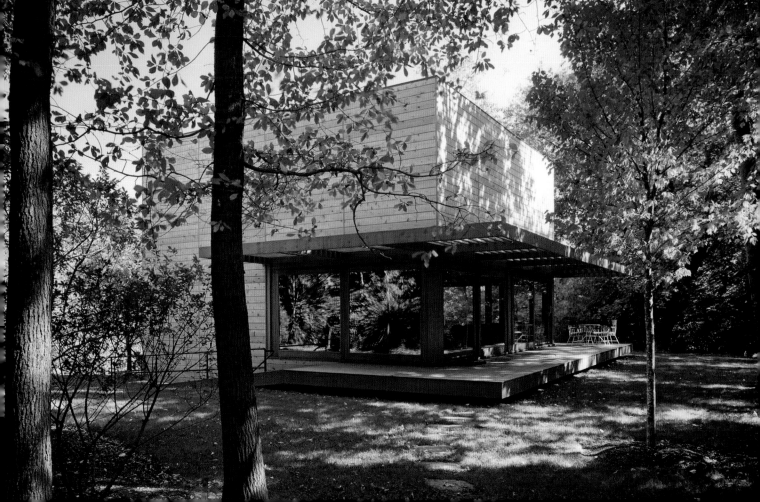

Below A section through the
property details the slope of the
roof, designed to achieve optimum
acoustics. It also shows the
basement guest apartment below
the stage and seated areas of
the auditorium.

Bottom Four elevations display
the varying gradient of the site
from the building's front (at left) to
rear (right middle). The apartment
window is shown at low level on the
side elevation.

Opposite The floating veranda
and massive brise soleil are a grand
architectural statement on this
otherwise plain timber box. The
slatted awning is both a decorative
element and a functional aspect
of the design.

Opposite bottom The exquisitely
simple detailing of the auditorium is
subordinate to the luscious black
piano. Thin maple boards are
lacquered to a high sheen and the
ceiling shape seems to accentuate
the volume of the space.

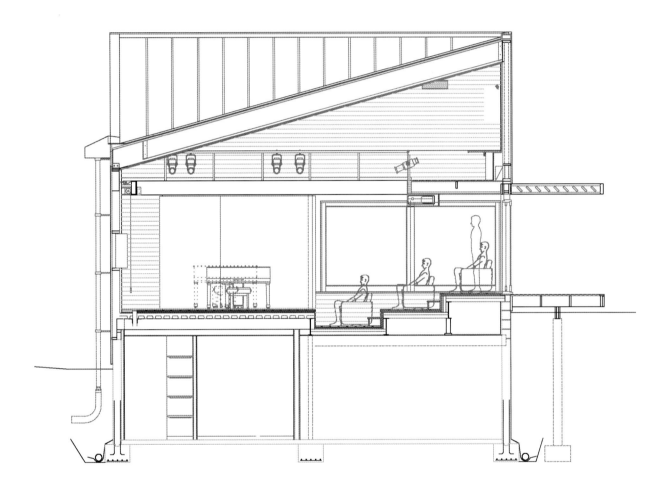

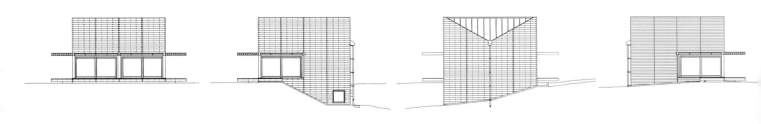

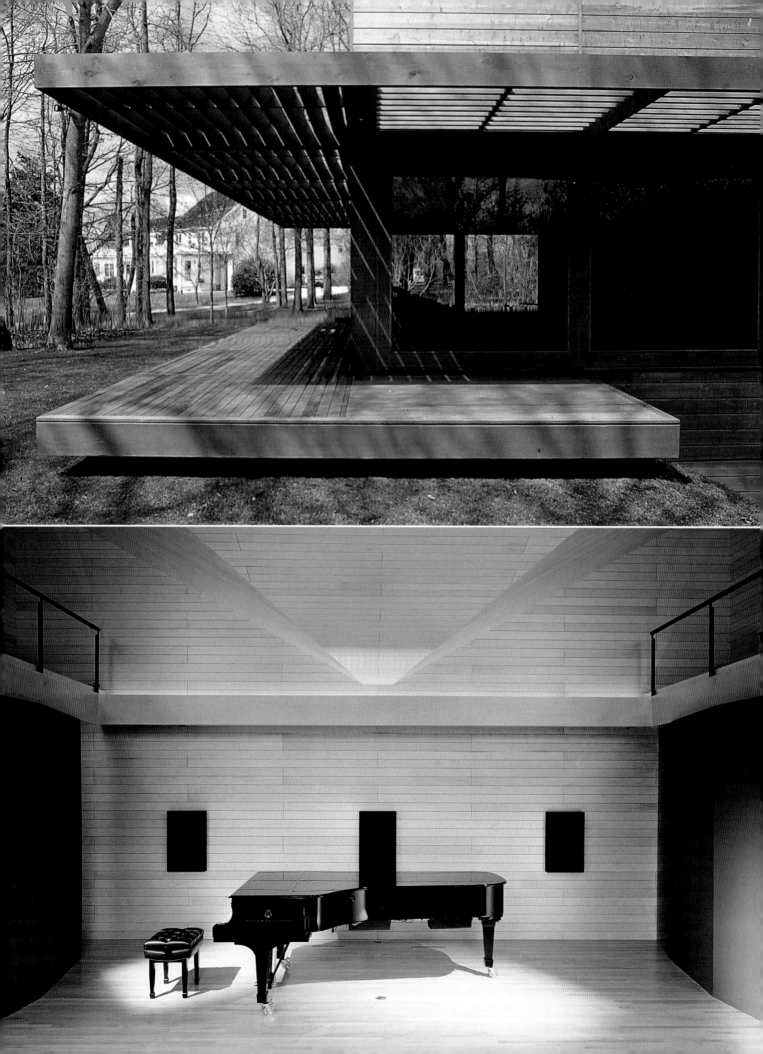

(EEA) Erick van Egeraat associated architects
Moscow, Russia

The new Avant-Garde residential complex currently being designed in Moscow by (EEA) Erick van Egeraat associated architects consists of five residential blocks. The design was started in 2001, and the estimated date for completion is 2007. But these are not the concrete monoliths typical of much of the city's housing; each is themed on a painting by an artist from Russia's avant-garde period.

EEA conducted extensive studies to understand the intrinsic compositional structure of each selected painting and to discover an appropriate architectural interpretation. The design for the Rodchenko Tower is based on Alexander Rodchenko's *Linear Construction* (1919). A layering of continuous glass skins hints at the fluidity of space of the artist's paintings and his ability to find accidental and non-orthogonal manifestations in a chaotic world.

Inspired by Kazimir Malevich's *White on White* (1918), EEA has designed the Malevich Tower with intricate detailing and subtle variations, graduations between solid and transparent, heavy and light materials, the whole conveying the artist's fascination with beauty in the smallest of things.

The Popova Tower – Luibov Popova, *Painterly Architectonic with Three Stripes* (1916) – conveys the ambiguity between space and depth, creating a three-dimensional form from two-dimensional objects. This method is similarly used on the Kandinsky Tower, based on Wassily Kandinsky's *Yellow-Red-Blue* (1925). The spatial depth of the painting leads to an architecture that uses several layers. Finally, Alexandra Exter's *Sketch for Costume of Salome* (1921) informs the design for the Exter Tower. The diverging pleats in the façade and the distorted mass of the building translate directly from the folds and pleats of the artwork.

Right Interiors of all of the towers – here, the Kandinsky tower – are clean and modern, a neutral aesthetic that contrasts with the richly textured exteriors of the Avant-Garde development.

Above Illustrations show the five towers, each distinct and connected to a work by the Russian avant-garde artist after whom it is named. From left: Exter Tower, Kandinsky Tower, Malevich Tower, Popova Tower, and Rodchenko Tower.

Right The five towers stand close together in a massive residential development. Their harmonious design is a huge departure from conventional Russian mass housing.

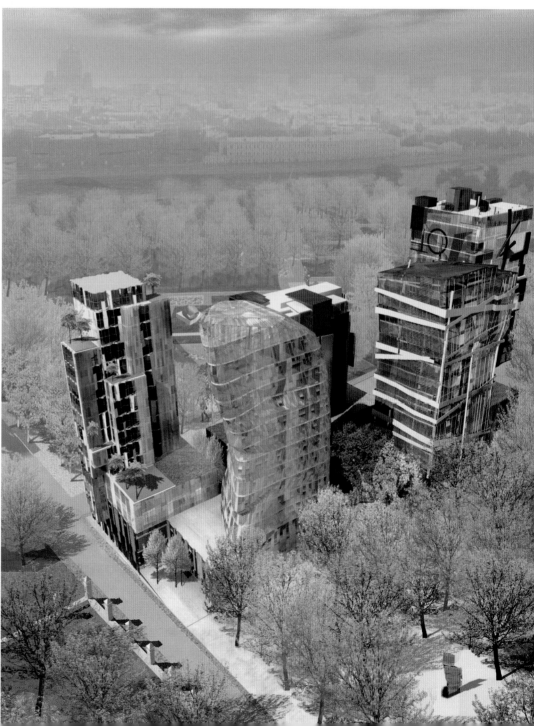

Blue House

FAT London, UK

Above Blue House is relatively conventional internally. The open-plan ground floor features a lounge area (top) with views through to the kitchen and dining space. This opens out on to a courtyard. The hatched area (bottom left) is an external porch space for the front door.

It has been called cartoonish. Its designer and owner dubs it "Adolf Loos meets South Park". Blue House, by Sean Griffiths, principal at London practice FAT (Fashion Architecture Taste), is a clarion call for the Post-Modern revival that he predicts will soon happen.

FAT is not your usual architectural practice and its members tend not to tread the conventional line. So when Griffiths decided to build a house/studio for himself, he reacted against what he calls the "abstraction of so-called serious architecture." The exterior of Blue House is clad in powder-blue cementicious boarding, giving it an American clapboard feel. However, that is where similarities end and post-Post-Modernism takes over.

A rudimentary "house outline" projects from the front of the main façade at street level, while above it 18 tiny windows line up in office-block style – both elements hint at what lies within. The garden fence features a cut-out powder-puff cloud, and other primary shapes adorn the main façade.

However, what on the exterior is a bold architectural statement becomes a functional home and workspace internally. The property comprises a family home, a work studio with separate entrance, and a self-contained studio flat. The interior is playfully conventional, but it does not bow to the aesthetic as the exterior does. Adequately sized rooms are sensibly arranged and decorated. There is just a hint of the humour that is lavished on the exterior in pink-painted steps to a child's bed and hearts carved out of the wooden landing balustrade.

Blue House forces a smile even from the hardest of heart. But it is also a dynamic response to the architectural norm that not many houses can boast.

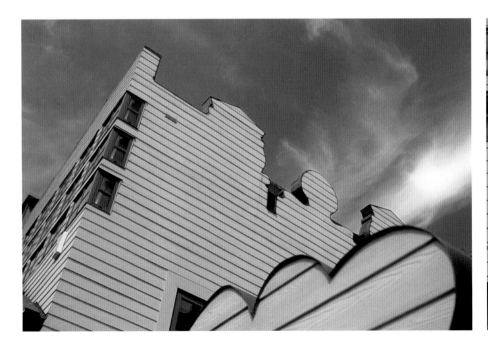

Right Externally, the architect has thrown away the rulebook of contemporary architecture. The playful façade implies the dual purpose of the spaces within. A twee cut-out of a home indicates the residential aspect, while rows of windows allude to the architect's partner's home-run business.

Below A detail of the "house" element illustrates the almost cartoon-like distortion of proportions in the architect's quest to get the message across.

Opposite bottom Post-Modern decoration adorns the roofline. This is owner and designer Sean Griffiths rebelling against what he sees as the boring Modernists who have hijacked architecture and stripped away its artistic, decorative side.

Right Colour is an important part of all of the work of FAT. Here Griffiths uses contrast to great effect in the first-floor landing area. Red walls could be intrusive and garish but instead they are an interesting foil to the turquoise and mustard.

Below right Light streams into the master bedroom through the rows of "office" windows. Although they seem to allude to a work area, the studio is actually located lower in the building – another of Griffiths' clever juxtapositions.

Opposite Looking through the ground floor from the living space, deep turquoise surrounds frame the view of the dining area with the mezzanine and its heart motif balustrade beyond. Nothing is designed without a smile in Blue House.

Pixel House

Beige Design | San Francisco, USA

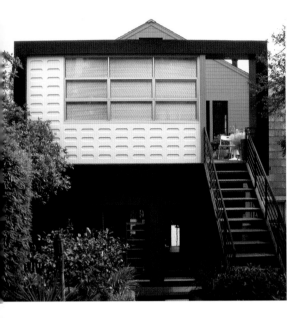

Located in San Francisco, in the heart of the Internet and multimedia industries, is the Pixel House, by Beige Design. The project is a two-storey addition and intrusion through an existing house to create a graphic design studio, new bedrooms, and a kitchen area. The clients wanted to break away radically from tradition for the new addition and create something that echoed their interest in multimedia and the world of digital technology.

The structural catalyst for the project's design is the box window frame at the front of the property. This is extruded through to the rear of the house, where it emerges and grows to form the architectural "dialogue" from which the second-floor rear elevation is composed. On to this frame, architect Thom Faulders has translated the single dots, blips, zeros, and ones that form digital language into a cohesive architectural expression. The building façade features a solid MDF panel with pill-shaped openings through which natural and artificial light can penetrate. This is of primary importance to the design: the outline of a visitor standing outside is seen and yet it is disembodied into a series of individual points of shadow – it becomes pixellated. This is similarly true of the "wider picture": throughout the day, as light levels and colours change, so the panel pixels alter and the façade subtly changes.

This aesthetic is carried through to interior doors and screens, too, creating a distinct barrier or frontier from the original property to its 21st-century addition. Faulders's architectural addition upholds the traditional ornamentation of buildings in the San Francisco area and takes it forward into the new millennium.

Above The pixel façade is on the rear of the house, but this becomes a second front, as it is the only entrance to the new third-floor live/work space. Visitors find the entrance by walking under the house through a yellow tube.

Right Pixellated design is evident throughout the property. This attention to detailing is what transforms a quirky aesthetic into the all-embracing fascination with the computer age that its occupants display.

Right Ornamentation is an important legacy of San Francisco's traditional architecture. Simple yet effective, the pill design produces tactile façade detailing, described by the architect, Thom Faulders, as a dot-matrix of information.

Below Seen in close-up, this pixel panel shows its real qualities. The solid MDF façade is cut through to reveal a translucent fibre layer. Light penetrates through this, producing varying effects inside and out as daylight or artificial illumination glows through it.

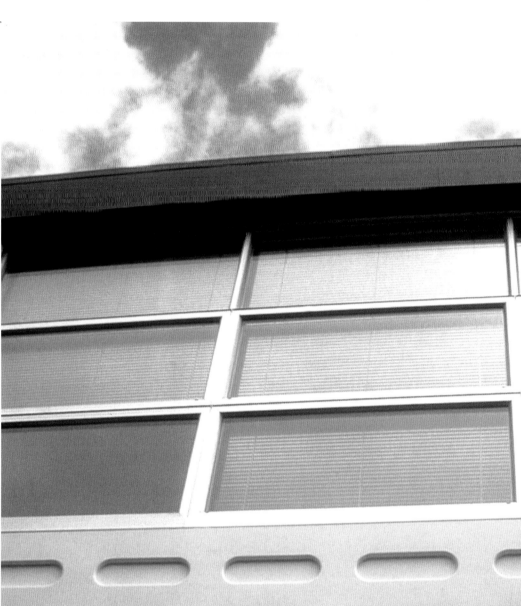

Thistle Star

Hays Associates | Santa Fe, USA

From the exterior, Thistle Star, by Hays Associates, has an almost primitive feel to it. Constructed from adobe – the colour of the surrounding parched earth – the house is a collection of low-slung rectilinear forms reminiscent of the traditional pueblo revival style. As such, the property sits well in its landscape as an unassuming, adequate dwelling.

The interior, however, is where both architect and client have excelled. Walls coated in rich hues and dark woodwork transport the visitor into a formal and ordered yet luxurious world. This is the Arts and Crafts Movement making a stand in the 21st century. Architect Jim Hays employed local craftspeople – from cabinet-makers to stonemasons – to realize the client's desire to create a beautiful, interesting home in which the eye is constantly on the move without wanting to look outside.

The property is the perfect backdrop for the owner's large collection of art and artifacts, while also making its own statement with beautifully crafted interior decoration and fittings. This was not achieved without difficulty, though. Marrying the ad hoc nature of adobe construction with the regimentation of cabinet-making was not easy, but the devotion of architect and craftspeople won through to produce an exquisite property of unique aesthetics.

Spatially, Thistle Star has surprises too. The main entertaining area is the great room, an expansive space with high coffered ceiling, rich red walls, and bookcases; in contrast, a recess with fireplace in the master bedroom offers a cosy nook in which to relax and reflect. Thistle Star is a harmonious combination of inspired design and traditional crafts, a modern museum piece.

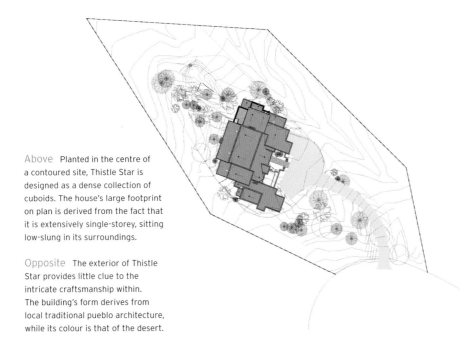

Above Planted in the centre of a contoured site, Thistle Star is designed as a dense collection of cuboids. The house's large footprint on plan is derived from the fact that it is extensively single-storey, sitting low-slung in its surroundings.

Opposite The exterior of Thistle Star provides little clue to the intricate craftsmanship within. The building's form derives from local traditional pueblo architecture, while its colour is that of the desert.

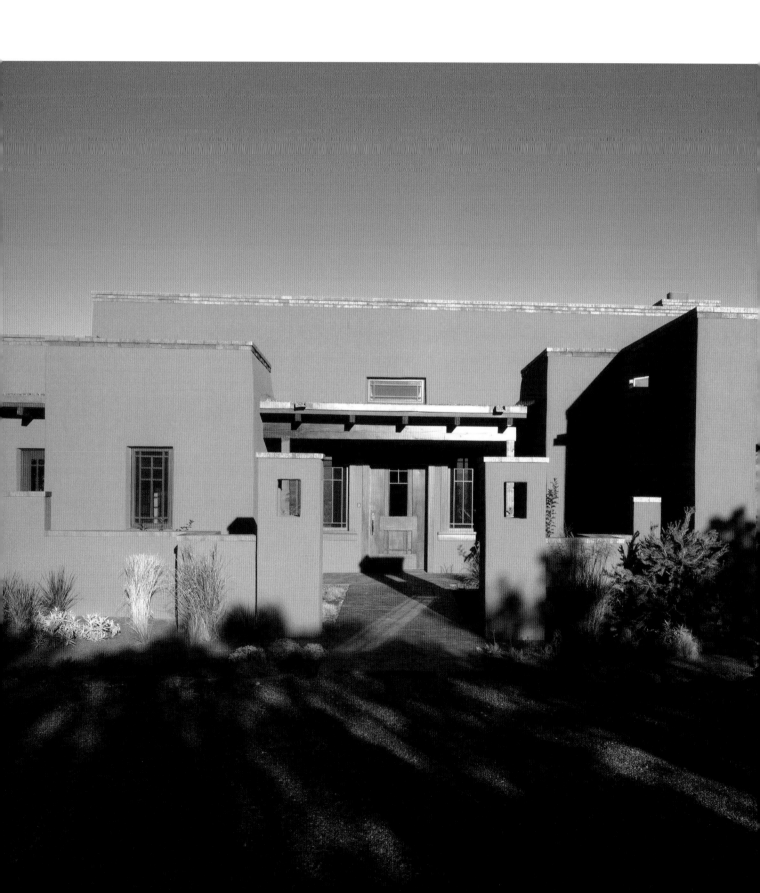

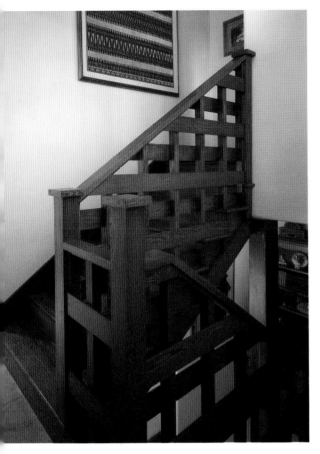

West elevation

East elevation

South elevation

North elevation

Above Local craftspeople and methods were employed at every stage of construction. Thistle Star pays homage to often forgotten handmade work – this balustrade seems to be of woven timber.

Above These elevations illustrate how the property sits on the graded site. Designed as a collection of forms, it harks back to a time when a family would extend their home as required or as they could afford it.

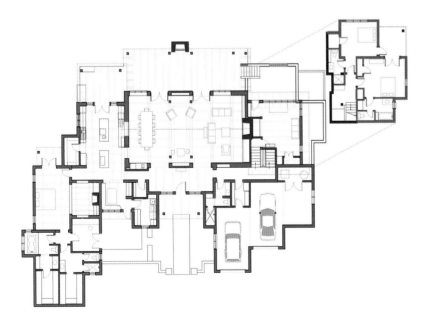

Left At the heart of the house is the great room (see also opposite bottom) where the family gathers to eat and relax. Radiating off this on all sides are other spaces for living, both internal and external. The house almost rambles in plan, creating interesting finds around each corner.

Opposite top Unlike most new projects, this is a 20th-century design that seeks to celebrate the architecture of the past. The ingle-nook in the master bedroom, lit from above by a small skylight, features formal timber bookshelves and a stone fireplace.

Opposite The double-height space of the great room is framed in timber and coloured deep red. Timber plays an important part in the aesthetics of Thistle Star, its workability being instrumental in the hand-crafted feel of the house.

Alsop Architects
Groningen, Netherlands

CiBoGa

Will Alsop's direct and bold use of colour enables him to connect easily with the public, and it is used to dramatic effect on a masterplan and architecture in the Dutch town of Groningen. The masterplan will transform a derelict gasworks into a residential neighbourhood of 920 homes. It comprises housing designs, by numerous architects, built on "*schotsen*," or "ice floes" – sculpted green hills that hover in the landscape and are linked by car-free routes of "glittering tarmac, coloured ponds and streams, creating an intimate, fresh environment," according to the architect.

Alsop has also designed buildings for one *schots*. The CiBoGa project includes three buildings that are independent but interact in a setting of water features, coloured bridges, and contemporary landscaping. A striking loft apartment block, clad in coloured glass, signals the *schots* from afar. It is the first time this material has been used on a large-scale housing scheme, and it has instant welcoming appeal. Adjacent town houses feature a warm timber façade, which sweeps around to create and protect a semi-private courtyard at the heart of the development. Finally, the studio houses are clad in coloured prefabricated concrete panels. Pigments added to the cement at manufacture produce subtle shades, complemented by a second "layer" of balconies that emphasize the colour.

The architectural designs rely on both their material quality and their colour – textures and perceived depths – to work. Occupants will feel ownership of their individual block and their particular space within it, owing to the individuality achieved by Alsop's intuitive designs.

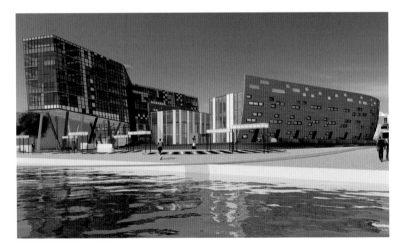

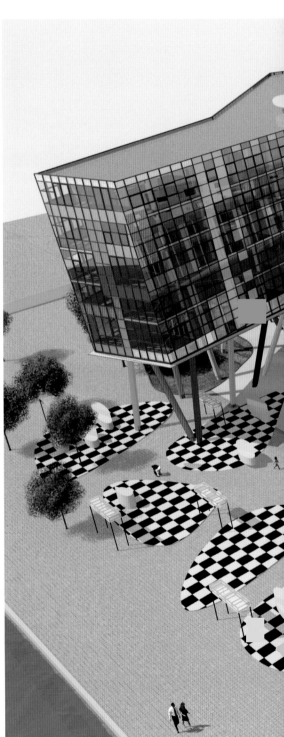

Above Alsop Architects' trademark building on stilts is an initial eye-catching element of one of the most unusual housing developments ever seen. The architect also has an eye for colour and utilizes it at every opportunity.

Right While shying away from labels such as "Post-Modern," Alsop creates an architectural version of abstract art at CiBoGa. Unconnected shapes, colours, and styles crash into one another to form a jarring but evocative development.

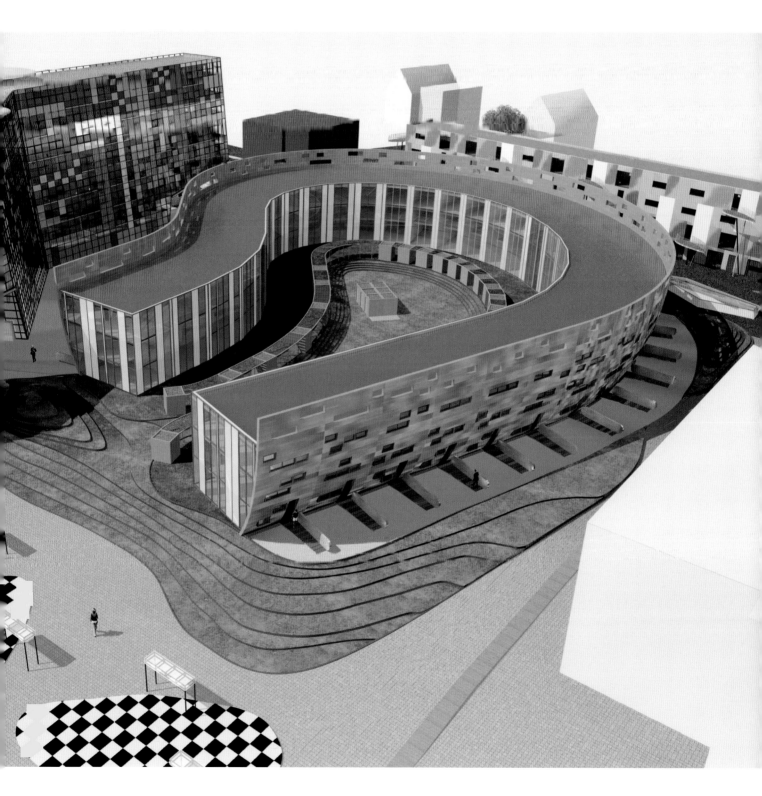

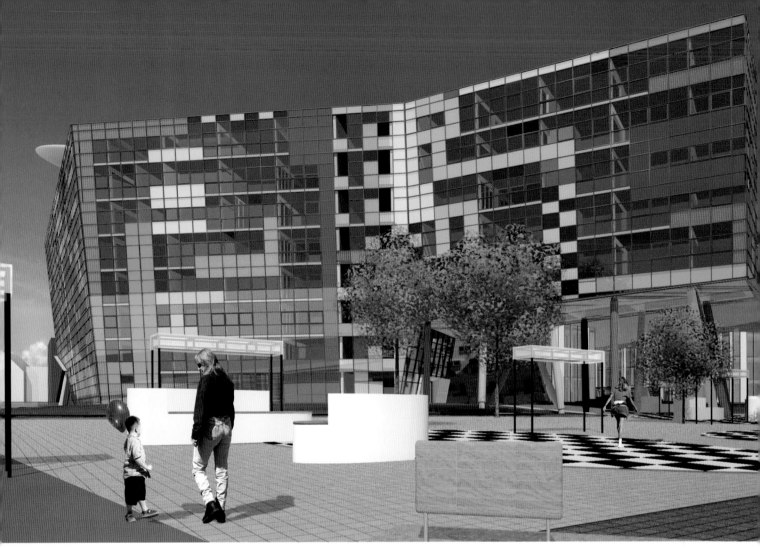

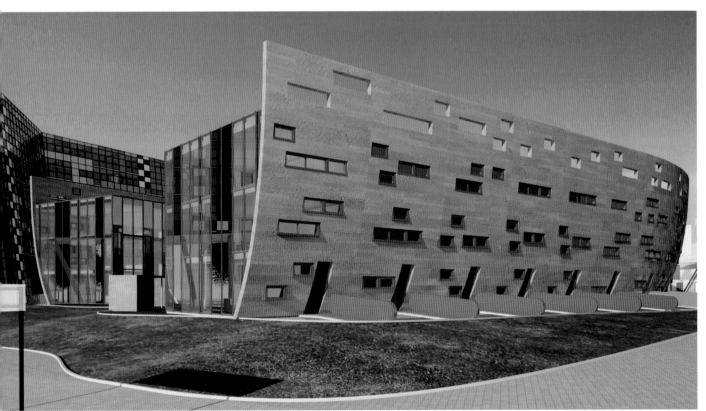

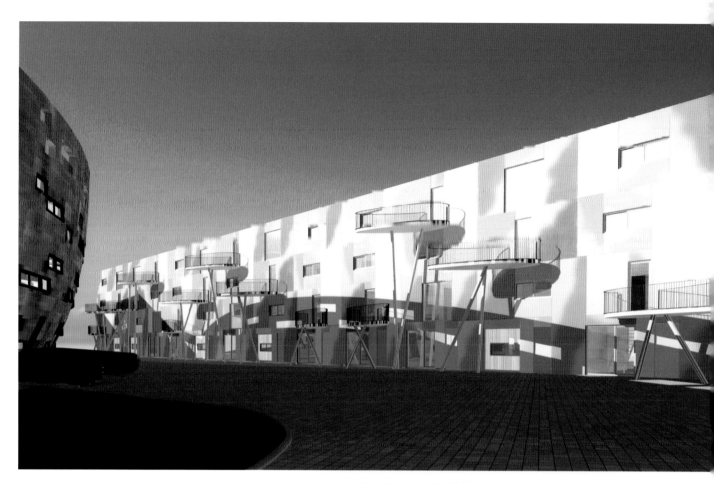

Above and right The studio house apartment block is the most conventionally shaped building on the site, but coloured concrete façade panels and precarious balconies on stilts challenge the norm, in tune with the overall design of the development.

Opposite top The glazed façade of the loft apartments is adorned with colour, reminiscent of a Tetris video game or a multicoloured Scrabble board. Landscaped external areas are no less gaudy: off-the-wall design has created an exciting and rewarding communal environment.

Opposite Perhaps the most unusual of the housing blocks, oddly dubbed "town houses," this curvaceous timber-clad boat hull sits on a grass mound and wraps around a central courtyard, providing a semi-private space.

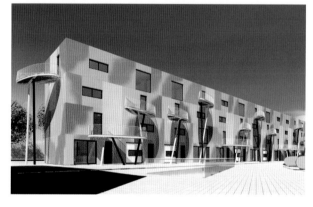

DoMa Gallery

On a rural estate in Maryland, two collectors wanted to create space for their contemporary art collection that had outgrown the house. The most prominent building on their estate was a ramshackle barn which, while it looked quaint, was a virtual ruin. W Architecture has restored and upgraded this barn to such a degree that now it not only houses works of art but also acts as a guest house, complete with bedroom, bathroom, kitchen, dining area, office, exercise room, and sun deck.

The architect has preserved the natural character of the barn by stabilizing its timber façade with steel plates and rods to strengthen the form. Into this has been built a Modernist glass pavilion. This element rests lightly on the barn's stone base and rough-sawn timber joists. To the south side, the barn retains its original slatted timber façade – this also acts as a filter, shading the artworks from strong southerly sunshine. The north elevation is treated differently: it is opened up to reveal the glass structure and allow in more light, while providing views to the meadows beyond.

The barn's main level houses the gallery and the living and dining areas, with the guest quarters situated below in the stone base. A loft level is mostly given over to the double-height gallery, but a small section serves as an office or study and leads out on to a balcony.

At one time there were to be moveable screens in the gallery space on which to hang additional artworks. These have since been scrapped because, as the owner says, the award-winning gallery is "a work of art in itself."

Above The project's humble beginnings as a barn are well illustrated in these line drawings. The glass box, inserted at first-floor level, is the only major intervention in this wonderfully simple structure.

Right Light filters through the original slatted timber walls of the barn, casting magical dancing rays of light across the main living and gallery space. The building's beauty comes not just from its Miesian glass box but also from its interaction with the original barn.

Opposite Set within landscaped grounds, DoMa Gallery is a startling combination of new and old. This north elevation is open, revealing the crisp new living space. The south side retains its timber slat façade, offering only a glimpse of what is inside.

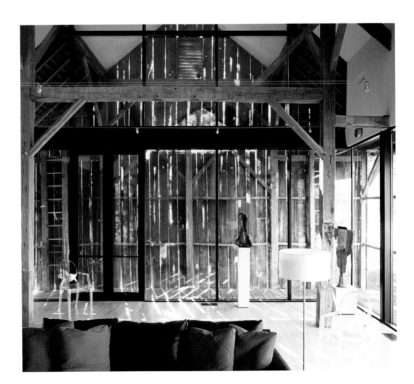

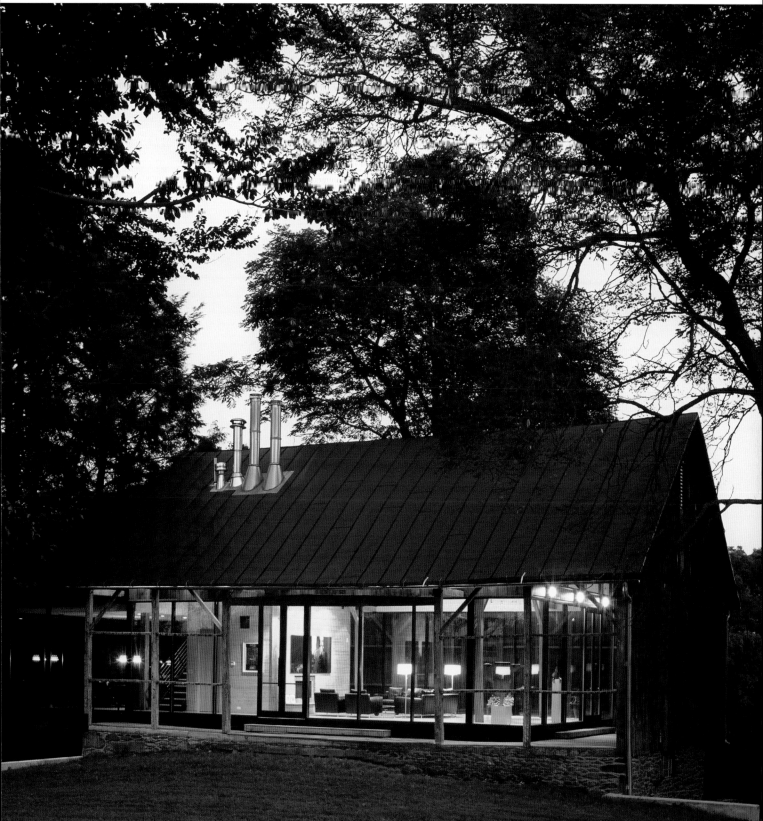

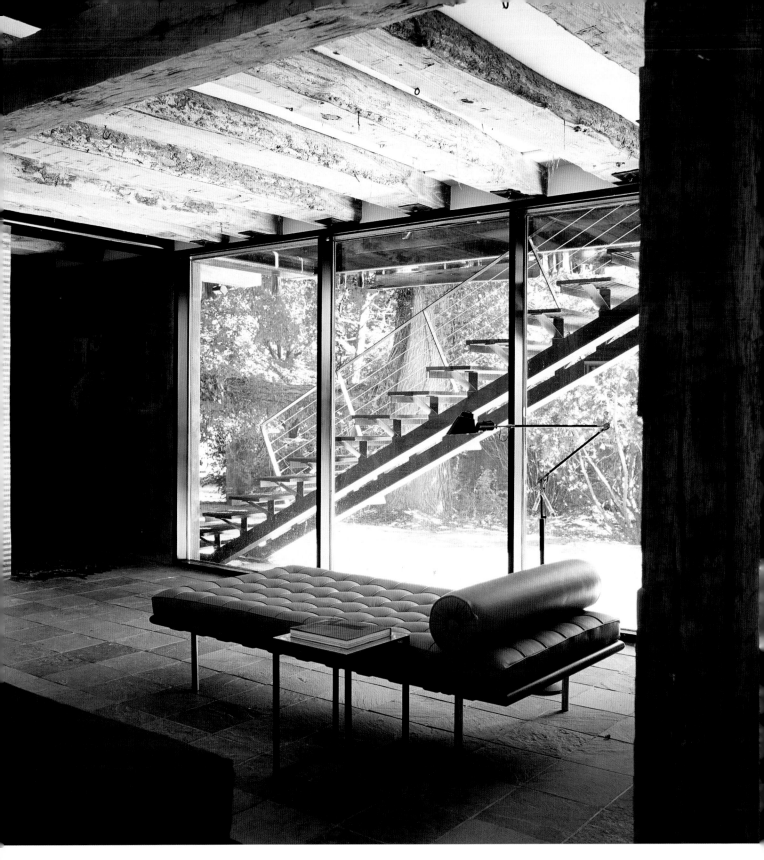

Above The basement level of
the property is sparsely furnished,
akin to any other art gallery. The
natural materials chosen – stone,
timber, and leather – have a tactile
quality, as a counterpoint to the
steel and glass of the façade and
the stair outside.

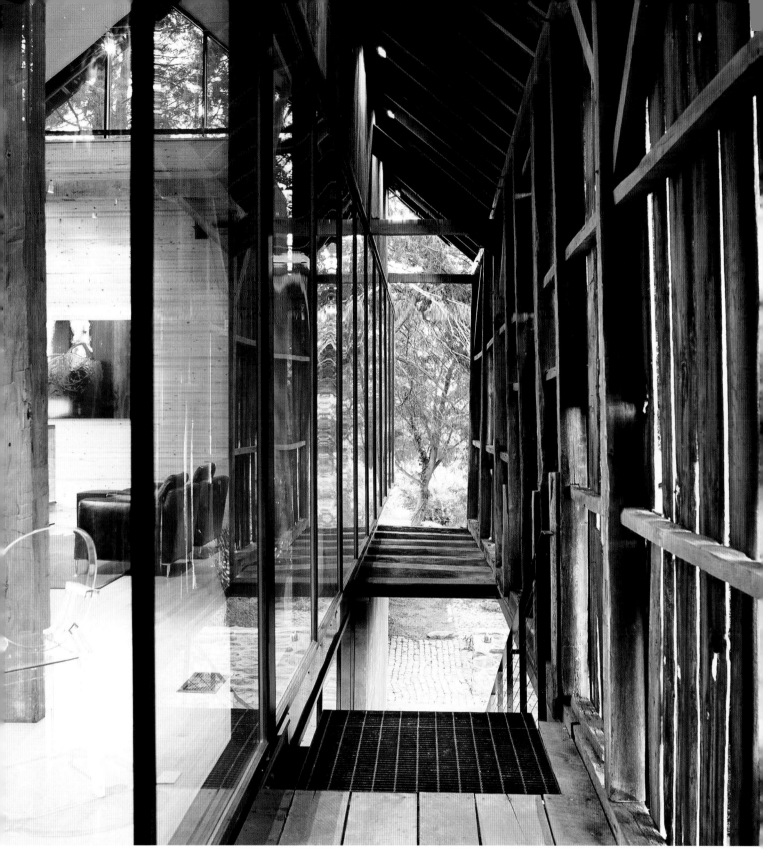

Above Nowhere is the
juxtaposition between new and old
so apparent as in the corridor space
between the enclosed gallery and
the original barn wall. The contrast
in materials, ages, and construction
techniques creates a wonderful
timeless aesthetic.

ARCHITECT AND PHOTOGRAPHER DETAILS

PROJECT	ARCHITECT	IMAGES
CONDITIONS		
Casa Equis	Barclay & Crousse +33 1 492 35136 atelier@barclaycrousse.com	Jean Pierre Crousse Robert Huarcaya
Ray 1	Delugan Meissl +43 1 585 3690 haasler@deluganmeissl.at	Rupert Steiner +43 1 581 9520 office@rupertsteiner.com
Hua Guan House	WOHA Design +65 6423 4555 admin@wohadesigns.com	Tim Griffith +1 415 640 1419 tim@timgriffith.com
Voss Street House	Featherstone Associates +44 (0) 20 7490 1212 mail@featherstone-associates.co.uk	Tim Brotherton +44 (0) 20 7613 2558 brotherton@another.com
Fin-Topped House	Ben Addy +44 (0) 20 7467 0653 ben@amintaha.co.uk	Photographs property of architect
Beach House	Architects Ink +61 88 364 1434 adelaide@architectsink.com.au	Trevor Fox +61 (0) 4111 55669
One Centaur Street	de Rijke Marsh Morgan +44 (0) 20 7803 0777 alex@drmm.co.uk	Photographs property of architect
Suitcase House	Edge Design Institute +852 2802 6212 edgeltd@netvigator.com	Asakawa Satochi Howard Chan Gary Chang
MATERIALS		
Peninsula House	Sean Godsell Architects +61 3 9654 2677 Godsell@netspace.net.au	Earl Carter +61 3 9525 5288
Belper House	Hudson Architects +44 (0) 20 7490 3411 sam@hudsonarchitects.co.uk	Photographs property of architect
Living Tomorrow 3	Living Tomorrow UN Studio www.unstudio.com	Christian Richters +49 251 277 447 chrichters@aol.com
Skolos/Wedell Home	Mark Hutker Architects & Associates +1 508 540 0048 www.hutkerarchitects.com	Thomas Wedell of Skolos-Wedell www.skolos-wedell.com

Natural Ellipse	Masaki Endoh and Masahiro Ikeda	Daici Ano
	edh-endoh@mvi.biglobe.ne.jp	+81 03 3664 1767
	daici@mac.com	
Vertical House	Lorcan O'Herlihy Architects	Michael Weschler
	+1 310 398 0394	Leah Levine (agency)
	loh@loharchitects.com	+1 818 783 7241
		leah@l2agency.com
Sinclairs	Project Orange	Photographs property of architect
	+44 (0) 20 7689 3456	
	mail@projectorange.com	
Sued.See	Gerner Gerner Plus	Manfred Seidl
	+43 (0) 1 596 2204	+43 (0) 1786 0600
	office@gernergernerplus.com	

ENVIRONMENT

Grafton New Hall	Ushida Findlay	Photographs property of architect
	+44 (0) 20 7278 6800	
	nicola.dewe@ushidafindlay.com	
Solar House	Robert Adam Architects	Carlos Dominguez
	+44 (0) 1962 843843	+44 (0) 207 622 2255
	admin@robertadamarchitects.com	
Growing House	Ahadu Abaineh	Photographs property of architect
	Almaz1844@hotmail.com	
Bloembollenhof	S333	Jan Bitter
	+31 (0) 20 412 4194	post@janbitter.de
	info@s333.org	
Iden Croft	Eldridge Smerin	Photographs property of architect
	+44 (0) 20 7228 2824	
	mail@eldridgesmerin.com	
m-house	Tim Pyne	Wyn Davies
	+44 (0) 20 7739 3367	www.wyndavies.com
	info@m-house.org	
Murphy House	Blue Sky Architecture	Laurence Pugh
	+1 604 921 8646	Leigh Taylor Ellis
	bsa@blueskyarchitecture.com	Holliwell + Smith, Blue Sky Architecture
New Eden House	Cullum & Nightingale	Richard Nightingale
	+44 (0) 20 7383 4466	
	www.cullumnightingale.com	
	for letting information go to	
	www.grenadine-escape.com	

BUDGET

Heeren Shophouse	SCDA Architects	Albert Lim K S
	+65 6324 5452	+65 6242 8038
	scda@starhub.net.sg	
Loftcube	Studio Aisslinger	Steffan Janicke
	+49 (0) 30 315 05 400	+49 306 148 612
	studio@aisslinger.de	mail@steffen-janicke.de

Steve's Retreat	Theis & Khan +44 (0) 20 772 99329 patricktheis@theisandkhan.com	Photographs property of architect
Rubber House	Simon Conder Associates +44 (0) 20 7251 2144 sca@simonconder.co.uk	Stephen Ambrose +44 (0) 7866 602627 ste@stephenambrose.co.uk
Elemental Housing	ONL +31 10 244 7039 oosterhuis@oosterhuis.nl	www.trans-ports.com www.webvannoordholland.nl www.oosterhuis.nl
Six Wood Lane	Birds Portchmouth Russum Architects +44 (0) 20 7253 8205 info@birdsportchmouthrussum.com	Photographs property of architect
Rural Retreat	Buckley Gray +44 (0) 20 7426 0303 mail@buckleygray.com	Photographs property of architect
SU-SI	Kaufmann Kaufmann +43 5572 23690 office@kjarch.at	Ignacio Martinez +43 5577 88362 ignacio.martinez@aon.at

AESTHETICS

Butterfly House	Chetwood Associates +44 (0) 20 7490 2400 julie.paxie@chetwood-associates.co.uk	Edmund Sumner +44 (0) 20 7501 6477 edmund@edmundsumner.co.uk
Piano House	Rafael Viñoly Architects +1 212 924 5060 fgretes@rvapc.com	Roman Viñoly
Avant-Garde	Erick van Egeraat associated architects +31 10 436 9686 eea.nl@eea-architects.com	Photographs property of architect
Blue House	FAT +44 (0) 20 7251 6735 fat@fat.co.uk	Oscar Paisley +44 (0) 20 8471 8118 oscar@oscarpaisley.co.uk Will Jones
Pixel House	Beige Design +1 510 525 9602 thom@beigedesign.com	Thom Faulders
Thistle Star	Hays Associates +1 505 982 5467 Hays@haysinc.com	Robert Reck Photography +1 505 247 8949 robert@robertreck.com Julie Dean +1 505 986 8847 jldbjj@qwest.net
CiBoGa	Alsop Architects +44 (0) 20 7978 7878 www.alsoparchitects.com	UBIK Marc Heesterbeek +31 (0) 20 423 0329 ubikmh@xs4all.nl
DoMa Gallery	W Architecture +1 212 981 3933	Erik Kvalsvik +1 202 362 6312 ek@erikkvalsvik.com

BIBLIOGRAPHY

A major part of the research for this book was carried out on the Internet.

MAGAZINES

A+U, Japan Architect Co, Tokyo

Architects' Journal, Emap, London

Architectural Record, McGraw Hill Construction, New York

Architectural Review, Emap, London

Building, CMP Information, London

De Architect, CMP Information, London

RIBA Journal, CMP Information, London

Su Casa, Hacienda Press, Albuquerque

*Wallpaper**, IPC Media, London

World Architecture, The Builder Group, London

BOOKS

Asensio, Paco, *Los Angeles Houses*, teNeues, New York, 2002

Constant, Aroline, *Eileen Gray*, Phaidon, London, 2000

Le Corbusier, *Towards a New Architecture*, Architectural Press, Oxford, 1923/2001

Frampton, Kenneth, *Le Corbusier*, Thames & Hudson, London, 2001

Frampton, Kenneth, *American Masterworks*, Thames & Hudson, London, 2002

Lootsma, Bart, *Super Dutch*, Thames & Hudson, London, 2000

Maddex, Diane, *Frank Lloyd Wright, Inside and Out*, Pavilion, Brighton, 2001

Siegal, Jennifer, *Mobile: the art of portable architecture*, Princeton Architectural Press, New York, 2002

Wallis, Allan D, *Wheel Estate*, The Johns Hopkins University Press, Baltimore, 1991

INDEX

ACKNOWLEDGMENTS

Cover: Delugan Meissl/Rupert Steiner; Back cover: Barclay & Crousse Architects/Jean Pierre Crousse; 2 Tim Pyne; 7 Sean Godsell Architects/Earl Carter; 8–9 Alsop Architects/UBIK Marc Heesterbeek; 10 Mark Hutker & Associates/Thomas Wedell; 11 Barclay & Crousse Architects/Jean Pierre Crousse; 14 top left Architects Ink/Trevor Fox; bottom left Featherstone Associates/Tim Brotherton; top right WOHA Design/Tim Griffith; bottom right Barclay & Crousse Architects/Jean Pierre Crousse; 16–17 Barclay & Crousse Architects/Robert Huarcaya; 18 Barclay & Crousse Architects/Jean Pierre Crousse; 19 Barclay & Crousse Architects/Robert Huarcaya; 22–25 Delugan Meissl/Rupert Steiner; 26–29 WOHA Design/Tim Griffith; 30–31 Featherstone Associates/Tim Brotherton; 32–35 Ben Addy; 36–37 Architects Ink/Trevor Fox; 38–41 de Rijke Marsh Morgan/A Mack + A de Rijke; 42 Edge Design/Gary Chang; 43 Edge Design/Asakawa Satochi, 44–45 Edge Design/Gary Chang; 48 top left Lorcan O'Herlihy Architects/Michael Weschler; bottom left Masaki Endoh/Daici Ano; right Sean Godsell Architects/Earl Carter; 50–55 Sean Godsell Architects/Earl Carter; 56–57 Hudson Architects; 58–61 Living Tomorrow/Christian Richters; 62–63 Mark Hutker & Associates/Thomas Wedell; 64–67 Masaki Endoh/Daici Ano; 68–69 Lorcan O'Herlihy Architects/Michael Weschler; 70–71 Project Orange; 72–75 Gerner Gerner Plus/Manfred Seidl; 78 top Blue Sky Architecture/Laurence Pugh; bottom Ushida Findlay; 79 top Robert Adam Architects/Carlos Dominguez; bottom Cullum & Nightingale/Richard Nightingale; 80–83 Ushida Findlay; 84–87 Robert Adam Architects/Carlos Dominguez; 88–89 Ahadu Abaineh; 90–93 S333/Jan Bitter; 94-95 Eldridge Smerin; 96–99 Tim Pyne/Wyn Davies; 100–101 Blue Sky Architecture /Laurence Pugh; 102–103 Blue Sky Architecture/Leigh Taylor Ellis; 104–107 Cullum & Nightingale/Richard Nightingale; 110 top left Studio Aisslinger/Steffan Janicke; top right ONL; bottom Buckley Gray; 111 SCDA Architects/Albert Lim K S; 112–115 SCDA Architects/Albert Lim K S; 116–119 Studio Aisslinger/Steffan Janicke; 120–121 Theis & Khan; 122–123 Simon Conder Associates/Stephen Ambrose; 124–127 ONL; 128–129 Mike Russum/BPR; 130–131 Buckley Gray; 132–133 Kaufmann Kaufmann/Ignacio Martinez; 136 left Erick van Egeraat; right Rafael Viñoly Architects/Roman Viñoly; bottom Chetwood Associates/Edmund Sumner; 138–139 Chetwood Associates/Edmund Sumner; 140–141 Laurie Chetwood; 142–143 Chetwood Associates/Edmund Sumner; 144–147 Erick van Egeraat; 150–151 FAT/Will Jones; 152–153 FAT/Oscar Paisley; 154–155 Beige Design; 156–159 Hays Associates/Robert Reck; 160–163 Alsop Architects/UBIK Marc Heesterbeek; 164–167 W Architecture/Erik Kvalsvik.

In the spirit of all the best Oscar ceremonies, I'd like to thank quite a few people for their help, guidance, and support on this project. Thank you to Laura Iloniemi for her ideas and introductions and to commissioning editor Mark Fletcher for promoting my idea. Immense gratitude also goes out to all of the architects, developers, photographers, and image creators whose work is included in these pages and to the publicity agencies that have assisted me in finding these fabulous architectural projects.

Emily and Hannah at Mitchell Beazley, you've both given great support throughout the project; and Lancton, thank you for photography advice. Thanks also to Kirsty Seymour-Ure for her editing expertise and to Chris Wilkinson for writing the foreword for the book. And finally, and most importantly, I could not have achieved this work without the support of my partner, Stephanie, and monkey (you know who you are). Thank you all.